Illustrating the Past
Artists' interpretations of ancient places

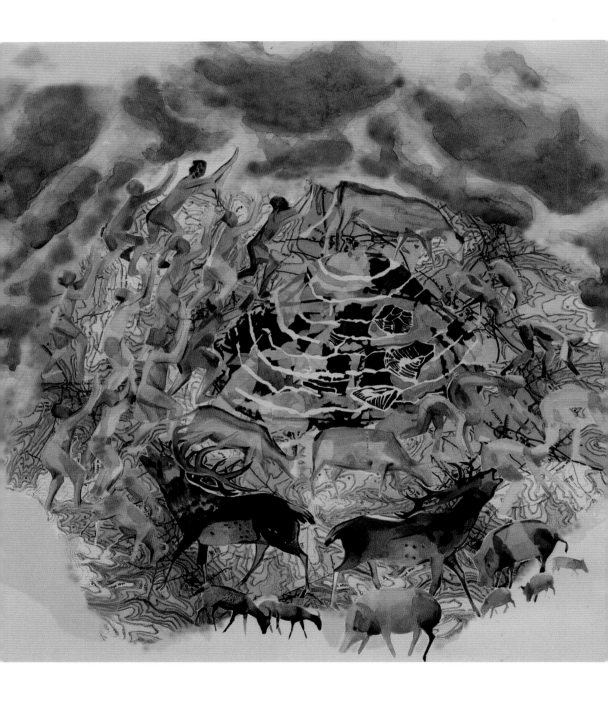

Illustrating the Past

Artists' interpretations of ancient places

Judith Dobie

 Historic England

Published by Historic England, The Engine House, Fire Fly Avenue, Swindon SN2 2EH
www.HistoricEngland.org.uk
Historic England is a Government service championing England's heritage and giving expert, constructive advice.

First published 2019

ISBN 978 1 84802 272 0

British Library Cataloguing in Publication data
A CIP catalogue record for this book is available from the British Library.

For more information about images from the Archive, contact Archives Services Team, Historic England, The Engine House, Fire Fly Avenue, Swindon SN2 2EH; telephone (01793) 414600.

Brought to publication by Jess Ward, Publishing, Historic England.
Typeset in Georgia Pro 9/11

Edited by Susan Kelleher
Proofread by Kim Bishop
Indexed by Read Indexing
Page layout by Hybert Design

Printed in the Czech Republic via Akcent Media Limited

Front cover: Neolithic/Bronze Age children, Silbury Hill, Wiltshire by Judith Dobie (see Fig 8.9). Collage, watercolour, crayon, 300 × 270mm, 2010 [IC245/001]

Inside front cover: Detail of the pencil rough for Fig 8.7, Silbury Hill, Wiltshire in the Roman period. [© Judith Dobie]

*Frontispiece: A collage of Silbury Hill by Judith Dobie and John Vallender. Silbury Hill can be explained as a kind of gigantic, chaotic collage in which materials, substances, people, animals, plants and place come together as a montage of the landscape.
Collage, mixed media, 490 × 420mm, digitally assembled 2013 [IC005/046]*

Inside back cover: Detail of the pencil rough for an illustration of Silbury Hill in the 10th to 11th centuries. The top of the hill is flattened and a watchtower forming part of the fortifications at this time is conjectured. The landscape is shown as being farmed with a bread wheat crop being harvested and gleaned in the foreground. [© Judith Dobie]

Contents

Preface

Our understanding of the human past is very limited. The mute evidence from excavation – the dusty pot sherds, fragments of bone, slight variations in soil colour and texture – encourages abstraction and detachment. Reconstruction art offers a different way into the past, a different insight to that obtained from the long, heavy texts of archaeological reports. At its best it delivers something vivid, vital and memorable.

The seven artists featured in this book – seven of the many artists who have worked for the Department of Ancient Monuments, Directorate of Ancient Monuments and Historic Buildings, English Heritage and Historic England – in their different personalities, interests and backgrounds bring different perceptions and slants to their art. Illustrators working in archaeology are often anonymous and yet the picture that summarises an excavation can be the idea that endures.

Whenever possible the chapters on individuals are based on conversation and correspondence. Allan Adams, still working for Historic England, wrote his own chapter and case study explaining his working method. Similarly, Peter Dunn's case study is in his own words. The rest of the book has been written by Judith Dobie.

Acknowledgements

The idea for a book on archaeological reconstructions came from Paul Backhouse, Head of the Imaging Group at Historic England. Trevor Pearson, Visualisation Manager at Historic England, oversaw the project and was continually encouraging and supportive.

Glyn Coppack talked to me of his experience as an Inspector of Ancient Monuments as did John Clarke, who worked as an Interpretation Manager at English Heritage over the same period.

My information about the Royal Commission on Historical Monuments of England (RCHME) and the development of their style of illustration comes from Allan Adams, architectural illustrator, who as well as writing his own chapter and case study was most helpful with ideas and different slants to the book. I am grateful to Mark Bowden, Historic Places Investigation Team Manager at Historic England, who read the text and corrected and commented on it.

Most of the images in the book come from the Historic England photographic library and archive where Jo Beach and her team made the originals available and have been interested and encouraging throughout the project. Likewise, I have had much help searching for books from the Historic England library.

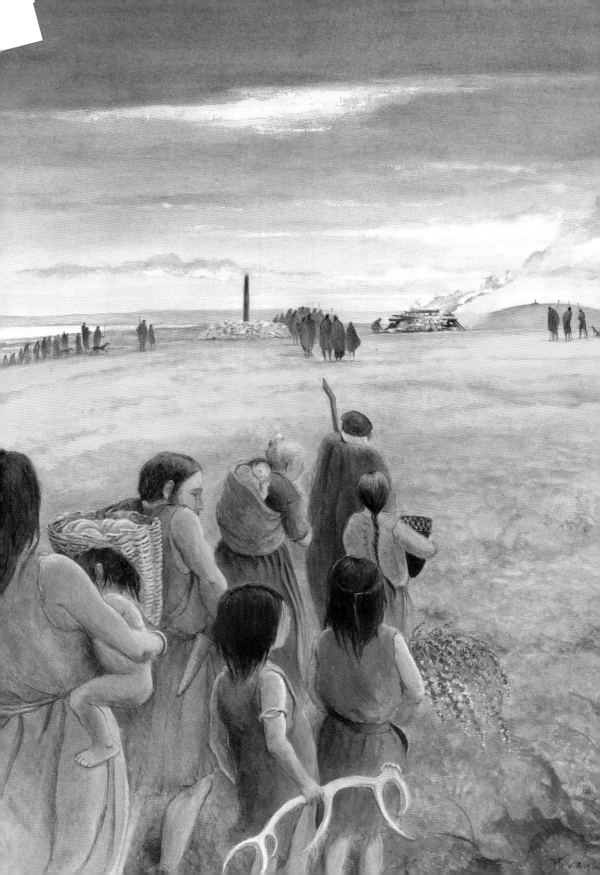

1 | Introduction: Ways of seeing the past

'The past is dead and we cannot reconstruct it as it was.'

(Edmonds 1999, x)

There is a gap between the fragments of evidence of the past uncovered by archaeology and our understanding of the whole picture. We try to fill that gap by combining what evidence we have with our imagination to create an image. Reconstruction art is the attempt by an artist to visualise scenes from the past almost as though the artist themselves were there drawing what they saw before them.

The further back we look, the less evidence we have to construct a picture. There is little evidence available for the Palaeolithic and Mesolithic periods of the Stone Age when communities were no more than extended families dispersed and fragmented in the landscape, a little more for the Neolithic and Bronze Age (Fig 1.1), considerably more for the Iron Age (*see* Fig 1.11) and a lot of information to reconstruct Roman times. The period after the Romans, the 5th and 6th centuries and the early medieval period, used to be called the Dark Ages for there is so little surviving evidence for a time which seems to be marked by warfare and the disappearance of urban life, but we have many sources of information about life in medieval times when there are written records and documents, and even more for post-medieval times.

Our information for the earliest periods comes mostly from archaeology; not just excavation but other techniques such as field survey, aerial reconnaissance, geophysical survey and environmental sampling. The science of archaeology has progressed rapidly from the 1960s and now, by examining the flora and fauna found in soil samples, we can reconstruct an ancient landscape. Such knowledge was not available to the first of the reconstruction artists selected for this book – Alan Sorrell, who worked from the 1930s to the 1970s. His reconstructions are often aerial views of a site, reflecting the fact that, while excavation is good at revealing building and settlement plans, it is less likely to uncover the detail of day-to-day activities which are fugitive and fragile. When Sorrell was active the general method of excavation was by digging a trench and removing 'the loose rubble' until substantial walls or floors were revealed. Philip Barker's work at Wroxeter in 1966 demonstrated a different way of working. Excavating a small area alongside earlier excavations he defined 14 phases of occupation above the highest remains recognised by previous excavators. By meticulous observation, recording by drawing and photography of the different colours, textures and degrees of wear of the soil, he identified what were timber structures. At Chester in 2004 Tony Wilmott's skilful excavation of the Roman amphitheatres uncovered the story of a delivery of sand to the arena. Grooves in the soil showed how the cart had slid off the road, tilted and spilt the sand. In earlier times it is unlikely that the traces of this incident would have been recognised (Fig 1.2).

There are different strands to reconstruction art as different artists have different aims and different audiences to address. One way of discussing these

Fig 1.1
Cremation, Higher Hare Knap, Quantock Hills, Somerset, Bronze Age

Jane Brayne's illustration for the academic publication *The Historic Landscape of the Quantock Hills* (2006) was based on landscape survey and comparison with excavated sites such as Brenig Valley, North Wales. It shows a ring cairn with a central upright post, the funeral pyre and on top of a distant hill, a barrow. She depicts the features recorded by field survey but also paints an atmospheric picture of small family groups living dispersed in a wide, open landscape coming together for special ceremonies.

Watercolour, gouache, 420 × 300mm, 2005

[© Jane Brayne]

Fig 1.2
Sand spill, Chester Roman Amphitheatre, Cheshire, c AD 90

This drawing by Judith Dobie illustrates an incident when the cart slipped from the roadside kerb during the delivery of sand for the amphitheatre arena.

Pen and ink, 125 × 285mm, 2016

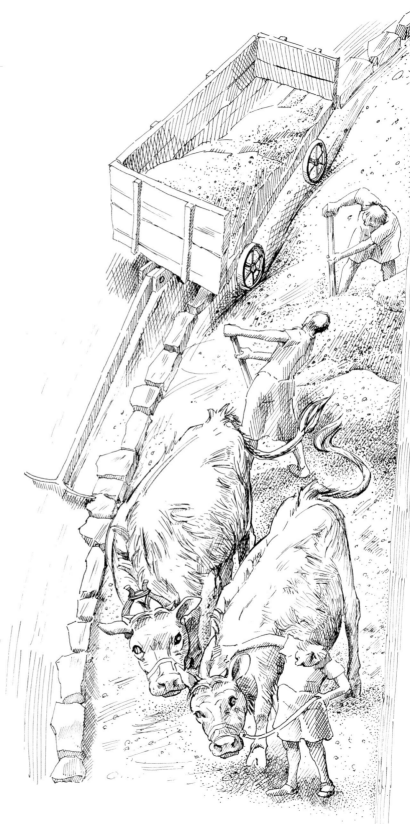

different sorts of illustration was suggested by the illustrator and artist Kelvin Wilson at a lecture in 2014 at the University of York when he identified three groups of reconstruction artist based on their different working practices and styles, namely 'the Technicians, the Narrators and the Educators'. One could think of the Technician as someone who works closely with the archaeologist or other expert, interpreting their ideas, the picture they produce aimed at a narrow, informed professional audience. Then there is the Narrator who paints for a wider public, maybe building on the work of the first group of illustrators using their research but aiming to capture and engage the nonspecialist public (Fig 1.3). Their work might be used in books and magazines or for museum displays. Finally, the Educator would be the school textbook illustrator or illustrator of children's historical novels or nonfiction books, or in earlier times the illustrator of adults' historical novels.

Of course, there is a crossover from category to category and the same illustrator might work in different ways to produce different sorts of pictures. The neo-Romantic artist Alan Sorrell was a reconstruction artist in the narrative category in that his pictures tell a story (he describes his figures as actors on a stage) but he was meticulous about accuracy, probing and questioning and therefore was also a technician. The pencil notes and rough sketches that passed back and forth between Sorrell and the archaeologist as the picture was constructed demonstrate this. He might question the archaeologist over their interpretation of the evidence. Working with R Gilyard-Beer in 1967 on the illustration of the Chapel of Nine Altars at Fountains Abbey, he questioned the Assistant Chief Inspector of Ancient Monuments over the significance of the putlog holes in the wall elevation. Gilyard-Beer is reported to have replied on 25 October 1967 thanking Sorrell for his letter, and for his 'very ingenious' suggestion about the putlog holes in the chapel. On balance he thought that these holes were ordinary putlogs and not the seating for corbels carrying the wall posts of the late timber roof and concluded that it would be best to stick to their original solution. In a similar way, although the English Heritage artist Terry Ball could be classified as a technician aiming to present a cool, neutral, objective image, he writes how in fact he struggled to keep his personality out of his pictures and was unable to ignore the abstract qualities of a painting – the light, form and tone which are so much a part of the appeal of his pictures.

The Narrators

These different genres have a history. The narrative style of reconstruction painting goes far back in European art. Until the Impressionist movement of art in the mid-19th century, European visual art was primarily concerned with reconstructing past events – usually with a religious theme. During the Middle Ages painters would show detail in their pictures as contemporary rather than historic. It was only in the 15th century that the differences in material culture between periods began to be recognised and only in the Renaissance, after the study of antiquities was established, that more regard to accuracy is found in the painting of classical subjects. The discovery of Herculaneam in 1738 and Pompeii, first discovered in 1599 and then rediscovered in 1748, encouraged a new precision.

Fig 1.3 Molenaarsgraaf house, The Netherlands, early Bronze Age

Kelvin Wilson's picture illustrates an incident revealed by the excavation of a prehistoric farmstead in The Netherlands – the death of a teenaged boy who choked to death on a fish bone. This is a difficult subject to depict and Kelvin has chosen to approach the subject indirectly by building on the known elements from the excavation – the timber-framed house with thatched roof, the woven floor coverings, the sheepskin rug, the baskets and pots. The boy was buried in a small barrow constructed against the wall of his parents' home and Kelvin has interpreted this as a sign of how loved and missed he was, how he was still a part of the family. He has expressed these feelings by depicting the boy as a vulnerable infant, centre of attention, his mother's hand stretched out to him. In this way he emphasises to the viewer how awful the choking death was and builds a bridge between the distant past and today. Kelvin is a narrator, trying to make events appear more real to us, not in a literal photographic way but in an emotional sense, telling the story by capturing the essence of the situation.

Acrylic and pencil coloured digitally, 500 × 700mm, 1998

Although at the Renaissance being an artist ceased to be regarded as a trade or occupation like any other and was seen as a calling, in reality the large mass of artists was still organised in guilds and companies, still had apprentices like other artisans and still relied for commissions on wealthy aristocrats. Their purpose remained to supply beautiful things. There were various schools of thought that quarrelled among themselves over the nature of beauty but generally there was much common ground.

Towards the end of the 18th century this common ground seemed to gradually disappear. Through its opposition to images in churches the Reformation put an end to the common use of pictures and sculptures in large parts of Europe and forced artists to look for new markets. Painting ceased to be an ordinary trade, knowledge of which was passed down from master to apprentice; instead it became a subject like philosophy to be taught in academies. Artists first called their meeting places academies to stress equality with scholars and it was only in the 18th century that these academies gradually took over the function of teaching art to students. The academies, first in Paris then London, began to arrange annual exhibitions of their members' works. Now we are used to the idea of artists painting with the intention of sending their work to an exhibition to attract attention and to find buyers, but then this was a momentous change. These annual exhibitions were social occasions which made and unmade reputations. Perhaps the most immediate and visible effect was that artists everywhere looked for new types of subject matter.

Subject matter was narrow – Bible stories, the legends of saints, mythologised ancient Greece, heroic tales of Rome and allegorical subjects illustrating some general truth. Now artists felt freer to choose their subjects. An example of this break from tradition was John Singleton Copley's large picture of Charles I demanding the surrender of the five impeached Members of Parliament (Fig 1.4). Copley (1737–1815) was an American working in England and as such would have felt freer of old-world customs and readier to try new experiments. His picture caused a sensation when it was exhibited in 1785. Such an episode had never been the subject of a large painting before and was very controversial, but also the way Copley set about the task was unprecedented. The idea for the picture had been suggested by his friend the history scholar Edmond Malone who also provided him with historical information. In addition, Copley consulted antiquarians and historians about the exact form of the House of Commons in the 17th century and about the dress that would have been worn and, to make his picture as detailed and accurate as possible, he travelled from country house to country house collecting portraits of men who had been Members of Parliament at that time. The French Revolution gave enormous impetus to this type of interest in history and for well over a century many artists, both great and small, saw their task as exactly this type of antiquarian research, helping the public to visualise moments of the past. One hundred and fifty years later the reconstruction artist Alan Sorrell set about his five murals telling the history of the area of Southend-on-Sea in exactly the same way as Copley had so long before (see Fig 2.2).

History painting was the dominant form of academic painting for most of the 19th century after which the style of painting changed direction. In England the Pre-Raphaelite Brotherhood looked back to early Renaissance painting, to a time when they believed artists were honest craftsmen copying nature for the greater glory of God. They saw history painting as having become grandiose

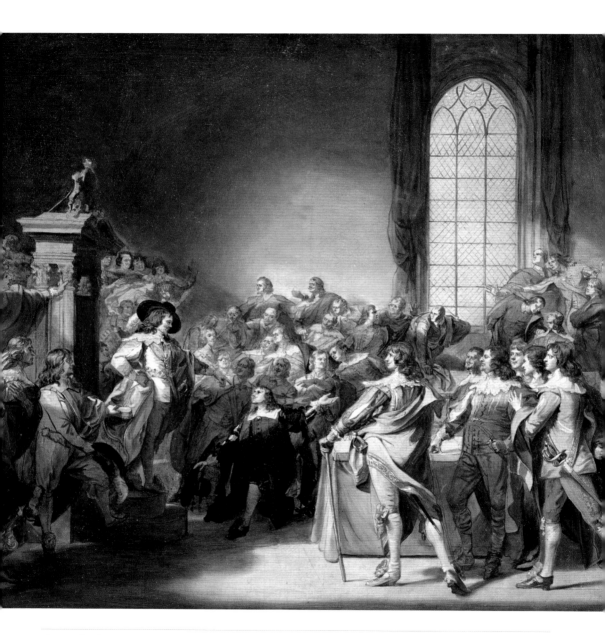

Fig 1.4 *Charles I Demanding the Surrender of the Five Impeached Members of Parliament*

This painting of 1785 by John Singleton Copley was a break from the established tradition of European art – a new type of subject matter and a new type of method reconstructing the chosen historical scene as accurately as possible, as it would have been seen by a contemporary witness.

Oil on canvas, 25 × 30in (641 × 765mm)

[Harvard Art Museums/Fogg Museum, Gift of Copley Amory, Jr. 1957. 224 Imaging Department
© President and Fellows of Harvard College]

and theatrical and believed that they could make a new precise, vivid and uncompromising art for the modern Victorian world. Their hard-edged style, partly influenced by daguerreotypes, the first practicable method of obtaining a permanent image with a camera, aimed for precise accuracy. The art critic John Ruskin, in a letter to *The Times* in May 1851 wrote, 'The Pre-Raphaelites will draw either what they see or what they suppose might have been the actual fact of the scene they desire to represent irrespective of any conventional rules of picture making' (Barringer *et al* 2012, 52). Encouraged by Ruskin the Pre-Raphaelites represented nature with an intensity of detail. William Holman Hunt (1827–1910) was one who aimed to make his pictures as authentic as possible. An Evangelical Christian with a mission as a painter of Christ, he set sail for Palestine in 1854 and painted a series of pictures set in actual biblical sites for which Jews posed as their historical forbears (Fig 1.5). It was an archaeological reconstruction of the life of Jesus.

In France, as at the Royal Academy, the convention had been to paint in the studio using careful graduations of tone from light to dark but the movement against this took a different direction to the Pre-Raphaelite movement in England. First, through Delacroix (1798–1863), who rejected such artificial conditions and believed colour more important than draughtsmanship, then through Millet (1814–75) and Courbet (1819–77) and the school of 'Realism' who determined to draw the world as they experienced it, saw their work as a search for truth and were impatient with theatricality. And then through Edouard Manet (1840–1926) and his followers who brought about a revolution

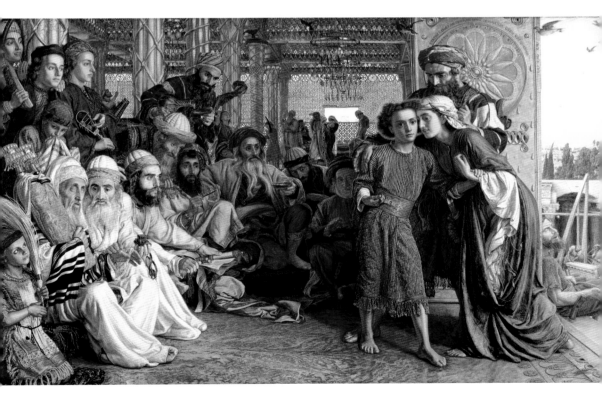

Fig 1.6
The Gare Saint-Lazare

Painted in 1877, Claude Monet creates the effect of light streaming through the glass roof of the railway station on to the steam and engines and carriages. The magical effect of light and air was more important to him than the subject of the painting.

Oil on canvas, 21.2 × 29in (543 × 736mm)

[Claude Monet, *The Gare St-Lazare* © The National Gallery, London (NG6479)]

in the rendering of colour, demonstrating that in the open air we do not see individual objects each with its own colour but rather a bright medley of tones which blend in our eye or really in our head to create the form. Claude Monet (1840–1926) among others developed these ideas. It was Monet who urged his friends to abandon the studio and never to paint a single stroke except in front of the subject. The idea that all painting of nature be finished on the spot demanded changes of technique. Nature – clouds, light, reflections – change minute by minute and to catch these characteristics the painter must work rapidly straight onto the canvas, caring less for detail than for the effect of the whole. This lack of finish, an apparent slapdash approach, was an affront to traditional artists. It was not just the technique that was so controversial but also the motifs chosen. For example, Monet's picture *The Gare St-Lazare* painted in 1877 does not show the station as a meeting place – there is no narrative to the picture, but instead he paints the effect of light streaming through the glass roof onto clouds of steam, the hazy forms of engine and carriages emerging from the confusion (Fig 1.6).

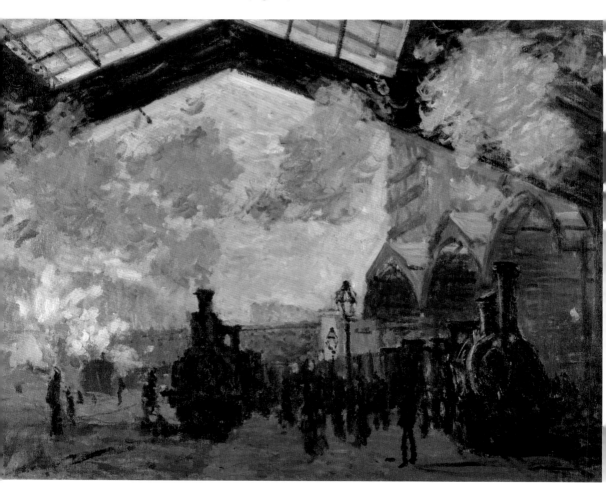

This movement of art, Impressionism, was hastened on by photography, by the development of the portable camera and the snapshot. Photography was to push artists further on the way of exploration and experiment. There was no need for painting to perform a task which a mechanical device could perform better and more cheaply.

This shift of thought was antipathetic to the history artist. The idea of painting fleeting moments of colour and light was contrary to their aim of painting character and place. Britain was slow to adopt these ideas at first, but gradually history painting moved from being a fine art and part of the mainstream to a graphic art – a branch of artistic development.

As history art declined, graphic art became influential. In the 19th and 20th centuries there was an explosion in the variety of illustrated papers and magazines. The growth of illustrated papers in the first half of the 20th century was equal to that of television and radio in the second. One reason for this was that from the 1820s there were advances in print technology including in 1822 the introduction of steel engraving, which allowed tens of thousands of quality prints from a single plate. From 1827 it became possible to combine woodcuts with the text, unleashing a flood of popular illustrated books and magazines at a more general level. One example is *The Penny Magazine* which at its height sold 200,000 copies a week and may have been read by as many as a million people. The ruins of castles and abbeys and famous historical sites like the Tower of London were favourite subjects. Its chief rival *The Saturday Magazine* also featured historic sites and published plates from Joseph Nash's *Mansions of England in the Olden Time* (1839–49). The plates illustrated views of Tudor and early Stuart country houses with groups of authentically drawn characters (Fig 1.7).

Fig 1.7
The Hall in the
Little Castle, c 1620

Plate from Joseph Nash's book *The Mansions of England in the Olden Time* (1840) made when the Little Castle at Bolsover Castle in Derbyshire was unfurnished. Nash travelled England drawing houses for his book.

Two-tone lithograph, approx. 10.5 × 14.25in (267 × 362mm) The lithographs in the book were made by M and N Hanhart and Samuel Stanesby.

Similarly, there was a great increase in the publication of illustrated scientific texts aimed at a new popular audience. A different sort of scientific illustration developed to engage this audience, one that was dramatic and naturalistic, often based on fragmentary evidence. The science writer Louis Figuier published some of the first books on prehistory aimed at the general reader. *La Terre Avant le Deluge* appeared in 1863 with illustrations by Eduard Riou, a pupil of the French artist, printmaker and illustrator Gustave Doré (1832–91). This was followed in 1870 by *L'homme Primitif* which presented the facts and arguments concerning the antiquity of man. As well as many line drawings of artefacts and archaeological sections Figuier included a sequence of 30 engravings by Emile Bayard (1837–91); a French illustrator now best known for his illustrations of Cosette from Victor Hugo's *Les Misérables*. (His drawing of her gazes down from posters all over London advertising the musical). The engravings explained the development of humans from Stone Age to Iron Age (Fig 1.8). The book was very popular, an English translation followed in the same year and in the first three months of publication 5,000 copies were sold. The idea of a narrative of reconstructions was copied by many other science writers.

Two journals were influential in the illustration of archaeology, *The Illustrated London News* and the *National Geographic*. *The Illustrated London News* was the main vehicle for archaeological reconstructions. The Anglo-French artist Amédée Forestier (1854–1930) at first recorded ceremonial and state events for the paper but from 1900 to 1930 he worked entirely on the illustration of archaeology. So vivid and successful were his illustrations that over 100 years later, although ideas of the past are constantly revised, his illustrations of the Glastonbury lake villages (Fig 1.9) and his paintings of prehistoric London are still in print. He was followed at *The Illustrated London News* by the artist Alan Sorrell; his first pictures for the magazine, the excavation and reconstruction of the Roman forum at Leicester, were published in 1937 and he was still producing work for them in the 1970s (Fig 1.10).

Internationally the *National Geographic*, the official magazine of the National Geographic Society dating from 1888, produced some of the most innovative and attractive work in the 20th century using the best American illustrators. Its primary focus was on geography and ethnography but history and archaeology featured too.

To sum up, the long tradition of European art which had primarily been concerned with reconstructing past events and which lasted until the end of the 19th century shifted, influenced by the new art of photography and the French Impressionist movement of art which, instead of painting character and place, aimed to capture the moment, the fleeting impressions of light and colour.

This change coincided with advances in printing techniques enabling images to be printed with text and the introduction of steel engraving allowing tens of thousands of impressions to be printed from a single plate. Allied to an enthusiasm in the public for history and archaeology, the genre of narrative art moved from fine art to a graphic art and out of the main line of art to a niche position in archaeology.

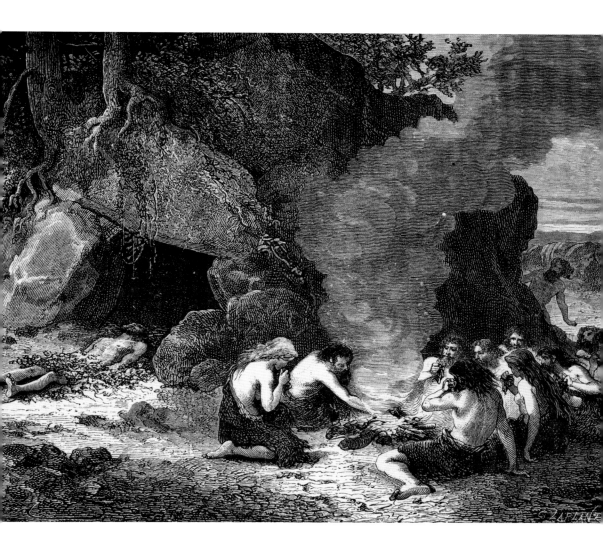

Fig 1.8 *Funeral Feast During the Great Bear and Mammoth Epoch*

Emile Bayard's picture for Louis Figuier's book *L'homme Primitif* (1870) is one of a series of 30 engravings depicting human life from the Stone Age to the Iron Age based on the excavation of French cave sites. It was inspired by the discovery of a hearth at the front of the cave at Aurignac. Figuier argues that the remains of burnt bones and shells from the hearth 'enable us to form some idea of the way in which funeral ceremonies took place among the men of the great bear epoch and that the parents and friends of the defunct accompanied him to his last resting place, after which they assembled together to partake of a feast in front of the tomb soon to be closed on his remains'. This was a different sort of picture in that it was inspired by archaeological evidence. It was this combination of current research findings and Bayard's dramatic, romantic drawing which made the engravings so influential.

Steel engraving, size unknown

[Linda Hall Library of Science, Engineering & Technology (GN738.F48 1870)]

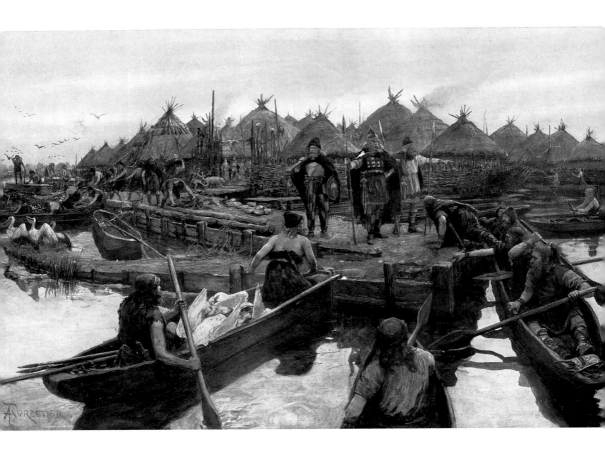

Fig 1.9 Lake village, Glastonbury, Somerset, 200–50 BC

Amédée Forestier based his illustration for *The Illustrated London News* (December 1911) on the evidence from Arthur Bulleid and Harold St George Gray's excavations at Glastonbury between 1892 and 1907. It illustrates Arthur Bulleid's article 'Not the Woad Daubed Savage of Old History Books: The Civilized Ancient Briton'. The figures are drawn from late 19th-century romantic representations of ancient Gaulish warriors and many elements in the pictures are now seen as wrong. For instance, the chieftain's helmet resembles a North Italian crested helmet and his sword Tarquinian swords of the late Bronze Age. But in spite of this the illustration is still used over 100 years after it was painted. It is artistically so attractive – the strong shapes of the dark shadows and the direction of the canoes pulling the viewer into the picture – this is probably the reason for its longevity.

Watercolour, 26.3 × 19.1in (720 × 485mm)

[© Illustrated London News Ltd/Mary Evans]

Fig 1.10 Leicester excavations, 1936

It was by chance that Alan Sorrell was in Leicester in 1936, sketched Kathleen Kenyon's excavations of the forum and was commissioned by *The Illustrated London News* to draw a reconstruction of the site as the archaeologist imagined it. The two illustrations printed together made an impression on the archaeological world and commissions from Mortimer Wheeler and the National Museum of Wales followed.

Pencil, size unknown, 1936–7

The Technicians

A government bill of 1882 created a post of Inspector of Ancient Monuments that General Pitt-Rivers (1827–1900) was invited to fill. The first Inspector of Ancient Monuments, he is regarded as the father of modern British archaeology. He had models made of the findings from the sites he excavated in the late 19th century, and museums built to display the finds, so it might have been expected that he would have used reconstruction paintings to explain his excavations since he is well known for the dictum 'Describe your illustrations don't illustrate your descriptions' – the picture for him came first (Piggott 1965, 174). However, he probably chose not to use reconstructions because, despite the rich tradition of history/narrative painting (or maybe because there was this tradition), as archaeology in the 19th century began to become more scientific, archaeologists turned away from such vivid imagery that could be construed as unscholarly and emotional. They used measured, schematic drawings (with a hard, sure line and no shadow or sensorial information) defining their archaeological reports as academic, rational and objective. Difficult to read, these drawings highlighted the need for experts.

The work of the artist turned archaeologist Heywood Sumner (1853–1940) stands out in contrast to these spare, minimalist drawings. Heywood Sumner could be classified as a scholar or technician in that he rarely allowed himself to be drawn into speculation about the sites he drew. Yet the style of his drawing – he was an artist of the Arts and Crafts Movement – is decorative and attractive. A self-taught archaeologist, his earliest archaeological work involved surveying the earthworks of Cranbourne Chase and he went on to publish three studies of ancient earthworks in Wessex. His perspective evocations of archaeological landscapes are a model of clarity and a visual delight. His style of drawing was so influential that you can see echoes of it in the archaeological excavation reports of the 1950s and 1960s produced by archaeologists such as Stuart Piggott, Paul Ashbee and Brian Hope-Taylor (Fig 1.12).

Although there was a division between scientific technical illustration used in excavation reports and a more emotive picture making seen as appropriate for a wider public, there were exceptions to this – archaeologists who with artists aimed to combine truth with imagination. As early as 1866 Dr Ferdinand Keller (1800–81) used an 'Ideal sketch of a Swiss lake dwelling' for the frontispiece of his archaeological report on *The Lake Dwellings of Switzerland and Other Parts of Europe* (Fig 1.13). The image is described as being 'restored' from the latest discoveries. This intriguing and appealing picture was influential and it formed the basis for one of Emile Bayard's sequence of illustrations in *L'homme Primitif*. John Lubbock, 1st Baron Avebury (1834–1913), who introduced the first law on the protection of the UK's archaeological and architectural heritage and helped establish archaeology as a scientific discipline, and was therefore not thought of as an enthusiast for pictorial reconstructions, commissioned two similar pictures from the illustrator Ernest Griset to hang on his walls. Much later, Alan Sorrell's work illustrates archaeologist and Inspector of Ancient Monuments John Hamilton's report, published in the 1950s, of the Bronze Age site and brooch at Clickimin in Shetland (*see* Fig 2.14). Likewise, Sorrell painted reconstructions of the Late Saxon farmstead of Mawgan Porth in Cornwall for the archaeologist Rupert Bruce-Mitford's excavation report (*see* Fig 2.1). Images such as these are a link between imagination and science giving the archaeologist a different way

Fig 1.11
Two British nobles, 200 BC

Peter Connolly has based his picture on descriptions of the appearance of the Iron Age peoples of Britain by Roman writers such as Strabo and Diodorus, as well as using archaeological data and models to pose for his image. In the background he shows a roundhouse, the form of which is based on an actual reconstruction at Butser Farm in Hampshire by the archaeologist Peter Reynolds. His construction of the Pimperne Iron Age house from a site in Dorset had an impact on the way such buildings were regarded. In its reconstructed size and form it impressed with the organisation, labour and forethought that must have gone into such architecture and changed the terminology of Iron Age buildings from hut to house. Peter Connolly was an academic, an expert in Roman armour, as well as an illustrator and this picture is the work of a technician in that it is based on hard fact. However, it is difficult to categorise artists or pictures completely and the glance between the couple gives us more of a story than just a description of their appearance.

Gouache, size unknown, *c* 1985

[© akg-images/Peter Connolly (AKG321267)]

Fig 1.12 Bird's-eye view, Hod Hill and of Hambledon Hill, Dorset

In the forefront of this picture by Heywood Sumner is Hod Hill with Hambledon Hill behind. The hills are an outcrop of chalk on the south-west corner of Cranbourne Chase separated from the Dorset Downs by the River Stour. Hambledon Hill was first occupied in the Neolithic period but little remains of Neolithic activity and it is primarily seen as an Iron Age hill fort abandoned about 300 BC perhaps in favour of Hod Hill. Hod Hill was inhabited by the Durotriges tribe in the late Iron Age. Heywood Sumner was an artist of the Arts and Crafts movement, a painter, illustrator and craftsman. His drawing style, used so successfully and attractively in his illustrations of the archaeology of the New Forest and its surroundings, was startlingly different to other archaeological drawings of the time and very influential.

Pencil and watercolour on board, size unknown, c 1910

[Private collection]

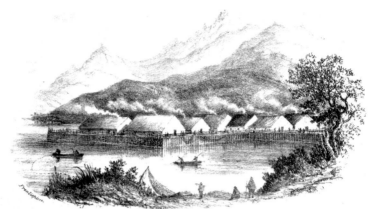

IDEAL SKETCH of a SWISS LAKE-DWELLING.
"Restored" from the latest discoveries.

to express their arguments in the excavation report. A good reconstruction will be accurate and true to the scientific data but it can bring more than that, it can hint and suggest, create a mood or atmosphere. In this way pictures can take on a life of their own and be much more powerful than the written or spoken word and more memorable. You could understand therefore that some archaeologists might see a danger in this, might have misgivings about archaeological reconstructions that expressed more than the minimum, and might feel, by such vivid depiction, that they would lose control of their archaeological information. An example of this happening was the illustration of the Saxon Royal Palace of Cheddar, commissioned from Alan Sorrell by *The Illustrated London News*. The site was excavated by the archaeologist Philip Rahtz. Rahtz liked the sketch very much but was troubled when it was used again and again in different publications until it assumed an authority he felt he could not justify based on the excavation evidence alone. The drawing represented just one possible version of a reconstruction of the palace, maybe Rahtz's best idea, but it could not be regarded as definitive. In this way the power of an illustration can remain long after the ideas that it first represented have been superseded and their lifespan ended.

As the science of archaeology developed, reconstruction art became unfashionable and few paintings were made. In the 1960s and 1970s a few archaeologists drew pen-and-ink line drawings to illustrate their sites. In the newly formed archaeological drawing office of the Ancient Monuments Department of the Ministry of Works Elizabeth Fry-Stone drew what must have been the office's first reconstruction – a pen-and-ink drawing of Fussell's Lodge, a prehistoric burial mound in Wiltshire. David Neal, who later became head of the office, drew isometric and axonometric reconstructions of Roman buildings based on evidence from his own archaeological excavations. David's understanding of building techniques and his draughtsmanship enabled him, for example, to reconstruct the evidence for two-storeyed villas (which was then controversial), based on the width or strength of the exterior walls and the presence of small rooms suitable for staircases (Fig 1.14). He used the drawings to present the possibilities of the archaeological evidence to his fellow professionals. In this way the expert argues his case to another expert using a language they both understand.

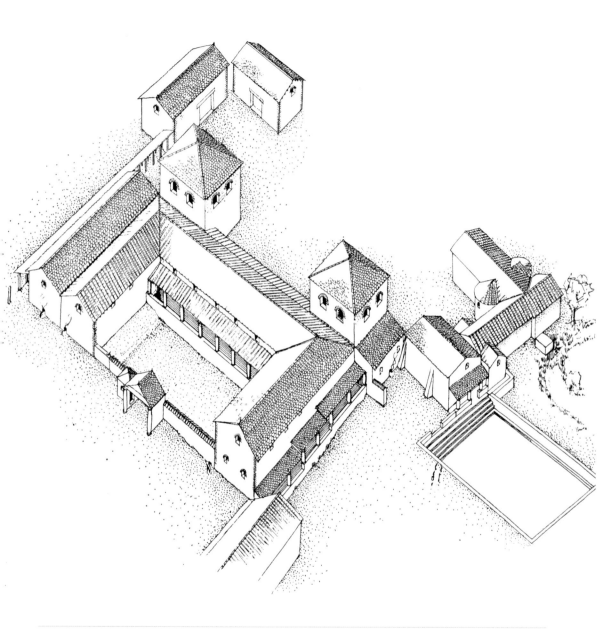

Fig 1.14 Gadebridge Park Roman Villa, Hemel Hempstead, Hertfordshire, c AD 325

David Neal's drawing shows the villa at its most spacious and comfortable with large heated rooms and mosaic floors. His reconstruction braves a two-storeyed villa with towers and in the archaeological report he argues the case for second floors in villas, which was then very controversial and is still not accepted by everyone today.

Pen and ink, size unknown, 1973

[© David Neal]

The Educators

At the beginning of the 20th century there was a growing trend for the use of reconstructions in museums. Influential in this was Henry Fairfield Osborn, Curator of Vertebrate Paleontology at the American Museum of Natural History. Public education was a priority for Osborn and he saw reconstructions as an important way of explaining and presenting archaeological theories. From the 1880s he was using paintings to portray prehistoric animal life and, after visiting the cave sites of France and Spain and becoming interested in palaeoanthropology, in 1915 he published *Men of the Old Stone Age* illustrated by Charles Knight. The book was very influential and popular and this led to Knight's commission for three murals to be the central feature of the first exhibition on human evolution at the museum. The exhibition opened in 1924 and the murals were so attractive and successful that the museum was swamped with requests to reproduce them. The impact this made, the realisation of how effective reconstruction could be in transmitting ideas, led to a whole new generation of reconstruction artists (Fig 1.15).

School textbooks and children's books with a historical storyline influenced changing ideas and styles of reconstruction illustration. If you compare history textbooks of the 1930s with books 20 years later, what would strike you would be the increase in pages devoted to illustration as opposed to text – but it was not just the number of illustrations but the type of illustrations that changed. Pre-war books used mostly maps and plans to illustrate but post-war books employed a greater variety of pictures. Influential in this change was the work of C H B and M Quennell, a husband-and-wife team whose first history textbook was published in 1918. Charles Quennell was an architect and Marjorie Quennell an artist so their talents complemented each other. Their approach did

Fig 1.15
Cro-Magnon artists painting in Font-de-Gaume at Les Eyzies-de-Tayac, France

Charles Knight was a specialist reconstruction artist working at the American Museum of Natural History. His picture reflects the curator Henry Fairfield Osborn's view that the cave art paintings of Southern France were the birth of art. The omission of women in the mural is significant, an explicit instruction from Osborn to Knight introducing the idea that women were not involved in cultural achievements such as the production of art.

Materials unknown, size unknown, 1920

[Image #608, American Museum of Natural History Library]

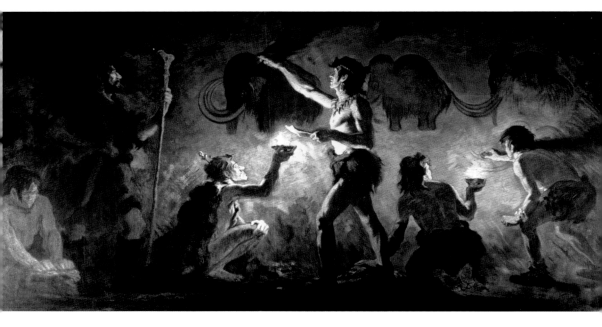

Fig 1.16
Illustration from
Everyday Life in Prehistoric Times, Vol 2, The New Stone, Bronze and Early Iron Ages, (1926)

Many of the illustrations in the books by Marjorie and Charles Quennell were like this one showing the use of a Neolithic saddle quern. Their books showed how objects discovered on excavation were used.

Pen and ink, size unknown

not just influence the style of history books but history teaching itself. *A History of Everyday Things in England* and the 'Everyday Life' series were accounts of how ordinary people had lived explained by exploring Britain's social, artistic and technological history through objects. The first two volumes of a *A History of Everyday Things* were produced in 1918 and 1919, the second two in 1933 and 1934. In between the Quennells worked on their 'Everyday Life' series exploring Britain from the Stone Age to Norman times. They engaged with contemporary research in their writings, drawing on published scholarly works and periodicals. Reginald Smith, Keeper of the Department of British and Medieval Antiquities at the British Museum was the proofreader of their manuscripts. The type of illustrations they used was also new; the books were full of reconstructions (Fig 1.16).

Following on from the Quennells' books was R J Unstead's 'Looking at History' series first published in 1955. R J Unstead wrote hundreds of school textbooks mainly for primary schools, ranging in subject matter from prehistoric to modern times. The Quennells' books were essentially sized for text but 'Looking at History' had a larger page format giving more scope for illustrations. They were extensively illustrated with drawings, colour plates and photographs and light on text. 'Looking at History' sold 8 million copies and had 50 sequels. Textbooks tend to have a long shelf-life and a post-war generation of schoolchildren's ideas of the past were created by these books.

Fig 1.17
Illustration from
The Tower of London: A
Historical Romance (1840)

Lady Jane Grey stumbles
across a carelessly abandoned
executioner's axe in St John's
Chapel on her first night in the
White Tower in this illustration
by George Cruikshank for
Harrison Ainsworth's book that
was serially published from
1840. Books such as this were
hugely popular in the 19th
century but by the 20th century
the idea of illustrating novels for
adults had died out.

Steel engraving, printed 4.5 ×
3.75in (118 × 98mm)

[Hulton Archive/Getty Images
(463988361)]

In the 19th century, books by Mallory, Tennyson, Stevenson, Scott and other
historical novelists were richly illustrated. George Cruikshank (1792–1879)
illustrated Harrison Ainsworth's novels *The Tower of London* (1840) and
Windsor Castle (1842) with drawings which are a mixture of ghostly figures and
accurately observed architectural features (Fig 1.17). They were hugely popular
(so much so that visitors to the Tower enticed there by the alluring pictures were
disappointed by the dilapidated fortress that they found) but during the 20th
century the idea of illustrating fiction for adults died out. However, this did not
apply to children's books and the period from 1960 onwards is particularly rich.
In this, Oxford University Press and their children's book editor Mabel George
were influential. Two artists who illustrated historical fiction stand out from the
group Mabel George gathered – Charles Keeping and Victor Ambrus.

Charles Keeping's first commission by Oxford University Press was to illustrate Rosemary Sutcliff's book *The Silver Branch,* a story of Roman Britain published in 1957. Mabel George's commissions gave her artists responsibility for the design of the storybooks as well as the illustrations so size, position, shape of the pictures and text as well as such details as endpapers was their choice. This is an accepted procedure now but at the time it was common for the text to come first and a complaisant illustrator to be found to add to it. Charles Keeping writes that he tried to treat the book differently, to do margin drawings and double-page spreads, 'fighting across pages and God knows what else' (Martin 1989, 40) (Fig 1.18). A new idiom was emerging for the illustration of historical fiction. Keeping's ideas about accuracy in detail were forthright: 'I tried to look up what Romans wore and promptly forgot it ... Nobody knows what Vikings dressed like – it's absolute nonsense. You can make up anything' (Martin 1989, 40). This sounds cavalier but actually the dress in his pictures is perfectly plausible. The purpose of these illustrations is not to prove anything correct, their purpose is to illuminate and combine with the fictional text. Charles Keeping thought of illustration as a jazz duet, the picture and text each with their own solos and then coming together – a combination to create a mood or atmosphere.

Fig 1.18
Illustration from
***The Silver Branch* (1957)**

Charles Keeping's illustration of the battle at Calleva [Silchester] shows fighting across pages.

Pen and ink, double-page spread, 275 × 215mm

[By permission of Oxford University Press, UK]

came straggling up a long wooded ridge; and from the crest of it found themselves looking down on the Londinium road.

And along the Londinium road and all across the country below them, like a river in storm spate, was pouring a wild flood of fugitives, reserves and horse-holders probably, for the most part; mercenaries breaking back and streaming away from the battle; a broken rabble of barbarians on foot and on horse-back, flying for their lives.

Justin felt suddenly sick. Few things in the world could be more pitiless than a beaten and demoralized army; and only a few miles away the Londinium road ran through Calleva!

Flavius broke the silence that had gripped them all with something like a groan. 'Calleva! It will be fire and sword for the whole city

if that rabble get in!' He wheeled about on the men with him. 'We must save Calleva! We must ride with them and hope for our chance at the gates. There's no time to wait for orders. Anthonius, get back to Asklepiodotus and tell him what goes forward, and bid him, in the names of all the gods there be, to send up a few squadrons of Cavalry!'

Anthonius flung up his hand, and wheeling his horse was away almost before the words were spoken.

'Cullen, cover up the Eagle. Now, come on, and remember we are fugitives like the rest until we are within the gates,' Flavius cried. 'Follow me—and *keep together!*'

Justin was at his side as usual; Cullen with the Eagle under his ragged cloak and the spear-shaft sticking out behind him, Evicatos

Victor Ambrus was different. His approach to research is exemplified by his book *Horses in Battle* published in 1975. In it he displays a basic insistence that historical fact should be presented in a way that is physically and functionally plausible, not merely accurate in matters of decorative detail. He writes:

'The first few drawings [I made] were seriously wrong, in that the figures were not sitting on their horses properly. So we took it into our heads that we'd go riding and it made all the difference being on horseback, riding in a group and observing the horse in front' (Martin 1989, 92).

He brandished a sword on this ride, swishing it from side to side to experience how the cavalry fought and to work out how he could convey this (Fig 1.19). A highly successful book illustrator, latterly Victor Ambrus became well known for his work on the television programme *Time Team* where he drew reconstructions while the archaeologists excavated.

Fig 1.19 Illustration from *Horses in Battle* (1975)

Victor Ambrus using his experience of horse riding illustrates a scene from the American Civil War – a Federal corporal and Confederate Cavalryman in a sabre duel.

Pen and ink, printed size 180 × 130mm

[© Victor Ambrus]

And then there are the non-fiction illustrators. Two of the best would be Stephen Biesty and David Macaulay. Biesty specialises in cross sections and cutaways, accurate but full of detail and life. He explains how by drawing you can better understand how things are constructed, and you can uncover layers of accumulated history. Then with cutaways you can explore even further. 'When you start including figures you can show how people relate to the space and you can explore the realities and practicalities of the place, how people lived, how they adapted to their surroundings, how they slept, how they ate' (Blake 2003, 44). David Macaulay marries architecture to storytelling. He trained as an

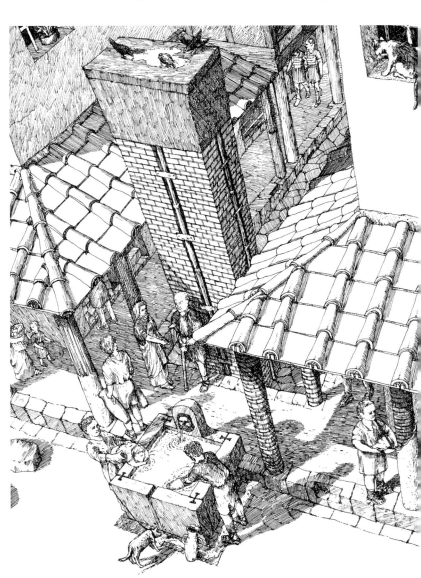

Fig 1.20
CITY: A Story of Roman Planning and Construction (1974)

David Macaulay's book explains in pen-and-ink drawings the planning and construction of an imaginary Roman city founded between 300 BC and AD 150. Trained as an architect, he combines architecture, history and archaeology in his illustrations.

Pen and ink, full-page printed 220 × 300mm

architect and studied in Rome, Herculaneum and Pompeii. His black-and-white pen drawings represent an intersection between illustration, architecture, history and archaeology (Fig 1.20). Originally aimed at children, his books are popular with adults too. They explain the architectural and engineering processes behind buildings. Accurate information, detailed research, careful observation – these are the attributes of the technical archaeological illustrators of the 1960s and 1970s. The difference between them and Biesty and Macaulay is in the freedom of expression, which is reflected in the style of the illustrations and is revealing of the artist's personality (Fig 1.21).

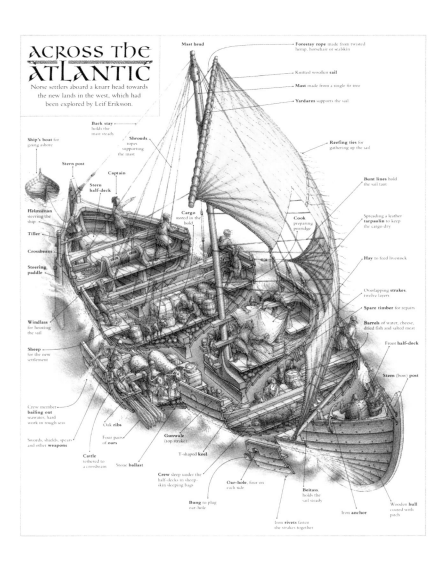

Fig 1.21
Norse settlers aboard a knarr, c AD 982

Stephen Biesty's illustration explains the construction of a Norse trading vessel called a knarr, the sort of ship that the Icelandic explorer Leif Erikson would have sailed in AD 1003 from Greenland across the North Atlantic to the land he called Vinland on the coast of America.

Pencil, Rotring pen and ink, watercolour, print size 290 × 370mm, 2011

© 2011 Stephen Biesty. From *Into the Unknown* by Stewart Ross & illustrated by Stephen Biesty. Reproduced by permission of Walker Books Ltd, London SE11 5HJ www.walker.co.uk]

Reconstruction art and the National Collection

The seven artists selected for this book, Alan Sorrell, Terry Ball, Ivan Lapper, Frank Gardiner, Peter Dunn, Allan Adams and Judith Dobie, all worked for the Ancient Monuments Department of the Ministry of Works – later English Heritage. Sorrell and Lapper were freelance artists, the others members of staff. Terry Ball worked in the architects' drawing office of the Department of Ancient Monuments. Allan Adams originally was employed by the Royal Commission on the Historical Monuments of England (RCHME) which in 2000 became part of English Heritage. Frank Gardiner, Peter Dunn and Judith Dobie all worked in the archaeological drawing office of the Department of Ancient Monuments. Many other artists have painted and drawn reconstructions for guidebooks, site graphics and archaeological reports but these seven were selected for the quality and quantity of their work, and for the influence it has had on ideas of the past – and to demonstrate how different artists tell a story of changing ideas in archaeology and the way that sites and monuments are presented.

It is possible to trace the beginnings of the organisation they all worked for to as far back as 1378 when the medieval Office of Works was established to build and maintain Crown properties. Its activities gradually expanded and by the 19th century they were wide and various. But in a more modern form the organisation dates from the parliamentary bill of 1882 which listed 68 monuments, a wish list, that the Office of Works would accept as a gift or purchase. Antiquaries had long been outraged by the acts of landowners who defaced such monuments as Avebury and Stonehenge (although it is true that some antiquaries could be seen as glorified treasure seekers who did more damage to ancient monuments than their owners). By the late 18th century the destruction had increased with the absorption of new land for agriculture, the breaking up of megaliths for road stone and the ploughing out of long barrows. The complaints of antiquaries were faint voices from a few people and easily ignored. It was the more scientific approach of the 1850s and 1860s led by General Pitt-Rivers which raised the status of archaeology as a discipline and increased general interest and caused notice to be taken. The act of 1882 allowed an owner of a monument to place it under the protection of the state, which would then take care of it on their behalf. Initially, after the passing of the bill, not one single landowner offered up a monument but then in April 1883 Little Kit's Coty House in Kent (the jumbled remains of a Neolithic chambered long barrow) was offered and although not on the schedule of 68 was accepted and so became the first acquisition. In May 1883 West Kennet Long Barrow in Wiltshire was secured and then Sir John Lubbock signed over Silbury Hill – a spectacular acquisition. By the end of 1884 14 monuments from the schedule for England and Wales had been brought into guardianship of the state and by 1910 things had so advanced that the Office of Works was established as the central government authority on ancient monuments and historic buildings with a growing portfolio of historic sites. The Ancient Monuments Consolidation and Amendment Act of 1913 strengthened their position. It introduced scheduling, another form of safeguard, which widened protection to thousands of monuments on private land. This first list of monuments and the increasing portfolio of sites in guardianship open to the public represented an established view of the nation's history and the government's acknowledgment of the state's cultural responsibility for the physical remains of its own history.

In 1913 44 British monuments were in the state's care, by 1933 273 and by the outbreak of the Second World War many more. The Office of Works was then running the largest visitor attraction in the country and had invented the entire apparatus of the heritage world we know today. A large portfolio of centrally managed historic sites, carefully presented and interpreted to the public who arrived by car, paid to get in and bought guidebooks and postcards. There were site museums, interpretation panels, custodians, illustrated handbooks and location maps. Today over 20,000 monuments in England are protected by scheduling; 400 of these sites are in guardianship of the state and comprise the National Heritage Collection. They were acquired to protect them but also to inform and educate the public about them, and this is where the work of the reconstruction artist comes in.

Initially there was hostility to pictorial reconstruction of the sites. No speculation was allowed in the form of drawings or paintings at the monuments. The reason for this policy was that it was felt that any attempt at reconstruction was bound to be guesswork and that even well-informed guesswork could never be certainty, thus to sanction any attempt at historical recreation would be to do no more than to give official backing to the ideas of one particular artist. It was only after the Second World War that a tide of public interest in archaeology and an enthusiasm for monument visiting persuaded the Inspectorate of Ancient Monuments to have three small travelling exhibitions to explain the development of the abbey, the castle and the Roman buildings on Hadrian's Wall. Alan Sorrell, well known for his reconstructions for *The Illustrated London News* and his work for the National Museum of Wales, was employed to paint reconstructions of forts and settlements on the Wall. Although the pictures were well received, they were only used in the exhibition and not at first on the sites or in the guidebooks. They were seen as something different and temporary. The site guidebooks (the blue books) were guidebooks to the monuments but in the Department of Ancient Monuments they were also seen as important primary documents. The measured survey of the sites made when they were taken into guardianship was usually the first accurate record and as such was seen as an essential part of the understanding of British history and archaeology. As the Office of Work's collection of monuments was nationally the only one properly recorded, it became the foundation on which scholars based chronology and development. The surveys revolutionised the study of Britain's past and had a profound long-term effect on the direction of scholarship. Highly technical and with a complete lack of social context you can see how the attitude they reflected clashed with the vision of the past that Sorrell's dramatic paintings presented. He painted his four pictures of the Hadrian's Wall sites in 1956 (*see* Fig 2.8). They were seen by an enthusiastic Minister of Works, Lord Molson, who urged that more reconstructions of the guardianship sites should be painted. This was awkward for the Department of Ancient Monuments who did not permit artists' reconstructions of the monuments to be displayed at the monuments, and to signal a change of direction a question was asked in the House of Commons: 'Whether he [the Minister] will arrange for drawings of ancient monuments as they might have appeared in use to be displayed at the monuments in his care' (Dykes 1981,19). The ministerial reply gave the seal of approval and over the next four to five years Sorrell painted over 50 pictures of the Ministry of Works' most popular sites.

In 1970 there were changes when the Ministry of Works was combined with others in a new super ministry called the Department of the Environment. There were more changes in 1972 when the Ancient Monuments Department was transformed into a largely self-contained section – the Directorate of Ancient Monuments and Historic Buildings.

After the establishment of the DAMHB the publicity officer asked Arnold Taylor, the Chief Inspector of Ancient Monuments, to produce a range of souvenir guides of a much more popular nature. Though Taylor, when Assistant Chief Inspector, had collaborated with Alan Sorrell on his very successful reconstructions of Welsh castles, he refused on the grounds that this would dilute the scholarly context of the blue guides. The Publicity Office went ahead independent of the inspectors, producing its own parallel series of guides and, at the same time as a gesture, many of the official guides were given covers with coloured photographs. Terry Ball and Frank Gardiner worked in this climate. Their reconstructions, close collaborations with the Inspectors of Ancient Monuments, were technical and scholarly.

In 1983 the functions of the DAMHB were transferred to a new independent agency – English Heritage. The emphasis was for 'a more engaging and imaginative presentation of the monuments to maximise their educational and commercial potential. This would require a commercial and entrepreneurial flair best located outside government' (Thurley 2013, 3). The freelance illustrator Ivan Lapper was in the forefront of the new presentation regime. His imaginative atmospheric pictures differ mostly from those that went before him in the predominance of human figures. Figures in pictures raise all sorts of questions that might otherwise go unasked. How did people interact with each other? Interactions convey messages about aspects of social organisation, gender, age, class and then depictions of humans speak powerfully to the emotions of the viewer. Glyn Coppack, who was an Inspector of Ancient Monuments during this period and schooled in a different regime, tells of his unease collaborating with Lapper on such sites as the Carthusian monastery of Mount Grace. In contrast the English Heritage Interpretation Manager, John Clarke, one of those in charge of the new presentations, tells of his pleasure in working with Ivan, of his speed and flexibility. He admits too how much he liked the control he had over a freelancer. In-house illustrators such as Terry Ball and Frank Gardiner, heads of their sections, were influential and difficult to overrule. Looking back on this time Glyn Coppack thinks perhaps that he was overcautious, too worried over detail, and that the changes made in site presentation and interpretation were appropriate and timely (Coppack, pers comm).

Peter Dunn and Judith Dobie, both working in the archaeological drawing office of English Heritage, were involved in the new direction. Peter went on to be the main reconstruction artist in the site interpretation department and his illustrations were also predominant in guidebooks. He aimed to bridge the scholarly work of Terry Ball with the liveliness of Ivan Lapper.

In 2000 another change came about when the Royal Commission on the Historical Monuments of England (RCHME) combined with English Heritage. The Royal Commission had been founded in 1908 to prepare a county by county inventory of monuments thought worthy of preservation. The way they worked was to consult with national and local expert bodies to make a list of sites. These would then be investigated by fieldwork and approved monuments would be added to the inventory. The first inventory, Hertfordshire, was published in

1910. Drawings in the form of plans and sections and landscape described by hachures, the tapered lines that are used in arrays to explain the topography of the land, were a record of what was seen. By the 1970s isometric cutaway drawings were usually used in the Royal Commission publications to explain the construction of buildings, the policy being to show nothing in the drawings that was speculation (Fig 1.22). A change came about with a book published in 1975 by Peter Smith of the Royal Commission on the Ancient and Historical Monuments of Wales (RCAHMW) called *Houses of the Welsh Countryside: A Study in Historical Geography*. This book broke new ground in the way it presented a wide-ranging study of Welsh historic domestic architecture. It is richly illustrated with numerous line drawings, many featuring reconstruction work. Later, in 1986, came *Monuments of Industry*, an illustrated historical record by Geoffrey Hay and Geoffrey Stell published by the Royal Commission on the Ancient and Historical Monuments of Scotland (RCAHMS). This had a big impact on how the RCHME illustrated industrial buildings. Drawings were more informative and interpretive with more reconstructed elements and more use of perspective as opposed to isometric drawings. The increasing use of the more natural-looking perspective view seems to coincide with a change of direction; the RCHME was moving from the publication of county inventories of buildings to thematic studies of architecture. These books were aimed at a less specialised audience. You can measure from isometric drawings, which is valuable to the professional, but perspectives are easier on the eye.

Fig 1.22
A classic longhouse

English Vernacular Houses (1975) by Eric Mercer is one of the Royal Commission on Historical Monuments of England's first thematic volumes. While innovative as a volume, it was conservative in its use of reconstruction drawings which were used to illustrate house types, not individual buildings. The longhouse drawing shows the RCHME's approach at the time. Isometric projection rather than perspective is used and elements which could not be measured on site are omitted. It also lacks details of internal fittings, for example in the cow house, which would probably have originally had some form of cattle stalls but, as these are rarely found to survive in situ today, they are not included in the drawing.

Pen and ink, printed
155 × 120mm

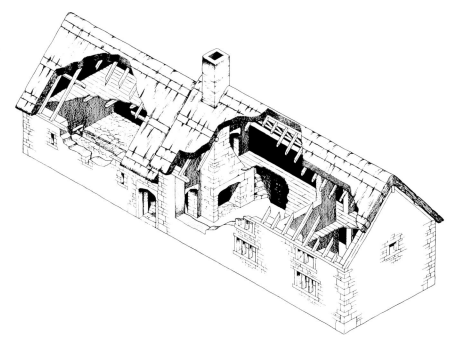

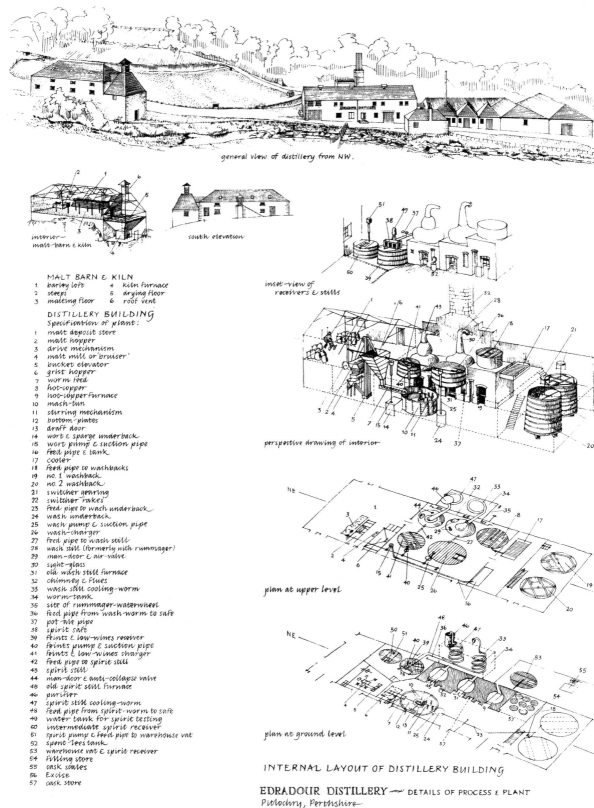

general view of distillery from NW.

interior—
malt-barn & kiln

south elevation

inset-view of
receivers & stills

perspective drawing of interior

MALT BARN & KILN
1. barley loft 4. kiln furnace
2. steeps 5. drying floor
3. malting floor 6. roof vent

DISTILLERY BUILDING
Specification of plant:
1. malt deposit store
2. malt hopper
3. drive mechanism
4. malt mill or 'bruiser'
5. bucket elevator
6. grist hopper
7. worm feed
8. hot-copper
9. hot-copper furnace
10. mash-tun
11. stirring mechanism
12. bottom-plates
13. draft door
14. wort & sparge underback
15. wort pump & suction pipe
16. feed pipe & tank
17. cooler
18. feed pipe to washbacks
19. no. 1 washback
20. no. 2 washback
21. switcher gearing
22. switcher rakes
23. feed pipe to wash underback
24. wash underback
25. wash pump & suction pipe
26. wash-charger
27. feed pipe to wash still
28. wash still (formerly with rummager)
29. man-door & air-valve
30. sight-glass
31. old wash still furnace
32. chimney & flues
33. wash still cooling-worm
34. worm-tank
35. site of rummager-waterwheel
36. feed pipe from wash-worm to safe
37. pot-ale pipe
38. spirit safe
39. feints & low-wines receiver
40. feints pump & suction pipe
41. feints & low-wines charger
42. feed pipe to spirit still
43. spirit still
44. man-door & anti-collapse valve
45. old spirit still furnace
46. purifier
47. spirit still cooling-worm
48. feed pipe from spirit-worm to safe
49. water tank for spirit testing
50. intermediate spirit receiver
51. spirit pump & feed pipe to warehouse vat
52. spent lees tank
53. warehouse vat & spirit receiver
54. filling store
55. cask scales
56. Excise
57. cask store

plan at upper level

plan at ground level

INTERNAL LAYOUT OF DISTILLERY BUILDING

EDRADOUR DISTILLERY — DETAILS OF PROCESS & PLANT
Pitlochry, Perthshire

Fig 1.23 (opposite)
Edradour Distillery,
Pitlochry, Perthshire,
Scotland

In the Scottish Royal
Commission this illustration
from *Monuments of Industry*
(1986) was seen as a key in
the development of a new style
to illustrate their publications.
In one page they have used
bird's-eye views, cutaways and
what they called 'developed'
elevations. In this way they
explained the flow of processes,
the buildings' layouts, the
relationships of buildings to
each other and the situation of
the buildings in the landscape.

Pen and ink, full-page
illustration 275 × 215mm

[SC 346804 © Crown
copyright: HES]

Architectural illustrator Allan Adams joined the RCHME in 1981 at a point in time when the Commission was shifting direction in publication. To start with, Allan's work was technical and reconstruction was taken only as far as the evidence proved. However, with increasing public interest, illustrations were gradually made more appealing by including people and machinery in industrial buildings, interiors in domestic buildings and by using colour, which had previously been too expensive. As with the Directorate of Ancient Monuments inspectors, there was at first reluctance by academics to accept what they saw as popularisation but gradually a more relaxed attitude was accepted and confidence gained by adherence to what could be supported by evidence.

Attitudes to the reconstruction painting in the old Inspectorate of Ancient Monuments and English Heritage have swung to and fro from hostility in the early days when images were banned from sites to enthusiasm today when visitors to the monuments are welcomed. What has driven the greater use of interpretation and reconstruction has been the curiosity and interest of the general public and this is how it should be.

Fig 1.24
Interior, Ynysymaengwyn,
Tywyn, Gwynedd, Wales

The central block of
Ynysymaengwyn was built
in 1758 but the interior was
probably remodelled in the Adam
style a generation later. This
illustration comes from *Houses
of the Welsh Countryside* (1975);
the use of perspective and the
reconstruction of interiors was
a breakthrough in illustration at
the Welsh Royal Commission.

Pen and ink, full-page
illustration, 245 × 185mm

[© Crown copyright: RCAHMW]

2 | Alan Sorrell

Born in 1904, Alan Sorrell was a painter of the neo-Romantic movement, a movement of art which looked back to the late 18th century, to the English artists of the Romantic Age such as Samuel Palmer, William Blake and John Constable. Neo-Romanticism was concerned with the indigenous, the antiquarian, the vernacular and with archaeology. There was a concept that the land was the primary determination of art, and landscape was viewed with nostalgia and romanticism. A graphic, bookish style, there was not the divergence between fine art and illustration in the 1930s that there is today and the Shell County guides of the time, edited and illustrated by a group of artists and writers such as Paul Nash and John Betjeman, changed the vision of British topography. The archaeological journal *Antiquity*, founded and edited by O G S Crawford, the pioneer of aerial photography, was influential to artists. The modernist flatness of aerial photographs which showed the land overlaid by the marks of occupation – like the lines and shapes in an abstract drawing, intrigued the artist John Piper (1903–92) a friend of Crawford. Piper demonstrates this with his juxtaposition of an aerial photograph of Silbury Hill, a drawing of 1723 of the Hill by the antiquarian William Stukeley and an abstract painting by the artist Miro to illustrate his essay 'Prehistory from the air' in the avant-garde journal *Axis* (No 8, 1937, 5–8). Piper had a long career, working in many different mediums and styles. As a young man he was an abstract artist, a modernist, influenced by Picasso, Braque and Mondrian and elements of abstraction remain in his pictures – even those painted during the war when artistically he was at his best and his paintings are naturalistic, influenced by the English artists of the Romantic Age.

The neo-Romantic movement with its emotional response to the British landscape and its history was precipitated by the Second World War. Looking back in his 1987 postscript to an essay first written in 1937 – 'Lost a valuable object' – John Piper writes how artists who had looked to the Continent for inspiration were now cut off. 'No more exhibitions of Picasso or Braque, Leger or Calder, Miro or Giacometti, no more arguments in French cafes or studios. We were on our own' (Mellor, D 1987, 110). Fear of losing the ancient buildings and precious sites of Britain inspired 'Recording Britain', a scheme initiated by the art historian Kenneth Clark in 1937. Established artists were commissioned to record buildings, landscapes and activities and in addition many younger artists were invited to submit pictures, always in watercolour, which was seen as an English medium, and paid for each accepted work. The scheme was financed from the Pilgrim Trust (a fund provided by the American millionaire Edward Harkness). The official government agency, the War Artists' Advisory Committee, was established in 1939 at the onset of war to commission drawings and paintings of churches, barns, castles, engines, aeroplanes, factories and bomb damage. Artists had to look and record.

Poetry, literature and the landscape were presented as the values and identity that Britain was fighting for. When the social research organisation Mass Observation, founded in 1937 by the anthropologist Tom Harrisson, poet

Charles Madge and film-maker Humphrey Jennings to record everyday life in Britain, carried out an early wartime opinion poll to ask people what they were fighting for, the response was a romantic picture of Britain, or more likely England of landscape, rural life, country churches and thatched cottages – rural roots seen as a motif of continuity.

Art styles in Britain therefore shifted from post-Impressionism to a Celtic, Gothic, romantic, linear style. The critic Geoffrey Grigson writes of the artist John Piper – an artist central to the neo-Romantic movement – as a 'producer of the theatrically of nature, the sonic light and darkness' (Grigson 1948, 205). The same atmosphere is created in Bill Brandt's photographs of the landscape and buildings of Britain and is evident in the films of Michael Powell and Emeric Pressburger. Powell and Pressburger's film *A Canterbury Tale* (1944) is a sort of pastoral poem to the Kent countryside dwelling on glorious moments in Britain's past, encompassing the idea of the heart of the nation.

These same elements are present in Alan Sorrell's paintings. He is part of the movement yet on the fringes and disappointed by his lack of recognition. By any reckoning he was a successful artist. A student at the Royal College of Art from 1924 to 1927, he won the Prix de Rome in 1928 and spent two years studying there, living at the British School. This was a formative time as he mixed with classical scholars, painters, architects, archaeologists and historians and the twin themes of his work, the depth of history and the fragility of the present, began to assert themselves. When he returned to England he taught life drawing at the Royal College; he would have known many of the artists of the neo-Romantic movement and indeed was friends with John and Paul Nash, Edward Bawden and Eric Ravilious, but he was an awkward, prickly man. He was a left-hander who was forced as a child to use his right hand, the left tied behind his back. He was uncoordinated and stuttered, not a clubbable person who would easily form cabals and alliances with other artists and different in that he was without the private education and means available to many of his contemporaries. So when Graham Sutherland, John Piper, John Minton, David Jones and others are talked of and written about, Alan Sorrell is marginalised as an illustrator in the niche area of archaeological illustration.

Returning from his studies in Rome in 1931, Alan Sorrell planned to make a living painting murals of historical scenes. William Rothenstein, the principal of the Royal College of Art and a supporter of Sorrell when he was a student there, offered him a post on the teaching staff. Most artists make part of their living by teaching and Sorrell had this security while seeking commissions for his mural painting. His first commission was to paint four panels for the municipal library of his hometown of Southend-on-Sea in Essex illustrating its history. The subject of one of the pictures was to be 'The refitting of Admiral Blake's fleet at Leigh' (a district of Southend), an event in the 17th-century Anglo-Dutch war. The way he set about this demonstrates the methods that he used later when he worked in archaeology. 'Learn about your subject before you can properly paint it' (Sorrell and Sorrell 1981, 10). He sent a questionnaire to a historian asking him about Leigh-on-Sea in 1652. He filled sketchbooks with drawings of ancient houses, trees and rippling hills, and he hired a fisherman to take him to sea to observe the tones of sea, shore and sky. He researched in the print room of the Victoria and Albert Museum, studying 17th-century Dutch engravings of dockyard scenes and ships and then undertook further study of ships at the Science Museum. *The Refitting of Admiral Blake's Fleet at Leigh During the First Dutch War* was exhibited at the Royal Academy Summer Exhibition of 1933 (Fig 2.2).

Fig 2.2
The Refitting of Admiral Blake's Fleet at Leigh During the First Dutch War, 1652

One of four panels illustrating the history of Sorrell's home town of Southend-on-Sea, Essex. This picture shows a 17th-century dockyard scene at Leigh-on-Sea, a district of Southend-on-Sea.

Oil on board, 108 × 48.25in (2.74 × 1.22m), 1933

[© Southend Museums]

It was by chance that he happened to be in Leicester in 1936 when Kathleen Kenyon was excavating the Roman forum. He drew the scene and the drawing was published in *The Illustrated London News* alongside his reconstruction of the forum from the same viewpoint (*see* Fig 1.10). The idea was to aim for a picture of probability, to convey to the reader what the archaeologist could see in his mind's eye. The pictures made an impact on the archaeological world and a commission from Mortimer Wheeler (1890–1976), one of the most charismatic and important British archaeologists, followed. This was for a reconstruction showing the Roman assault on the eastern entrance of Maiden Castle, incorporating evidence from Wheeler's recent excavations. After that Sorrell worked for the National Museum of Wales producing a reconstruction of the Roman town at Caerwent and legionary fortress at Caerleon. For the first time archaeology dominated his work.

When the war intervened, he enlisted in the RAF, first as a model maker then as a camouflage officer. The latter entailed spray painting acres of runways with patterns of hedges, fields and woods to deceive enemy bombers and then the survey of the works from the air. He believed that these survey flights influenced the control of aerial perspective in his archaeological reconstructions and if you compare pictures made before and after the war, such as the pre-war Venta Silurum, Caerwent, with views of Verulamium and Roman London which he painted after the war, you can see his increased control of the composition (Figs 2.3 and 2.4). He continued painting while he was in the RAF and pictures of life in the forces and of the scenes he saw around him were bought by the War Artists' Commission and are part of the Imperial War Museum and Tate Britain collections (*see* Fig 2.6).

When the war ended, he returned to Essex to live and when in 1948, along with almost the whole teaching staff at the Royal College, he lost his job following the appointment of a new head, he made his living from his archaeological paintings from then onwards. There were more reconstructions in collaboration with Cyril Fox, the Director, and V E Nash-Williams, the Keeper of Archaeology for the National Museum of Wales, and illustrations of Jarlshof and Clickimin, Viking and prehistoric settlements in Shetland, working with the archaeologist John Hamilton, then an Assistant Inspector of Ancient Monuments in Scotland. In 1951 he painted a series of pictures of Knossos, Jericho and Mohenjo-daro for the Festival of Britain exhibition. There were commissions from Professor W F Grimes for reconstructions of the Walbrook Mithraeum for the Museum of London, the excavation of which had caused huge public interest, and from Sir Ian Richmond illustrations of the Carrawburgh Mithraeum on Hadrian's Wall. Then from 1956 and for four to five years he worked solely on reconstructions of Ministry of Works sites.

His method of working was to begin with a series of thumbnail-sized sketch ideas of a monument or scene to fix on his composition. He would then walk the site with the ground plan as it was important to him to study the surrounding landscape, the rise and fall of the ground that would help explain the buildings. He saw the principles of perspective as fundamental to the working out of an archaeological drawing as it would have been to a baroque masterpiece – the establishing of a plan in perspective and the fixing of a standard of measurement was essential. The next stage was to develop the initial concept sketch into a draft image pulling together detail. He would fix the main shapes of his composition with charcoal and work over it with a mixture of media – pastel,

conté, watercolour and inks. Overlaying his rough with tracing paper he would then outline areas he felt doubtful about and annotate this with comments to the archaeologist. The drawing would go to and fro between Sorrell and the expert with both adding notes and asking questions. He was not just a recipient of instructions from the archaeologist, he raised questions and was asked for advice. It was collaboration – a search for the truth. There would be many changes before the final image was produced; even after publication they would sometimes return to the picture and alter it.

Although Sorrell showed attention and care for the accuracy of an image, the reason he was so influential, his pictures so successful, was that he was first of all an artist. He was aware of this himself. When first commissioned by the National Museum of Wales he wrote expressing the hope of being able to show that a historical reconstruction could also be a work of art and so have a 'far greater power of education and attraction than a possibly accurate drawing where form and design have perhaps not received such particular attention' (Dykes 1981, 13). His sketchbooks are full of drawings both for his archaeological work and for his other paintings; he made no difference between the two areas of work. Although, to him, the principles of perspective were fundamental to the working out of an archaeological drawing, he warned others to 'use this method warily as you would a photograph – it must be subject to imaginative correction – the human eye is right, not mere mechanical correctness' (Sorrell and Sorrell 1981, 24). He used photography only when forced to by lack of time; he thought a photograph inferior to a series of drawings. 'Photography falsifies the true visual facts. Angles are always wrong and special values non-existent. A good drawing has an ordered clarity – use of photographs leads to confusion of shapes' (Sorrell and Sorrell 1981, 23). At the Royal College, where he taught drawing from 1931, he was known to the students as 'Old Angles' because of his insistence on the importance of structure and form.

Scale was important: 'the picture shouldn't be too big. And not too much detail – let the viewer use their imagination – a picture can be flattened by detail – this is non art' (Sorrell 1973, 177–81). What he aimed for was the reality of a dream. His palette of colour was limited: 'Don't emulate nature'. That would destroy atmosphere. 'A picture should be contained in its frame, in its own world' (Sorrell 1973, 177–81).

He depicted people in a generalised sort of way; what were important were vitality, movement and drama. He writes scornfully of 'the dumpy little figures' supposed to give scale to their surroundings that archaeologists sometimes included in their pictures (Dykes 1981,11). In his illustrations of the Mesolithic hunter camp of Star Carr in North Yorkshire the figures are reminiscent of the hard-working peasants drawn by Millet and Van Gogh (*see* Fig 9.2). Prehistoric times were shown as hard and gruelling, the people as naked, rude savages. In his illustration 'Maen Madoc, Ystrad fellte, Powys', which shows the son of Dervacus inspecting his father's monument – an early medieval stone inscribed in Latin DERVAD FILIUS IVSTIIC IACTI (Dervacus the son of Justus here he lies) – the figures are actors in a drama; he is telling a story. In the picture the dress and bearing of the son of Dervacus suggest the same continuity of Roman traditions – as does the name Justus, the Roman script, the language and the position of the memorial stone beside the Roman road (Fig 2.5).

Fig 2.3 Venta Silurum, Caerwent, Gwent, Wales, 4th century

It was the success of Sorrell's reconstruction of the 'Basilica' at Leicester in 1936 that led to the National Museum of Wales's commissions for reconstructions of the Roman Town of Caerwent and fortress at Caerleon.

The town was founded in *c* AD 75 after the Silures tribe, who had a long history of resistance, were finally subdued by Sextus Julius Frontinus. The main road between Isca Augusta (Caerleon) and Glevum (Gloucester) runs through the geometric centre of the settlement which is divided by a regular grid of streets. Near the centre the forum and basilica take up almost a whole block. Originally the town's defences were a single massive earthen ramp enclosing an area of 40 acres (16.2ha). In the late 2nd or early 3rd century the earthen ramp was replaced by stone walls and an extended double ditch. The walls may have been as high as 27ft (8m).

Alan Sorrell painted this picture in 1937. His war work included aerial survey which, he felt, changed the way he painted his aerial views.

Watercolour and body colour, 27.5 × 36.5in (700 × 935mm), 1937

[J920611]

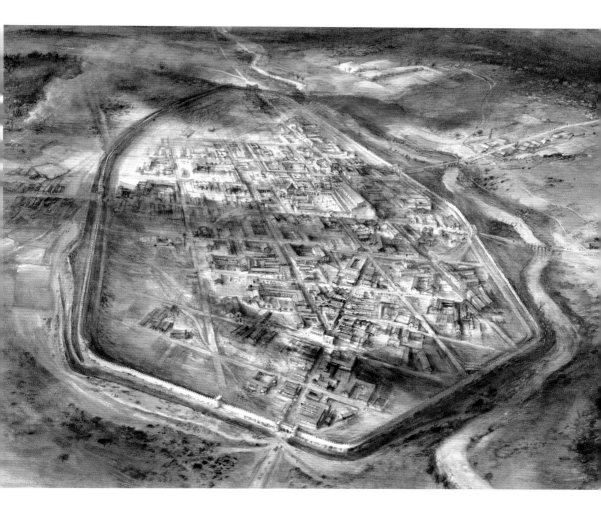

Fig 2.4 Verulamium Roman City, St Albans, Hertfordshire (from the south-east), late 3rd century

Sorrell's war work in the RAF included aerial survey. Compare this picture with Figure 2.3 painted in the 1930s and you can see the difference this experience made to his drawing of aerial views. In AD 155 the central part of the city was engulfed by a great fire but by the late 3rd century it was again a prosperous place with large, new, elegant houses of stone, three monumental arches and a stone town wall.

Mixed media, size unknown, 1960s

[© Verulamium Museum]

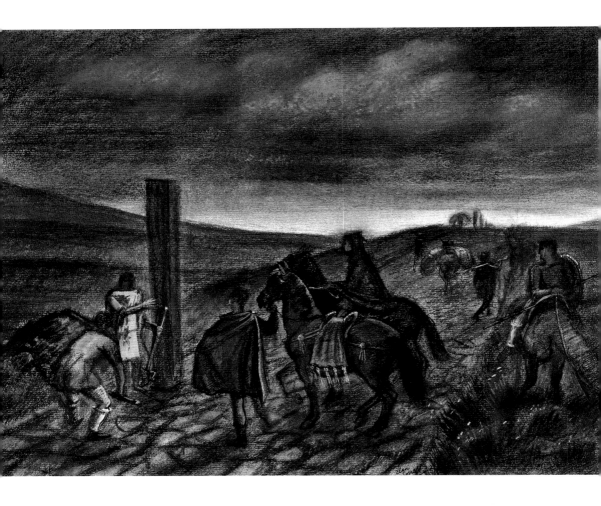

Fig 2.5 Dervacus's son inspects his father's monument, Maen Madoc, Ystradfellte, Powys, Wales, early medieval period

Alan Sorrell's drawing shows the early medieval inscribed gravestone to Dervacus. It stands in a remote landscape beside the Roman road which runs between the forts of Neath and Brecon. The stone was re-erected in 1940 after excavation by Sir Cyril and Lady Fox and this was the occasion of the reconstruction drawing. In the excavation report the point is made that the location of the stone indicated continuity into the Dark Ages of the Roman practice of burying the dead beside highways.

Gouache, pen and ink, chalks, watercolour, 10.5 × 14.7in (265 × 375mm), 1940

[© National Museum of Wales]

His pictures are full of atmosphere, light effects, dark rolling clouds, wind, and mysterious darkness. In this perhaps he looks back to the war when darkness became an overriding preoccupation in Britain. The world of the blackout (street lights were extinguished in September 1939), fires, explosions, searchlights and moonlight assumed great significance. You can see this in the work of other neo-Romantic artists, such as Paul Nash, Michael Ayrton, Eric Ravilious and John Craxton, and in Sorrell's own wartime picture 'Recruits leaving the camp' – a scene of recruits marching from the RAF station under a haloed moon (Fig 2.6).

The drama of high towers, the scale of extensive views, piles of cumulus or radiating shafts of theatrical sunlight; Sorrell liked to use these elements to break the rigidity of buildings. They create an overpowering atmosphere of imminent disaster. In this they reflect Sorrell's own feelings. The archaeologist Philip Rahtz, who worked with Sorrell on reconstructions of the Saxon Royal Palace site of Cheddar, asked him why his pictures seemed so ominous – why everybody looked so beaten down by the trials of life. 'That's the way I always feel myself' was the reply (Rahtz 2001, 191). His images reflected his perception of the fragility of the present.

Fig 2.6
Recruits leaving the camp, Bridgnorth, Shropshire, 1941

This drawing, which was a commission from the War Artists' Advisory Committee, shows recruits wearing packs and greatcoats leaving Bridgnorth camp at Christmas in the dark, hard winter of 1941. Alan Sorrell continued to paint and draw during his wartime service in the RAF. Some of these pictures are in Tate Britain and in the Imperial War Museum collections.

Chalk, ink and wash. 14.5 × 16.5in (370 × 410mm)

© Imperial War Museums [Art.IWM ART LD 1287)]

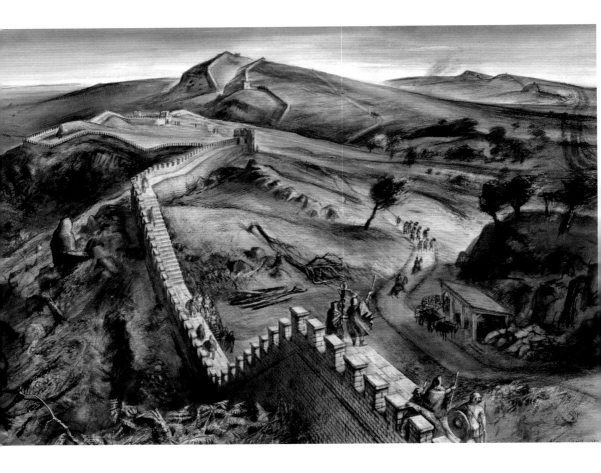

Fig 2.7 View from Steel Rigg, Hadrian's Wall, Walltown Crags, Northumberland, c AD 130

Hadrian became emperor of the Roman world in AD 117. His wall was a barrier, eventually of stone, which ran for 73 miles from the south of the River Tyne in Northumberland to the Solway Firth in Cumbria. It was 7ft 10in (5.2m) thick and between 15ft (4.6m) and 20ft (6.1m) high, marked with regular fortlets and signalling turrets closely spaced along its length and a series of larger garrison forts more widely spaced. It was a symbol of power, part of the framework of Roman military occupation which for over 300 years saw this tract of northern Britain as a frontier zone. Alan Sorrell's view emphasises the way in which the wall was an obstacle to free movement into and out of the province. The windswept feel to the picture is created by the movement of his brushstrokes as they follow the contours of the hills and slopes. He scrapes into the paper with a blade to emphasise the bare, thin vegetation and shape of the underlying landscape, stressing what a harsh, cold environment the Roman soldiers experienced.

Watercolour, body colour, pen and brown ink, 21.5 × 15in (550 × 380mm). 1959

[IC048/073]

It was *The Illustrated London News* that had led the way commissioning archaeological reconstructions. As far back as 1911 Amédée Forestier had drawn a series of views of the Iron Age lake villages of the Somerset Levels (*see* Fig 1.9) for the magazine and Sorrell was commissioned by them first in 1936 and then regularly afterwards. Properties were taken into the care of the state from 1883 but it was only after the 1930s that sites in guardianship increased from a mere handful to over 400. Greater mobility had led to a rise in tourism, and in response to this an increase in the number of travel guides such as the 'Highways and Byways' series and the 'Shell Counties' guides featuring historic sites and monuments and aimed at motorists. After the war the interest in archaeology and ancient monuments increased with national cultural regeneration, the emphasis on public education and the beginnings of subsidised archaeology.

Television was spreading ideas. One of the most popular panel games of the 1950s was 'Animal, Vegetable or Mineral?' where experts were asked what they knew of an object chosen from a museum. In one memorable programme a bowl of thin gruel was produced, successfully identified by Mortimer Wheeler as Tolland man's last meal (Tolland man was a Danish Iron Age man throttled ritualistically and preserved in a peat bog). The archaeologists Glyn Daniel and Mortimer Wheeler became television stars and a survey of the time showed a majority of London children hoping to be archaeologists when they grew up.

Initially, the Department of Ancient Monuments did not embrace this growing public enthusiasm for the past. Until the 1950s almost the only information provided for the visitor to a monument was textual – a notice or a guidebook. However, it was beginning to be recognised that there was a need for visual interpretation. Most of the monuments were ruinous and difficult to explain to the layman. Interpretative models were expensive, painted reconstructions a cheaper option. When Alan Sorrell was first commissioned by the Department of Ancient Monuments in 1956 they already had two travelling exhibitions explaining the development of the castle and the development of the abbey. They were mostly textual with photographs and diagrams, any gaps in knowledge filled with comparison with other sites. The third exhibition planned was of Hadrian's wall. As scarcely any Roman buildings survived in Britain except as foundations or footings, the comparison method was not possible and Alan Sorrell was asked to paint four reconstructions, the fort at Housesteads (Fig 2.8), its civil settlement outside the walls, the supply base at Corbridge and Willowford Bridge across the River Irthing. The pictures were to be academically well founded, based on the best archaeological and historical evidence available and helped by comparison with contemporary illustrations such as the forts that could be seen on Trajan's column in Rome.

In May, Sorrell travelled to Northumberland and spent three days visiting the sites. To give an idea how quickly and intensely he could work, upon his return home he completed the first rough of the Corbridge Supply Station within two days, the reconstruction of Housesteads Fort in three and then the civil settlement and Willowford Bridge, each of which took only four days. The pictures were a triumph and the Minister of Works, Hugh Molson, requested that there should be more painted reconstructions of the Ministry of Works sites. This caused some consternation in the Department of Ancient Monuments because for many years it had been an established principle that 'The Office of Works did not encourage or permit the exhibition of artists' reconstruction drawings of monuments at the monuments in its care: it did not accept such

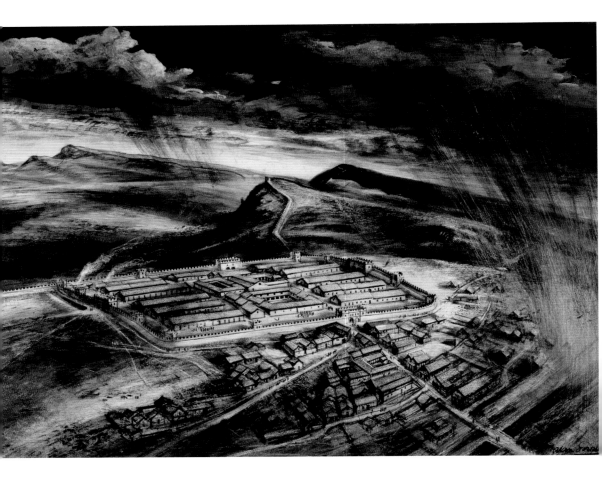

Fig 2.8 Housesteads Roman Fort, Hadrian's Wall, Northumberland, 3rd century AD

Roman forts throughout the empire evolved to a very similar pattern and Housesteads conforms to this. In plan they have an outline rather like a playing card, rectangular with rounded corners. Two gates midway along the short sides were linked by a main street and there were gates in each of the long sides. In the central area of the fort were the administrative buildings, including a headquarters building and the commanding officer's house. On either side was accommodation for the troops, their horses and stores. Housesteads is the most complete example of a Roman fort in Britain. The 5-acre (2ha) fort occupies a commanding position on the exposed Whin Sill escarpment and looking north it is easy to imagine oneself on the limits of an empire which once stretched from Northumberland to the Arabian Desert.

Monotone painting, tones of brown ink and line, white paint. Areas scratched out to show paths and shafts of light, 20 × 13.7in (510 × 340mm), 1956

[IC048/071]

drawings for display either as gifts or on loan, or on sale-or-return terms or by any other means and it did not include such drawings in any of its official publications' (Dykes 1981, 19).

This was an awkward position to reverse but even so a decision was made to commission a series of further paintings to be reproduced at the monuments concerned as well as postcards to be sold on the sites. To reinforce this decision a question was asked in Parliament 'whether he [the Minister] will arrange for drawings of ancient monuments as they might have appeared in use to be displayed at the monuments in his care' (Dykes 1981, 19). The Minister's reply gave the seal of approval to the project:

> The Ministry of Works are anxious to enable the general public to visualize what ancient monuments looked like in the days when they were in use. Mr Alan Sorrell has therefore been employed to carry out drawings and has received the advice of the Ministry's architects and archaeologists. There can of course be no assurance that the reconstructions are accurate in detail but it is believed they give a fair impression of what the buildings must have looked like (Dykes 1981, 19).

The announcement was applauded by *The Illustrated London News*:

> We have the testimony of many readers that reconstructions do indeed make 'dry bones live' and help in the attainment of that knowledge and understanding of what the past was really like ... This belief has now been attested in no uncertain way by the Ministry of Works which has specially commissioned from Mr Sorrell a series of reconstruction drawings of eight famous monuments. These drawings would be displayed at the sites concerned so that visitors might have some idea of what the places looked like in their splendour (*Illustrated London News* 1957, 191).

The first group of reconstructions commissioned after the Commons question were pictures of three major castles of Edward I in Wales – Conway (Figs 2.9 and 2.10), Harlech and Beaumaris – in collaboration with Dr Arnold Taylor, Assistant Chief Inspector of Ancient Monuments and the country's foremost expert in castles of this date. The results were startling. The shining white rendering which covered all external wall surfaces, the conical roofs and battlemented parapets, the siege engines standing on their platforms, presented a surprising new vision of familiar landmarks to the hundreds of thousands of people who visited the castles each year.

After the Welsh castles came Stonehenge (Fig 2.11), Minster Lovell Hall in Oxfordshire and the Jewell Tower (part of the medieval Palace of Westminster). Then the scheme broadened to include most of the popular sites in the country. In all, during this period of four to five years, Sorrell painted over 50 pictures.

It is not an exaggeration to say that Alan Sorrell created for the people of the time their idea of the past. As well as his work for the Department of Ancient Monuments, *The Illustrated London News*, National Museum of Wales and London Museum, he drew illustrations for many children's books about the past. Archaeological reconstructions are subject to revisionism but many of these pictures have long survived him in print. Until recently the very first pictures that he painted of the Hadrian's Wall were still included in English Heritage guides.

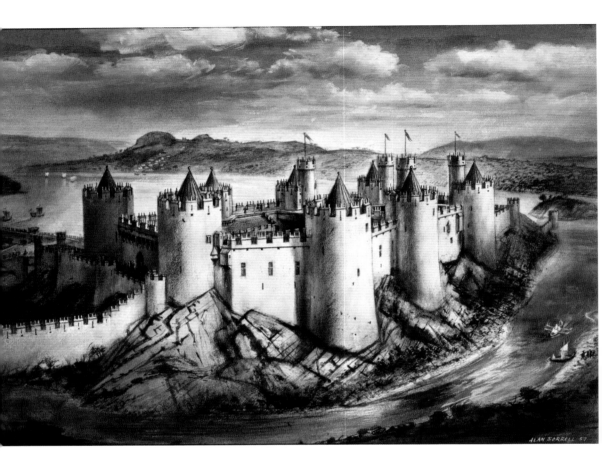

Fig 2.9 Conway Castle, Gwynedd, Wales, c 1290

In 1956, working with Arnold Taylor, Assistant Chief Inspector and castles expert, Alan Sorrell painted three pictures of Welsh Norman castles for the Inspectorate of Ancient Monuments. Conway Castle was built by Edward I from 1283 to 1289 during his conquest of Wales. It hugs a rocky coastal ridge of grey sandstone and limestone overlooking an important crossing point of the River Conway. One side is protected by the Gyffin stream which flows into the river and the other side defends the harbour of the town. Traces of limewash survive on all the walls and towers of the castle and originally it would have gleamed as it does in Alan Sorrell's picture.

Pen and ink, pastel, ink washes, gouache, 385 × 544mm, 1957

[Alan Sorrell]

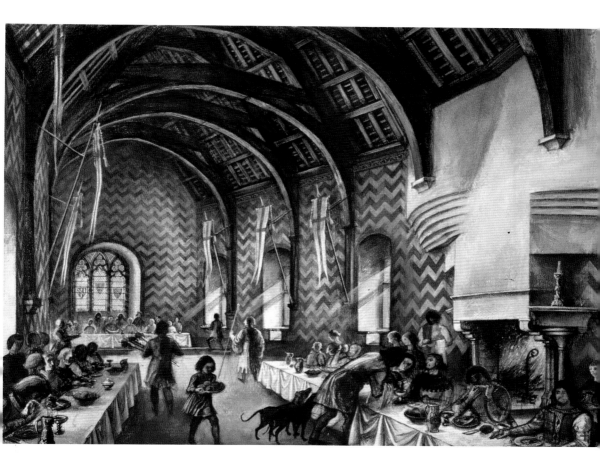

Fig 2.10 The Great Hall, Conway Castle, Gwynedd, Wales, c 1285

In his picture of the interior of the great hall Sorrell has balanced the direction and shape of the roof beams and the strong chevron patterning of the walls, taken from surviving decoration at St Faith's Chapel in Westminster Abbey, with the strength and vigour of his drawing of the figures which pull the viewers' eye to them.

Mixed media, 15.2 × 21.5in (390 × 550mm), 1962

[Alan Sorrell]

In his foreword to *Reconstructing the Past* (1981), an account of Sorrell's life and career edited by his son Mark, Professor Barry Cunliffe writes of the influence Alan Sorrell's work had on a generation; how the archaeological communicators of the 1950s, Mortimer Wheeler, Glyn Daniel and Alan Sorrell, scholars and experts in their own fields, could breathe life 'into the unprepossessing rubble foundations and dreary potsherds that form the raw material of archaeological research' (Sorrell and Sorrell 1981, 7).

Even as this revolution in the presentation of Ancient Monument sites was taking place, attitudes in archaeology at large were changing. Archaeological

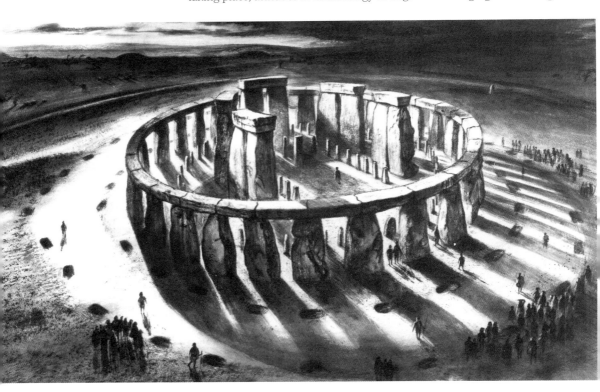

Fig 2.11 Stonehenge, Wiltshire, 1000 BC

This picture of Stonehenge as it might have appeared in 1000 BC is one of the first Sorrell painted for the Inspectorate of Ancient Monuments after the intervention by the Minister of Works Lord Molson in 1957. It was exhibited in the House of Commons tearoom to great acclaim. Six years of excavation had started at Stonehenge in 1953 directed by Richard Atkinson, Stuart Piggott and J F S Stone. The Ministry of Works in its annual report in 1954 had recommended commissioning the making of a model to explain the site, but the cost of £300 for the model and £2,000 for a hut to house it was too great. Sorrell was paid £200, which included expenses, for his reconstruction. Viewed from the east he shows the final phase of building when more than 80 huge blocks of sarsen stones had been dragged to the site probably from the Marlborough Downs about 24 miles away. The moving, siting, shaping and raising of the stones was a huge task. The lintels are curved on their inner and outer faces to make segments of a circle joined together with tongue-and-groove joints. All this was achieved by pounding and shaping the sarsens with stone hammers.

Watercolour, brown ink, conté crayon, 15.5 × 22in (390 × 560mm), 1957

[IC095/014]

reports, the academic publications of the results of excavation, had been idiosyncratic and personal until the1970s. Archaeologists such as Mortimer Wheeler, Stuart Piggott and Brian Hope-Taylor had a strong individual style of writing and drawing. Alan Sorrell's dramatic, narrative paintings complemented this style of report. The change came with the growing influence of science in archaeology; archaeological science expanded in this period and led the way in the study of organic remains, metallurgy, glass, conservation, and the early use of geophysics, x-ray, dendrochronology and carbon 14 dating. In the country science and technology were generally seen as the way forward. In 1966 Philip Rahtz, then one of the Ministry's contract archaeologists, published *The Preparation of Archaeological Reports* which was reviewed by Brian Hope-Taylor. Hope-Taylor, who had been an illustrator before he was an archaeologist, did not like Rahtz's book. Rahtz remembered, 'It was as though I had written a book about how to write a business letter when what he created was a work of art' (Rahtz 2001, 188). So as excavation reports became less individual and more formulaic, objective and scientific, reconstruction painting became unfashionable. Sorrell's pictures were viewed as overemotional and overdramatic. His work had always been controversial in the Inspectorate of Ancient Monuments. The Chief Inspector P K Baillie-Reynolds wrote of the trade-off they had to accept between Sorrell's diligence and accuracy and the turbulent atmosphere of his pictures; at a meeting in 1959 the Chief Information Officer Mr Howarth was deputed to talk to Sorrell about the stormy, sombre backgrounds to his pictures. So eventually, for a time, the use of reconstruction in archaeology almost stopped. The only works dared – isometric, technical line drawings of excavated buildings – reflected the spirit of the age.

In 1957, at the height of his career, Sorrell could hardly keep up with the demands for his reconstruction paintings. His work was used in books, television and museums throughout the country. And not just archaeological paintings: he produced a series of drawings recording the building of the nuclear power station at Hinckley Point in Somerset from 1957 to 1962 and in 1962 travelled in Egypt and Nubia recording the temples of the Nile under threat from the building of the new dam at Aswan. And there were his imaginative paintings such as *The Stone Men; Agamemnon's Homecoming; Via Appia* and *An Ancient Place* – paintings linked inevitably with his archaeological work.

By the time of his death in 1974 reconstructions were completely out of favour; the work of the neo-Romantics had become unfashionable too. They had enjoyed a vogue after the war popularised through Arts Council touring exhibitions and the influential series 'Penguin Modern Painters' – the first 17 titles appeared between 1944 and 1950 but later their influence waned with the drift towards more highly chromatic and nonfigurative trends in painting. But there is a cycle in these things; time leads to reassessment and just as Alan Sorrell and the neo-Romantics fell out of favour in the 1960s, so now there is an increasing interest in their work with recent exhibitions of Piper, Sutherland, Bawden and Ravilious, and Alan Sorrell, too, at the Sloane Museum in London and the Beecroft Gallery in his home town of Southend-on-Sea. Recently his 16m-long mural *The Four Seasons,* painted in 1953 for a wall of Myton School in Warwickshire's entrance hall, was listed. His work is collected and studied and still used in archaeology. It has survived so well because of its artistic quality; knowledge of the past increases and ideas change but it is the strength of the image that endures.

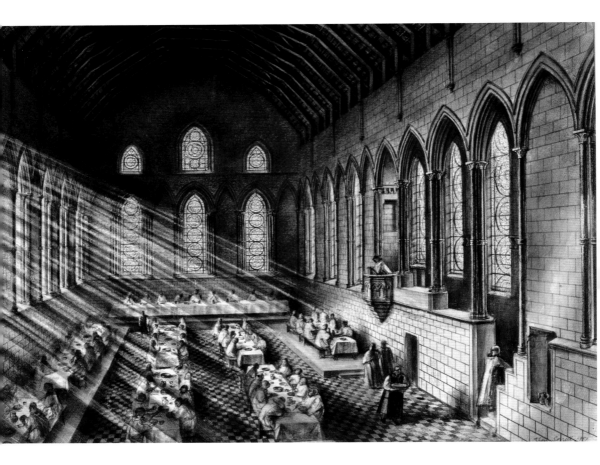

Fig 2.12 Interior of the refectory, Rievaulx Abbey, North Yorkshire, c 1250

Founded in 1132, Rievaulx Abbey was the first Cistercian monastery built in the north of England. The refectory is the largest and most elaborately decorated room in the abbey. The general effect is of austere simplicity tempered by the delicacy of the wall arcading and refined proportions of the arches on their slender supports. For much of the year the monks ate only one meal a day around noon. Meat was excluded from their diet and daily fare consisted of bread and usually two vegetable dishes with beans and leeks the staple. They drank beer made without hops. At the end of the room furthest from the cloister was a dais on which the prior and senior monks sat. The community sat on benches placed along the side walls with wooden tables on stone supports. The reader's pulpit was reached by a flight of stairs. Meals were taken in silence broken only by readings from the Bible or religious commentaries.

Mixed media, size unknown, 1959

[J980049]

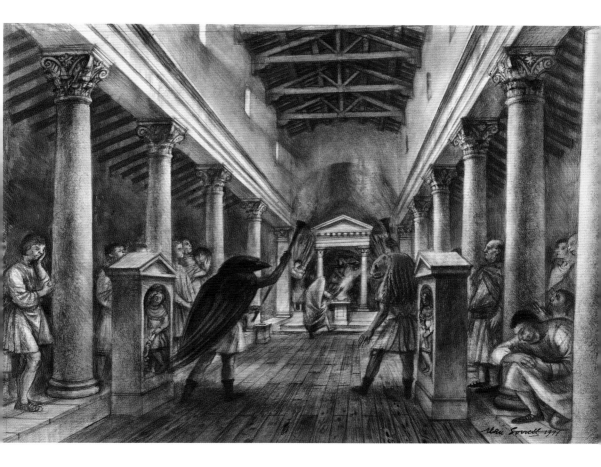

Fig 2.13 Interior of the Walbrook Mithraeum, London, AD 250

The cult of Mithras, the worship of the Irano-Indian god of heavenly light, appears to have spread from the east to Rome during the 1st century AD, gaining popularity in the following centuries. Mithras seems to have originated as a sun god born from heaven whose act of creation was to capture a white bull, take it to his cave and sacrifice it; from the blood which poured other creatures gained life. Temples of Mithras are small, confined spaces representing the cave where the bull slaying took place. The number of followers was limited and the brotherhood was a secret society with levels of initiation, all conducted in secret. Drama was part of the ritual. The picture shows two devotees wearing fantastic masks and costumes of the raven and the lion and carrying flaming torches. In the background the priest approaches the altar. When the Walbrook Mithraeum was excavated in 1952 by Professor Grimes the site became the centre of extraordinary public interest; on one day alone in 1954 35,000 people queued to see the excavations. This enthusiasm helped to persuade the Department of Ancient Monuments of the need to explain their monuments to the general public.

Pen and ink, watercolour, gouache, chalk, 26.5 × 19in (670 × 480mm), 1971

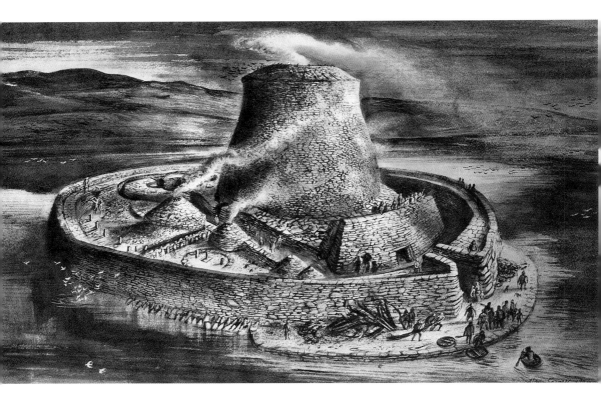

Fig 2.14 Clickimin Broch, Lerwick, Shetland, Scotland, 1st century AD

Clickimin Broch sits on a little island close to the southern shore of the loch at Lerwick. Alan Sorrell's pen-and-ink drawing shows the stone-built broch and encircling wall, the entrance defended by a rectangular blockhouse. Brochs are tapering circular towers as high as 15m built of drystone walling. At the base the main wall is solid; at Clickimin it is over 5m thick but upwards it tapers and divides with separate inner and outer walls bonded at vertical intervals by horizontal stone slabs which form floors running within the wall. Flights of steps carry the various levels. Brochs are unique to Scotland and are found around the coastal margins of the north-west mainland and the islands of the Hebrides, Orkney and Shetland.

Pen and ink, 16 × 11in (410 × 280mm), *c* 1960

[© Illustrated London News Ltd/Mary Evans]

Fig 2.15 The blockhouse, Clickimin Broch, Lerwick, Shetland, 100 BC

The blockhouse is earlier than the broch and it dates from about 100 BC. It is positioned behind the entrance through the enclosure wall and was for defence as well as for living in. John Hamilton, who excavated at Clickimin from 1953 to 1957, thought that the blockhouse would have housed an important group or family, probably the leaders of the settlers who fortified the islet. These were the archaeologist's ideas when Sorrell drew his picture but in recent years Hamilton's ideas have been challenged and the ring wall, blockhouse and broch are now usually assumed to be contemporary.

Pen and ink, 15 × 25in (385 × 635mm), c 1960

[008-000-016-877-R © Crown Copyright: HES]

3 | William Thomas (Terry) Ball

Fig 3.1
Goodrich Castle,
Herefordshire, 15th century

Goodrich Castle was originally
an earthwork castle built just
after the Norman Conquest. It
was rebuilt in stone in the 12th
century and the keep dates from
this time. It was then largely
rebuilt again in the late 13th
century when it was one of
the most up-to-date castles of
the period – a defensive shell
concealing residential buildings
of sophistication. It stands in
open countryside on the summit
of a hill above the River Wye
near the Anglo-Welsh border –
a defensive position protected
by a rock-cut moat. There is no
siege recorded in the castle's
history until it was attacked by
the Parliamentary forces in the
civil war; then a fatal flaw in the
defences was discovered when
the water supply was cut off and
the castle had to surrender. Terry
created this picture in 1994 and it
is opaquely and robustly painted
with body colour; compare
this to his earlier paintings of
translucent watercolour
(see Figs 3.8 and 3.9).

Watercolour with body colour,
770 × 600mm, 1994

IC044/016]

Terry was born in Greenwich, south-east London, in 1931, went to school
in Carshalton and aged 15 went to Wimbledon Art School. The illustrator
Raymond Briggs gives a snapshot of the art school at this time:

> We kept hearing rumours that the school was regarded almost as a joke
> outside because no one did anything remotely modern. We were told
> [at the college] that painting had stopped about 1880 and that art had
> gone downhill from then on culminating in the horrors of modern art.
> We were encouraged in the main to base ourselves on the Renaissance –
> Michelangelo, Piero Della Francesca and people like that – a very old
> fashioned traditional training. It was actually jolly good for an illustrator
> (Martin 1989, 230).

Terry also flourished in this atmosphere and in 1952 went on to study at
the Royal College of Art where among his contemporaries were Bridget Riley
and Frank Auerbach. At college he drew buildings and architectural features not
with an idea of a career but because they interested him. Graduating from the
Royal College he took a job as a hospital orderly. He planned to paint in his spare
time, to assemble enough work for an exhibition and hopefully a career as an
artist would follow.

In 1957 he went to Jordan and by chance worked on the archaeologist
Kathleen Kenyon's final season of excavations at Jericho. He drew finds from
tombs. He fell in love with Palestine and over the next 10 years spent long
periods of time there and in Jerusalem. His nephew Steven remembers Terry's
homecomings from the Middle East – a mysterious, romantic figure, smelling of
French cigarettes and oil paint. It was in Jerusalem during the restoration of the
Church of the Holy Sepulchre that Terry first grasped the value of reconstruction
drawing. One of his first works, drawn during the Six-Day War in 1967, shows
the church as it was rebuilt in the 1040s. The war brought him back to London
and in 1969 he joined the Ministry of Public Buildings and Works surveying and
preparing measured drawings in the Ancient Monuments architectural drawing
office. Eventually, in 1983, he ran the office in what had then become English
Heritage. By this time his talent for reconstruction painting had emerged. There
were pictures of the London Guildhall (see Fig 3.8), the Tower of London (see
Fig 3.9) and Windsor Castle (Fig 3.2), and then throughout the 1980s the
volume of work increased as he painted castles, abbeys and palaces collaborating
with colleagues in the Inspectorate of Ancient Monuments (Fig 3.3).

Terry's pictures were not artistic impressions but carefully considered and
meticulously argued reconstructions. A picture of architectural complexity could
take him months to complete. He would start on site with a discussion, choosing
the most appropriate viewpoint and considering the missing elements of
architecture. His first drawn lines would be the result of studying the measured
survey drawings and photographic archive. The preliminary drawings would
rapidly grow as ideas were tested graphically. Draft after draft followed with

Terry posing questions to his collaborating historian. He relished the work as an intellectual exercise. As well as working for the Ministry he had freelance projects notably for Cadw, the Welsh heritage body. Working within these heritage institutions he had access to all the archives, plans and photographs of sites and collaboration with archaeologists and architects. He constructed models of the more complex sites to get a sense of depth and to work out the best angle from which to view the scene. The view would be chosen for the amount of information conveyed rather than for any dramatic effect. He saw the model-making as the most valuable part of his preparation because the model, with the plans and elevations he drew to enable him to construct it, might throw up new theories, new interpretations of facts and challenges to original ideas. He would draw the model as the basis for the picture (rather than setting up a formal perspective drawing) but his preference if possible would be to draw his picture directly from the chosen viewpoint on the site.

Fig 3.2 Siege of Windsor Castle, Berkshire, 1216

Windsor Castle is thought to have been built by William the Conqueror in the first years of his reign, about 1070. This first castle was built of earth and timber with banks of chalk rubble quarried from the castle ditches topped with timber palisades and dominated by the large manmade motte which divided the upper and lower wards. Terry shows the castle at the height of the siege of 1216 when the timber had been largely replaced by stone. The keep is thought to date from the late 12th century – the work of Henry II, who is also thought to have built the masonry defences of the upper ward and part of the lower ward. You can see in the picture that the castle defences were not yet completed in stone but even so Windsor withstood a three-month siege by the forces opposed to King John. Terry's aim was to show the castle's architecture and situation. If you look closely you can see the machinery of the siege – the catapults and incendiaries and resulting burnt houses, but the date of the siege is just a peg to hang the reconstruction on. (See Figs 5.5 and Fig 6.1 to see how different artists approach a similar subject).

Watercolour, pen and ink, 914 × 1462mm, 1979

[Collection Trust/© Her Majesty Queen Elizabeth II 2017]

Fig 3.3 Aerial reconstruction, Richmond Castle, Yorkshire, c 1100

Richmond Castle was built by Alan of Brittany, Earl of Richmond, a supporter of William the Conqueror who was granted a huge amount of land after the Battle of Hastings. His Yorkshire estates included Swaledale and it was here, on a cliff above the river, that he built his principal castle and residence. Terry's reconstruction shows the castle as it might have been about the year 1100. It was defended by a high stone wall except on the south where a timber palisade probably protected the edge of the cliff above the river. Within the castle the dominating building is Scholland's Hall, a massive structure built for defence as well as to provide Earl Alan with a palatial residence. The other buildings were of timber and daub. They included lodgings for the earl's men, stables for his horses, and the many domestic buildings needed to support his household – kitchens, bakehouse, brewhouse, laundry, smithy, carpenter's shop, woodyard, storehouses and barns.

Watercolour, pencil, pen and ink, 770 × 550mm, 1989

[C085/007]

He felt himself pulled between art and science, or between reconstruction painting and measured record survey. He felt a responsibility to make clear what was fact and what hypothesis and was concerned when the reconstruction process strayed into hypothesis derived from documentary sources and by comparison with other buildings – information he regarded as sometimes unreliable. He knew that a drawing could give credibility to an idea when in fact the basis for it might be an illusion. It was important, he believed, to keep hold of the basic evidence and not to exaggerate or idealise. He characterised his reconstructions as attempting to place the bare facts into a realistic context.

Terry's pictures are cool, objective and architectural. Everything is described in clear thought-out lines and clear washes of paint. He defines shapes with ink contours. He used to restrain himself from adding too much to a painting, too much colour or too many marks – deliberately keeping his personality out of the image. 'Drawing', he said, 'is like writing, a selective process.' But this is only one side to his artistic work. He was a landscape and portrait painter in oils as well as watercolour. He was influenced by the romantic and topographic painters and illustrators from traditional French architects such as Viollet-le-Duc (1814–79) to watercolour artists of the 18th century such as Thomas Girtin (1775–1802). He was often dissatisfied with the forms and juxtaposition of colours and shapes forced on him by the restrictions of a view. He believed that too much dependence on mechanical means of picture making disrupted the link between the personality and temperament of the artist and resulted in a dull, lifeless picture. There is a balance, a felicity to his compositions even when constricted by the necessity of an awkward viewpoint – for example his painting of the Bishop's Palace of St David's, Pembrokeshire, around 1350 (Fig 3.4). The cutaway picture shows the interior of the hall built in Gothic decorated style with servants approaching from the kitchen from behind the wooden screen and from the undercrofts beneath the hall. The bishop and his guests sit at the high table at the far end of the hall. It is difficult to make an easy composition

Fig 3.4
Bishop's Palace,
St David's, Pembrokeshire,
Wales, c 1350

Terry has chosen an awkward visual angle of the Bishop's Palace to show his reconstruction of the massive trussed roof of the hall and the workings of the building with bishop and guests at high table and the servants and kitchens behind the wooden screen. Aware of this he has softened the image by showing a full moon high in the sky shining on the garden where trees cast dark shadows

Watercolour and body colour, pencil, size unknown, 1999

[Illustration by Terry Ball, 1999]

when half of the building is cut away to show the interior. It is a compromise between a technical illustration and a painting. In addition, the view looking directly at the corner, which has been selected to display as much as possible of the construction and use of the building, is awkward visually. But Terry has balanced this by showing the moon high in the left-hand side and the trees in the garden, lit by moonlight, casting shadows. By this romantic device he has created a cosy, intimate feeling to the interior scene, lamps lit, people going about their business preparing the meal.

He is the master of understatement. Even when showing a dramatic incident such as the attack on Penmaen Castle, Gower, by the Welsh prince Rhys Gryg (Fig 3.5) with the gate tower on fire, where others might have emphasised the drama with turbulent weather and landscape and a strutting prince, Terry's sea and sky are calm and Rhys Gryg sits quietly on his horse watching the fire from a distance. What Terry is interested in is the castle architecture and its situation in the landscape. He was critical of the figures in Alan Sorrell's pictures which he found overdramatic and distracting. The unobtrusive character of the people in his own pictures was deliberate; he admired, for instance, the way Canaletto composed his pictures and how it is the buildings that are adjusted to give drama and balance to the composition and the figures are – as Terry saw it – just there, quietly getting on with life.

Fig 3.5
Penmaen Castle Tower,
Gower, Wales, 1217

Today only a few grassy mounds remain of Castle Tower, and Terry Ball's reconstruction of the planked wall and timber-framed gatehouse is based on excavations of the early 1960s and evidence from other sites. Castles built of timber were very vulnerable to attack by fire and Terry shows just such an attack by the Welsh prince Rhys Gryg (d 1233).

Watercolour, size unknown, 1987

[Illustration by Terry Ball, 1987]

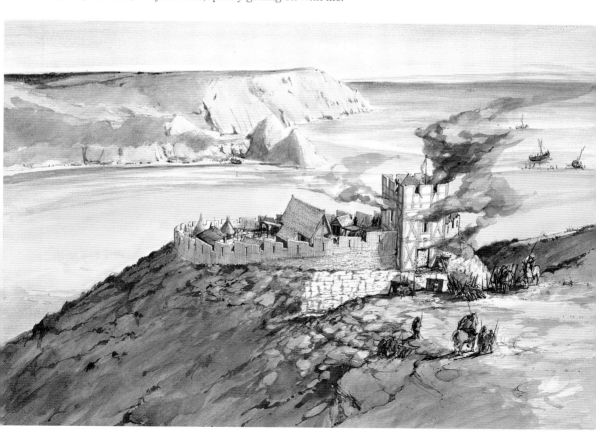

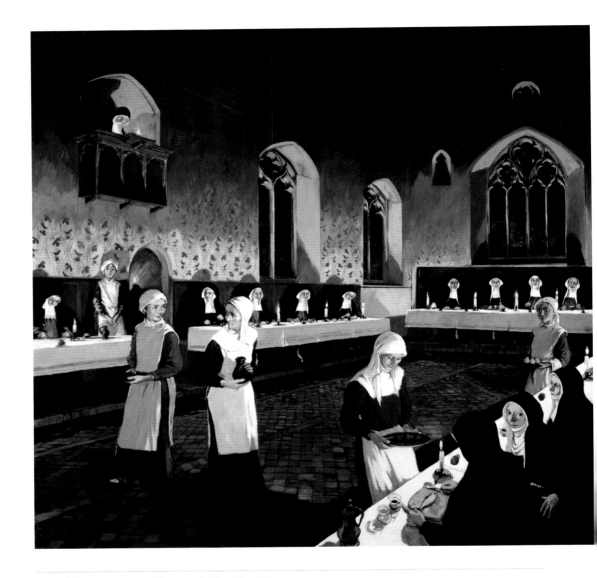

Fig 3.6 Refectory, Denny Abbey, Cambridgeshire, 15th century

Denny Abbey was first a house for Benedictine monks and then for the Knights Templar. After that it housed an order of Franciscan nuns, the Poor Clares – an enclosed order who had minimal contact with the outside world; they spent much of the day in silence and ate in silence listening to readings from the scriptures or other religious books. Terry's picture reconstructs the refectory as it might have looked in the 15th century. He shows the nuns at their one meal of the day with the serving girls who would have lived in the convent but were not part of the religious life. Most of the 14th-century tiled floor still exists and, around the walls, supports survive for a raised timber floor on which the nuns' tables and benches were set. The east end was raised to create a dais for the abbess and distinguished guests. There is evidence of wood panelling around the lower part of the walls with some painted decoration above but no fireplace, so dining there would have been a cold, austere experience.

Oil painting, 2470 × 2450mm, 1980s

[J930289]

Although most of the pictures he painted for English Heritage are architectural in watercolour with body colour and pen and ink, he could paint quite differently. When he left London in the 1990s, he lived in Suffolk on the coast at Walberswick where he painted atmospheric landscapes and portraits. A rare example of a different sort of picture for English Heritage is his large oil painting of the interior of the refectory at Denny Abbey in Cambridgeshire (Fig 3.6). The refectory – an empty hall – exists intact but barn-like and to enliven the space and show how the refectory might have looked Terry was asked to paint a scene based on evidence, with life-sized figures. The picture is positioned opposite the entrance and shows a scene of nuns (The Poor Clares) at their evening meal. High up in the pulpit a nun reads aloud from a religious book. In his watercolour paintings the figures are mostly unimportant, not quite the 'dumpy little figures' Alan Sorrell despised but just there to give a scale to the building – but at Denny the people are central and full of life and interest. To be able to change scale in this way from the tiny figures in his architectural watercolour paintings to the life-sized figures of Denny Abbey painted in oils seems remarkable and demonstrates his skills and versatility (Fig 3.7).

Terry still worked for English Heritage as a freelance reconstruction artist after he retired to Walberswick, sometimes altering work he had painted decades before as new guidebooks were commissioned and new information became available. Walberswick is popular with artists and Terry was part of a group who painted and exhibited there.

He was appointed an MBE in 1992 and was elected a Fellow of the Society of Antiquaries. Diffident, it was typical of Terry that at Walberswick nobody knew of these honours and that his mother only learnt of the MBE when casually reading the published newspaper lists. He died in 2011.

Fig 3.7
Self-portrait, c 2009
Terry, a small dapper figure, usually dressed in corduroy trousers and dark waistcoat and black beret. Although born in Surrey he had Irish roots of which he was very proud. He was very polite and very erudite with wide literary as well as artistic interests.

Oil, size unknown
[Terry Ball]

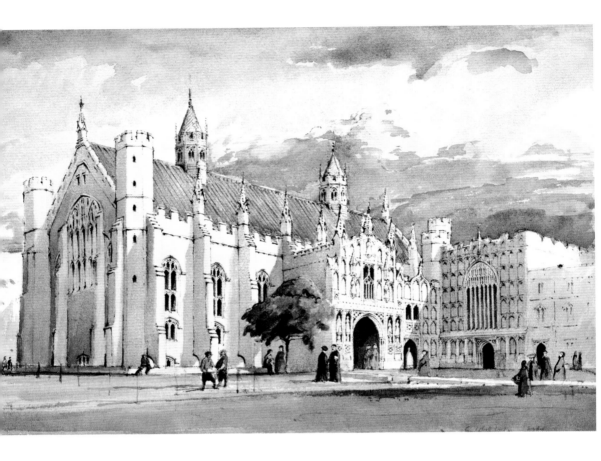

Fig 3.8 South–west view of the Old Guildhall, City of London, c 1450

There was a campaign of civic improvements in London from 1411 to 1450 and the Guildhall was redeveloped at this time. Between 1411 and the late 1420s the master mason John Croxtone created what was in reality a new Guildhall by extending the existing building in height and length. It was a stage for civic display rather than an office building. It was the main venue where citizens would experience civic justice and it was the public face of the wealthy City of London.

Watercolour, pen and ink, 510 × 370mm, 1973

[N840017]

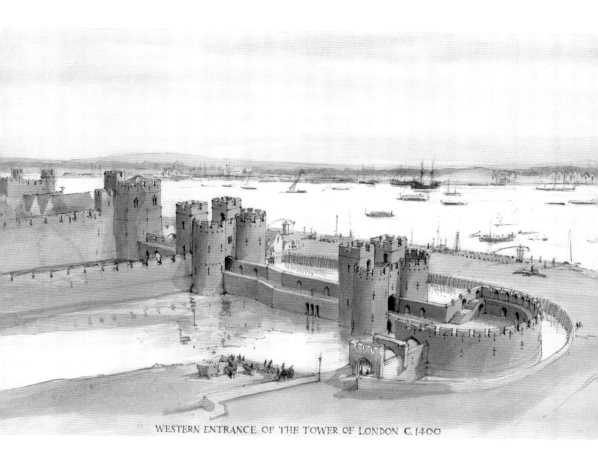

WESTERN ENTRANCE OF THE TOWER OF LONDON C.1400

Fig 3.9 Western entrance, Tower of London, c 1400

The picture shows the inner and outer gatehouses with a massive barbican all linked by stone causeways incorporating drawbridge pits. The D-shaped barbican and Lion Tower date from 1275: built for Edward I, this is where visitors would be greeted and probably dismount from their horses. Terry painted this picture in 1978 and it is a pure, translucent watercolour. Later on, if you compare it with such pictures as Goodrich Castle you can see his increased use of body colour (*see* Fig 3.1).

Watercolour, pen and brown ink, 340 × 590mm, 1978

[IC102/001]

Fig 3.10 Interior of the vestibule, pyx chamber and cloister, Westminster Abbey chapter house, London, 1250

Terry's cutaway of the chapter house and adjoining buildings shows the close connection between church and state in medieval times. The chapter house would have been entered from the cloister through a grand vaulted vestibule then up a flight of steps. The 13th-century octagonal chapter house is at first-floor level. As well as being the meeting room of the religious community this elegant vaulted room was used as a council chamber for the adjoining palace of King Henry III. In the forefront of the picture are the vaults of the royal treasury, the pyx chamber, which is older than the chapter house. It is part of the ancient dormitory range begun soon after the conquest and completed probably in the 1080s.

Watercolour, pen and ink, 530 × 590mm, 1985

[IC111/001]

Fig 3.11 Reconstruction of a scene inside one of the Keep Yard Barracks, Dover Castle, Kent, 18th century

Hastily erected by William the Conqueror soon after the Battle of Hastings in the autumn of 1066, Dover Castle has housed troops from the 11th century until after the Second World War. Terry's picture shows the interior of a dormitory room at the Keep Yard Barracks in the mid-18th century. There soldiers, as was customary at this period, lived a highly communal life, often sleeping two to a bed. Married men and their wives might also share the dormitory, draping hangings around their bed for a modicum of privacy.

Watercolour with body colour, 380 × 290mm, 1995

[IC032/010]

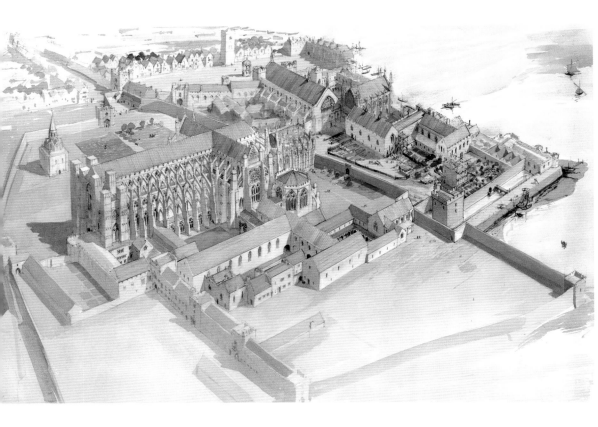

Fig 3.12 Westminster, London, 1510

Terry has drawn on evidence from archaeological excavation, medieval manuscripts, early maps and 18th-century topographical drawings and descriptions to create this view of late medieval Westminster. The old Saxon church on Thorney Island in the Thames – a small island of firm ground in the marshes upstream of London and its suburbs – was known as the West Minster to distinguish it from the even older East Minster, the cathedral church of St Paul in the City of London. Beside the West Minster successive Saxon and Norman kings built and enhanced a royal palace fronting onto the River Thames. You can see in the picture how the palace and abbey were crammed together on the small space. The abbey church, chapter house and cloister still exist today but very little remains of the medieval royal palace. Most of it was destroyed by fire in 1834. A few buildings survive – the crypt of St Mary Undercroft, the cloisters of St Stephen's chapel and the Jewel Tower. However, only the Great Hall built for William Rufus in the 1090s remains in anything like its medieval form to show the grandeur of this former royal residence.

Watercolour, pen and ink, 1010 × 660mm, 1993

[IC110/001]

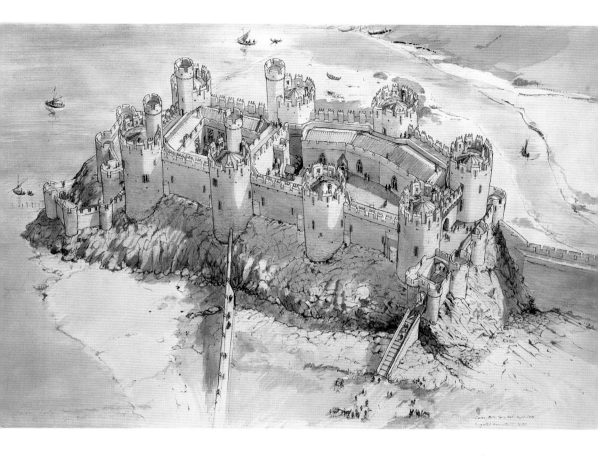

Fig 3.13 Conway Castle, 13th century

Conway Castle as it might have appeared at the end of the 13th century. The architect of Conway was Master James of St George, construction began in 1283 and it was completed by 1288.

You could compare Terry's picture with Alan Sorrell's painting of 1957 (*see* Fig 2.9); both were made in collaboration with Arnold Taylor, Chief Inspector of Ancient Monuments. Terry respected Sorrell as an artist but he was suspicious of the emotion in Sorrell's pictures. Here Terry has chosen a high viewpoint which shows the internal arrangements of the castle wards. Sorrell, with a lower viewpoint, is interested in the way the castle imposes itself on the landscape – which in reality it does – a Norman castle imposed on the Welsh!

Watercolour, pen and ink, 1986, amended 1996.

Illustration by Terry Ball, 1997]

4 | Frank Gardiner

Frank is from the East End of London and was born in Forest Gate, East Ham in 1942. He came to work in the archaeological drawing office of the Ministry of Works in the late 1960s and joined a group of five illustrators under the leadership of David Neal. Unlike many of the group Frank did not come from an archaeological background. He had left school at 13 to attend the Lister Technical College in West Ham studying architecture, technical drawing, calligraphy, and all aspects of art and design, for a City and Guilds qualification. After leaving in 1960 he worked as a graphic designer for the printers Waterlows and for the publishers Pergamon Press. In addition, he was a skilled calligrapher inscribing the certificates, diplomas, and honours letters that Waterlows produced. At Pergamon Press as a teenager he was a favourite of the notorious owner Robert Maxwell and was involved in producing the literature for his campaign for the parliamentary seat of Buckingham. What attracted Frank to a job at the Department of Ancient Monuments was the pen-and-ink drawing style employed in the drawing office. His grandfather had a collection of antiquarian archaeological books and as a child Frank had been fascinated by the steel engravings of knives, swords, shields and other ancient objects that illustrated them. He copied the drawings for the portfolio of work that he showed at his interview. He modelled his drawing style on them and believed they have never been bettered.

Artefacts were drawn with a mapping pen, a dip pen with the finest of nibs. It is a difficult skill to master and most people struggle to learn to produce the regular, parallel lines necessary to draw small, smooth objects in this way. Some people never succeed. Frank, with his calligraphic skills, found it easy and pleasurable. The atmosphere at his previous place of work had been frenzied and pressured. Time was money in the commercial world and people could be and were sacked if they did not complete a job in the time allotted. Working at the Department of Ancient Monuments, he enjoyed himself so much that it seemed to him as though every day was a holiday. He found the people he worked with quirky, erudite and endearing.

By his example he changed the style of drawing of the group. His positive, confident pen lines raked across the surface of the paper, explaining and defining form. At this time science was opening up new directions in archaeology. Objects from excavation were processed through the Ancient Monuments Laboratory and the use of x-ray to examine metal objects was a new thing. Frank liked to know how things worked (as a schoolboy his Saturday job had been with a clockmaker; his other part-time job was as a paperboy to Jack 'The Hat' McVitie, a notorious East End villain who acted as an enforcer and hitman for the gangster Kray twins. McVitie was stabbed to death by Reggie Kray in 1967). Frank loved the mechanism of objects and brought this interest into his work in the archaeological drawing office. Corroded iron locks previously just recorded as rusted casings, now with a series of x-rays at different exposures could be graphically dissected and explained visually by means of an exploded drawing. He aimed to be so thorough, so complete in his drawings that it would be possible to recreate the object anew from them.

At this time Alan Sorrell was still working for the Department of Ancient Monuments and by now, in the 1960s, his paintings were at last included in a few of the official guidebooks – the blue books. Previously they were used only for site graphics, special exhibitions and for postcards sold on site. However, during this period the archaeological profession was already turning from a highly personal, narrative style of report to something more scientific, as they saw it, and more objective, which meant Sorrell's style was out of favour. David Neal, the head of the drawing office, drew isometric, technical reconstructions of the Roman villas he excavated (*see* Fig 1.14). His experience spanned both art and archaeology, which is maybe why he felt less nervous about reconstruction drawings than most archaeologists at that time, but these were the only reconstructions drawn in the office.

Frank had no direct knowledge or experience of archaeology, so David Neal took him to work on his surveys of the Roman forts on Hadrian's Wall. This was almost the first time Frank had travelled outside London – indeed until he left school and worked in the City he had scarcely left the East End of London – and Northumberland was another world to him (Fig 4.2). He also worked on David Neal's excavations of the Roman villas of Gadebridge (1963–8) and

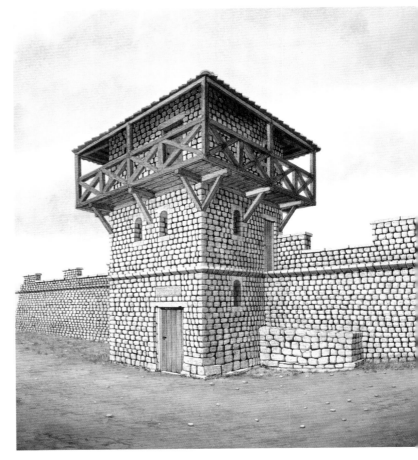

Fig 4.2
Brunton Turret,
Hadrian's Wall,
Northumberland,
2nd century

The signalling turret at Brunton on Hadrian's Wall east of Chesters Fort as it might have appeared when newly built in the early 2nd century. Along the line of the wall between each pair of milecastles were two equally spaced towers from which messages could be passed by smoke or beacon fires. The upper parts of these turrets do not survive and the arrangement of the turrets above wall-walk levels are conjectural but based on representations of towers on Trajan's column in Rome which dates from the same period.

Watercolour with body colour, 450 × 390mm, 1988

[J880257]

Gorhambury in Hertfordshire (1972–82) and the medieval palace of Kings
Langley (1974–6) and helped in the recording of the huge Woodchester mosaic,
the Great Pavement, in Gloucestershire (1973). All the while he was gaining
knowledge of archaeology, its methods and techniques.

 With a young family and needing more income, he painted in his spare
time, searching for images which would sell. It was David Neal who first
suggested he took his marine paintings, pictures of galleons in full sail, into the
galleries of Albemarle Street in the West End and two, the Parker Gallery and
the Omell Gallery, were impressed and took him on. He painted in watercolour
with body colour. His great love and an important influence on his art were the
English watercolourists of the 19th century – Thomas Girtin (1775–1802),
John Crome (1768–1821) and John Sell Cotman (1782–1842). He had an
extensive knowledge of paints and papers and the paraphernalia of painting,
the different brushes and colours and glazes. He was a skilful copyist and had
a sideline recreating paintings for clients when the original painting had been
sold. He was adept at staining the paper to age it and matching colours to the
appropriate date. He collected a huge library of books on ships and sailors,
bought a boat and became absorbed in the detail of sailing. The minutiae of
the rigging and tackle and canvas absorbed him and he relished drawing it
accurately, explaining visually the use and importance of each element (Fig 4.3).

Fig 4.3
Royal yacht *Alberta*, 1863

HMY *Alberta*, a 370-ton wooden
paddle steamer, was built in
1863 as a tender to the larger
royal yacht *Victoria and Albert
II*. She was used for voyages
across the Solent from Osborne
House on the Isle of Wight to
the south coast and after her
death in 1901 carried Queen
Victoria's body from Osborne to
the mainland. A marine painter,
Frank relished making this
drawing where his pen work and
attention to detail are displayed.
The yacht was broken up in
1913 and the illustration would
have been drawn from early
photographs of the yacht.

Pen and ink on board,
530 × 410mm, *c* 1987

[IC076/001]

Fig 4.4

The Old Baptist Chapel, Goodshaw, Lancashire, 1800

The Old Baptist Chapel was built in 1760 when this area of East Lancashire was a centre of religious dissent. It is one of the few nonconformist churches to have been studied archaeologically and the reconstructed interior is based on detailed research including an analysis of the original paints. This is one of a set of three pictures showing the development of the interior. It shows the interior with additions of 1800.

Watercolour, body colour, pen and ink, 560 × 380mm, c 1987

[IC045/002]

When David Neal left the drawing office in 1976 to be a full-time archaeologist, Frank Gardiner took over as head of the archaeological drawing office. Attitudes in archaeology towards reconstruction were softening. Terry Ball was already painting his architectural reconstructions for guidebooks and site graphics and with the creation of English Heritage in 1983 Frank was able to become more involved in reconstruction.

Frank, like Terry Ball, was a creature of the post-Sorrell era when archaeology turned away from populists such as Mortimer Wheeler, Glyn Daniel and Alan Sorrell to what was seen as a more scientific, objective approach. To paint in an objective, almost impersonal way came naturally to Frank. He loved constructing his pictures; he delighted in the geometry of perspective. He would explain how if you were challenged over the accuracy of your picture you could prove – by your perspective construction – that you were correct (Fig 4.4).

Archaeologists, not just illustrators, were nervous in those days of being found wrong. They feared that it would undermine them professionally, make them seem insubstantial, not serious. They were afraid of the power of an image and how it got into people's heads and stayed there, arguably becoming more influential than the written word. Frank was scrupulous in his pursuit of accuracy. When he went north to gather information for his reconstructions of the Roman bridges at Chesters in Northumberland and Willowford in Cumbria (Fig 4.5) he took his second-in-charge Jim Thorn, who stripped off at Chesters

and waded into the River Tyne to feel for the footings of the bridge which, under water, still survived. When drawing Orford Castle in Suffolk he was uneasy about the archaeological information he had been given, so he took his trowel to search for evidence. Visiting Osborne on the Isle of Wight with a group of Inspectors of Ancient Monuments and tasked to draw Queen Victoria's bathing machine, he was infuriated by their lack of interest in how the machinery actually worked. Medievalists, they had no knowledge or interest in the Victorian era and Frank went by himself to hack aside the undergrowth and search for the rails the machine ran on to reach the sea (Fig 4.6).

Fig 4.5 The Hadrianic Bridge, Willowford, Cumbria, AD 122

There were three bridges along the length of Hadrian's Wall. Little is known of the bridge which crossed the River Eden near Carlisle but there are still remains of Chesters bridge across the River Tyne and of the bridge pictured here at Willowford which crossed the River Irthing. The Hadrianic bridge at Willowford was built in the early 2nd century to carry the military road across the river. It crossed on low arches that sprang from the stone wall on the eastern side where traces of its abutment are still visible. Turrets defended the bridge at either end. Frank's reconstruction shows the turf wall – built of blocks of turf laid in courses – commencing at the west end of the bridge; it then ran for 31 miles westwards to Bowness-on-Solway in Cumbria.

Watercolour with body colour, 550 × 350mm, 1988

[C048/075]

Fig 4.6
Queen Victoria's
bathing machine, Osborne,
Isle of Wight, 1847

Prince Albert was a believer in
the benefits of sea bathing. In her
journal Queen Victoria recorded
her first experience of bathing on
July 1847: 'Drove down to the
beach with my maids and went
into the bathing machine where
I undressed and bathed in the
sea [for the first time in my life]
... I thought it delightful till I put
my head under the water when
I thought I should be stifled.'
After her death the bathing
machine was used as a chicken
shed. Frank's detailed drawing
enabled its reconstruction and
it can be seen at Osborne
House today.

Pen and ink on board,
540 × 680mm, 1986

[IC076/002]

One of his first reconstructions was of Furness Abbey in Cumbria. The
view chosen was from the window of the visitors' centre so that you could look
through the window at the ruins and then look at the picture of the reconstructed
abbey positioned beside you. David Honour, a colleague in the drawing office,
made a model of the building which Frank used as the basis for his picture.
It was a huge painting which created a lovely serene, mellow mood (Fig 4.7).
Jocelyn Stephens, the then Chairman of English Heritage, commandeered it for
his office. You might think that Frank would have been pleased at his success
but, alas, an expert in ancient woodlands criticised the depiction of the trees in
the picture. He claimed that the lower branches would have been cropped and
the canopy lifted. Although the trees were incidental as the abbey church was the
focus of the picture, Frank could not bear to think that there was an inaccuracy
in the painting and it was spoilt for him for ever.

His pictures are consciously designed with elements in the near, middle
and far distance precisely plotted. Colour and textures are calculated. His work
is orderly, precise, full of specific detail, mostly devoid of inhabitants. Careful
technique and a tendency to take a distant viewpoint are devices by which
he disengages and is a detached observer of the scene. A clear and concise
conception, no incidentals in the picture, everything is excluded which does not
support the chosen theme. Frank's intention, as when drawing an archaeological
find, was to make everything so clear-cut, so resolved, that the structures might
be physically reconstructed from his illustration (Fig 4.8).

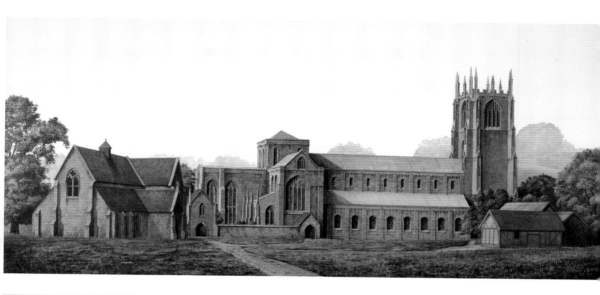

Fig 4.7
Furness Abbey, Barrow in Furness, Cumbria, 1500

Furness Abbey was founded in 1127 by Sauvigniac monks and in 1147 the abbey was absorbed into the Cistercian order. Its situation between the sea of Morecambe Bay, the marshes of South Cumbria and the Lakeland hills was isolated but Furness was wealthy and powerful with extensive lands and local deposits of iron. At the time of the dissolution it was the second richest Cistercian house in England. Most of the church dates from the second half of the 12th century, the belfry tower from about 1500 when much of the eastern end was rebuilt. Frank shows a south-facing view of the church looking at the north transept and crossing and on the left of the picture the abbey guesthouse.

Watercolour, 660 × 800mm, 1986–90

[J900267]

While the research and accuracy which went into the pictures was greatly valued by the archaeologists in the department, by the 1990s there was a drive to encompass the general public in the appreciation of the monuments and a more populist, less scholarly approach was required. To Frank's fury the intellectual work that he put into his pictures was sometimes stolen – as he saw it – his pictures embellished with figures and incidentals to make them more appealing and used in site graphics and guidebooks under another artist's name.

There are different sorts of illustrations and illustrators. Frank is a technical illustrator. His pictures based on archaeological evidence are an exercise of interpretation of the evidence, aimed at a specialist audience. Archaeological excavation often gives good material for building and settlement layouts but rarely for day-to-day events where little in the way of physical traces remain and it was against Frank's nature to make things up just to engage. What he is interested in is how things work, how they are made, how things are put together. Structures are pristine, unlived in, un-aged. Nothing happens in the pictures, the rooms and streets are empty, no one on the scene, no one there to see it even. What comes across in the paintings but not so much in reproduction is an almost surrealistic quality. Each brick or stone meticulously reproduced, every grain of wood defined, a perfect undisturbed world. They are illustrations of how to make a Roman turret or Victorian bathing machine; how they were used or lived in he leaves to others to explain.

Frank took early retirement from English Heritage in 1993 to work full time painting marine pictures. He lives close to the sea, which is his inspiration, at Walton-on-the-Naze in Essex.

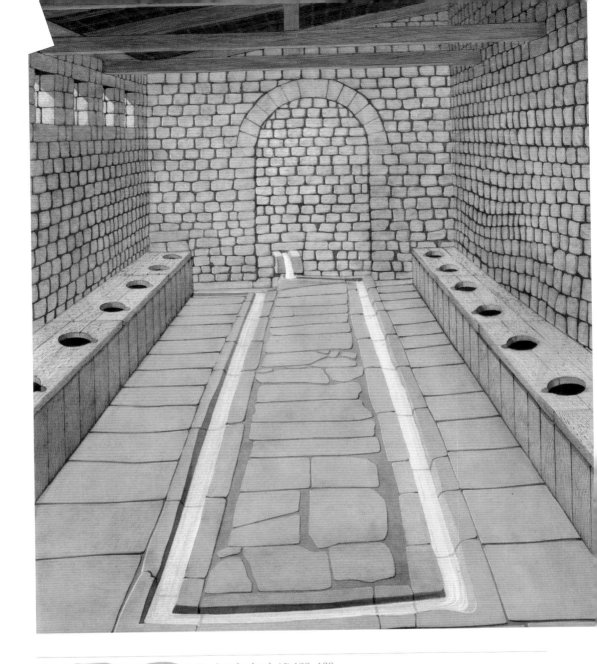

Fig 4.8 Latrines, Housesteads Fort, Northumberland, AD 122–138

This is a highly technical reconstruction of the latrines at Housesteads Fort. You can be sure that every surviving stone in situ will be recorded in the picture. Where Frank draws a wobble in the wall courses that is because that is how it actually is. Every stone is painted with a little edging of white where it catches the light and every individual stone has its shadow. The grain of the wooden seats is similarly exactly shown. The sewer for the latrines flowed in an anticlockwise direction from the top left corner. This system could only have worked when it rained for no aqueduct is known at this hilltop site but water was collected in stone tanks for a periodical flushing of the latrines. The sponge channel, which shows in the picture, flowed in the opposite direction. This water channel was for washing sponges used instead of lavatory paper.

Watercolour with body colour, 390 × 570mm, 1987

[IC048/045]

Fig 4.9 Hadleigh Castle, Essex, 1370

Hadleigh Castle was expanded and remodelled by Edward III who turned it into a grander property, designed to defend against French attacks. The picture shows Hadleigh as it may have appeared after the alterations, viewed from the north with the marshes fringing the Thames estuary in the background – the tide would have reached up as far as the base of the hill. On the east side of the castle the large circular towers are new, replacing rectangular ones, and there is a new entrance on the north side protected by an elongated barbican and beside it a high tower. In the foreground is the park pale – the fence which surrounded the deer park attached to the castle.

Watercolour with body colour, 510 × 380mm, 1991

[© Essex County Council]

Fig 4.10 Cawfields Milecastle, Hadrian's Wall, Northumberland 122–30 AD

There are three different designs of milecastles on Hadrian's Wall, probably the product of individual legions' building techniques. Cawfields, with its square interior and slightly thicker walls, was built by the 2nd legion. Frank has shown the milecastle tower as two storeys high but it could have been taller. No traces of internal buildings were recorded; those shown in the picture are conjectural. This is a good example of Frank's meticulous draughtsmanship. His drawing of the stonework has its own style and interest but it also emphasises the skill of the Roman builders and gives an impression of the Roman sense of order, control and discipline.

Pen and ink, 360 × 230mm, 1988

[IC048/100]

Fig 4.11 Temple of Antenociticus, Benwell Roman Fort, Hadrian's Wall, Northumberland

Built around AD 178 to AD 180, the small temple to the native god Antenociticus was discovered in 1862 in the vicus, the civilian settlement, outside Benwell Fort on Hadrian's Wall. Antenociticus was worshipped as an intercessionist and inspiration in military affairs. Elements of a life-sized statue – a sculpted head with a torc around its neck, parts of a lower leg and forearm – were discovered as well as two altars dedicated to the god. Frank shows the altars and statue in his uncanny, mysterious picture, the colour and texture built up by layers of spray paint making a soft, subtle atmosphere and light.

Watercolour, 570 × 390mm, 1990

[J900496]

5 | Ivan Lapper

Ivan Lapper's work came to the forefront during a period when there was a drive to make historic sites more commercially friendly and to raise visitor numbers to the monuments. Ivan Lapper's style of illustration suited this new, more outgoing regime. Although there was opposition from some quarters who mistrusted imaginative interpretations, his vivid, atmospheric reconstructions of the sites fitted the climate of the time.

Ivan Lapper was born in 1939 in Bilston in Staffordshire. His father was a builder but as a young man he had had ideas of being a fashion illustrator. In those days this was a most unlikely job for a person from his background but the idea of a career in art must have stayed with him, created a sympathetic background and influenced his son. So much so that when Ivan was 12 years old and attending – as he describes it – 'a very rough secondary school', he took himself to the Bilston School of Art and arranged leave from school to attend classes there one day a week. Boys at his school were expected to go into the local steelworking industry at the age of 15 and in preparation for this they spent a day a week away from lessons in the steelworks. Ivan's self-arranged departure to the art school was not appreciated by his teachers, who saw him 'as getting above himself', thinking himself superior to the other boys, and took it out on him in frequent canings.

Just before his 15th birthday he left the hated school and went to study at Wolverhampton School of Art. He specialised in illustration but the course was wide and varied and his studies covered a whole range of activities – anatomy, painting, lettering, typography, perspective, printmaking, pottery and modelling. He graduated with a Diploma of Art in illustration and in 1959 he applied to enter the Royal College of Art. After a week of interviews and examinations he was accepted into the engraving school.

Looking back he sees his time at the Royal College, 1959–62, as a golden time. There was a particularly rich vein of talented students among his contemporaries – David Hockney, Peter Blake, Ridley Scott, Alan Jones, Anthony Green, Tom Philips and David Gentleman were all students at the same time as he was. What was most important to him, what he enjoyed most as a student, was drawing from life. As well as drawing in the studio he drew in the London docks, in the streets and at the London stations. His sketchbooks were full of pictures of crowds, movement and activity and these elements remained fundamental to his work. Ivan sees good draughtsmanship as the basis of his art.

Ivan was 23 when he graduated from the Royal College and since then his whole working life, over 50 years, has been spent as a freelance illustrator. In addition, he has lectured a day a week in various colleges – Hornsey, St Martins, Camberwell, the Ruskin School and Kingston University to name just a few. His work has covered almost every field of illustration – books, magazines, newspapers, *Reader's Digest*, site graphics and museums. He drew the first moon landing and the Aberfan disaster for the *Daily Express* newspaper and the Great Train Robbery for *The Illustrated London News*. He contributed

Fig 5.1
Upper gun deck (detail), Pendennis Castle, Cornwall, 1540s

Pendennis Castle was one of a chain of fortifications built by Henry VIII between 1539 and 1545 along the south coast of England to protect the more important anchorages from use by enemy fleets. Although called castles they are really artillery forts and were designed to pack the maximum fire power into the smallest space. The upper gun deck is shown as it might have appeared in the late 1540s when local men – farmers and labourers – were mustered to practice using the castle guns in case of attack. Evidence for the picture comes from a gun inventory of 1547 and finds from the *Mary Rose* – Henry VIII's flag ship which sank in the Solent in 1545.

Watercolour, body colour, pencil, and crayon, 870 × 690mm, 1990s

[IC077/005]

many illustrations to the *Radio Times* magazine of the 1970s. In the heritage world he has worked for Cadw, the National Trust and Historic Royal Palaces. He first worked for the education department of English Heritage, then more work followed for site interpretation and guidebooks.

He would visit each site that he was going to illustrate accompanied by the interpretation designer and possibly by an archaeologist and the site inspector. On site he would sketch, take photographs and notes. He would have copies of the site archive, the plans and sections and old photographs. He would select the best viewpoint for his picture and then he would usually build a simple scale model of the site showing the structures and topography (Fig 5.2). Terry Ball was another reconstruction artist who made models to base his pictures on but Terry's were used as a method of primary research, a way of throwing up ideas and possibilities of architectural reconstruction. Ivan Lapper's models were part of his artistic reconstruction of the site – a means to understand the topography and select the best viewpoint. Sometimes, though, by this 3D method of reconstruction mistakes in earlier reconstructions of the monument would be discovered. Once the basic structures were agreed upon by the experts, he would photograph the model and would use this as the basis to draw his picture (Fig 5.3). He developed his drawing by adding figures, furnishings and objects, trees and vegetation, animals, and activities. He aimed to create an accurate reconstruction of the site but one with atmosphere – not just a purely architectural interpretation. He wanted to show how people had lived. Friends and family would pose for the characters in his pictures or sometimes he would draw from photographs or just from his imagination.

Ivan was popular with the site interpretation managers for his speed of work and reliability as well as for the vivacity of his paintings (Fig 5.4). He might arrive in the office with an illustration and be asked to change something. He could do this on the spot, cutting out, pasting, scraping, and redrawing. His pictures can be a problem to conserve as they are composed of so many materials. Writing of this time when English Heritage was a new organisation and Ivan a favoured artist, John Clarke the interpretation manager tells how the interpretation department's aim was to explain how the buildings were lived in. This was a new direction because previously the focus had been on the architecture, to show how the monuments were built. Now they wanted to show activity, how the rooms were used and that they were not always clean and tidy – Ivan was good at making spaces look lived in. It is hard to paint a mess for the mess is inclined to revert to some sort of order. Reconstructions often look very clean and tidy because the default mode of the human mind is pattern making. The interpretation managers liked to select different artists for different projects. They might use Terry Ball to paint the elaborate, delicate carved stonework of a monastic cloister but for a frenzied battle scene Ivan Lapper would be the choice (Fig 5.5). There could be input from many experts into a reconstruction of the sites but the direction had passed from the Inspectors of Ancient Monuments to the interpretation managers as to the overall presentation of the sites.

Fig 5.2
Model of Kidwelly Castle, Carmarthenshire, Wales, early 15th century

Ivan's simple model of Kidwelly Castle and town enabled him to plan his illustration, working out positions, angles, heights and the topography of the scene. He would photograph the model when all had been agreed with the experts and use the photo as a basis for his illustration.

Paper and card construction, size unknown, 2001

[© Ivan Lapper]

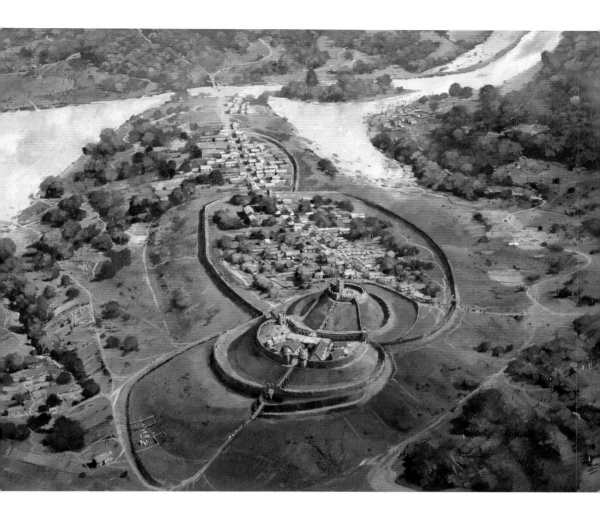

Fig 5.3 Aerial view, Totnes Castle, Devon, 12th century

You can look down from the battlements of Totnes Castle to the town below, which still retains a pattern laid out a thousand years before. Ivan's picture has stripped away later medieval and modern developments to show the town as it was in the 12th century. You can see that the castle in the foreground and the riverside suburbs in the background have been added to a fortified town established long before the Norman Conquest. The castle stands on a hill commanding the head of the River Dart; the Normans built their stronghold here to overawe the townspeople. The Saxon town most likely once extended over the whole area but was cleared when the huge earth mound (the motte) on which the keep stands, was constructed. The bailey, the enclosure by the motte, contains most of the castle's habitable buildings and is protected by a moat.

Gouache, crayon, pen, pencil, 1020 × 730mm, c 1991

[IC101/004]

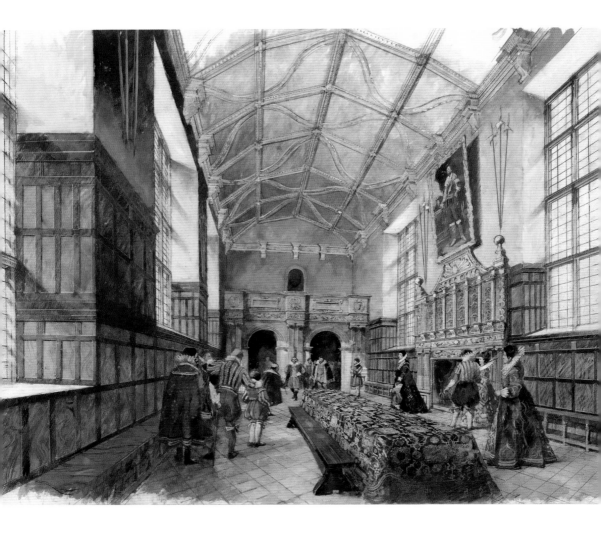

Fig 5.4 Kirby Hall, Northamptonshire, 1619

Building work began at Kirby Hall in 1570. It was one of many great Elizabethan houses built in the hope of receiving the Queen on her annual progress around the country. Although smaller than some of the other great houses, its richly carved decoration is exceptional and shows the arrival in England of new ideas in architecture and design. This scene shows the hall as it might have appeared when an inventory was taken in 1619. The hall has been greatly changed but the fine decorated ceiling Ivan Lapper shows still exists.

Gouache, pencil, pen, 1120 × 610mm, c 1988–93

[IC054/005]

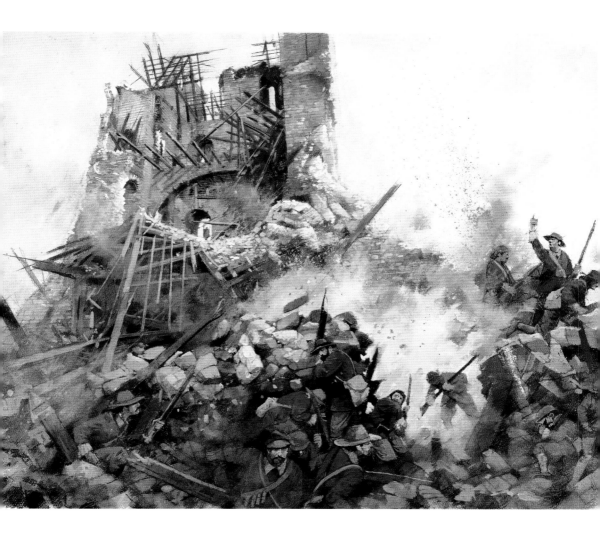

Fig 5.5 Scarborough Castle, North Yorkshire, 1645

Ivan has depicted the scene of destruction after Thomas Fairfax, general of the Parliamentary army, laid siege to Scarborough Castle on 18 February 1645. Scarborough was an important Royalist base, a harbour to receive supplies from the Continent and allow their passage to Charles I's principal army in the north at York. The bombardment was so intense that within three days the massive walls of the keep sheared and half of the building collapsed. Commander of the castle Sir Hugh Cholmley wrote, 'the fall of the tower was a very terrible spectacle, and more sudden than expected ... There were near twenty persons on top of the tower when it cleft, yet all got into the standing part except two.'

Gouache, pencil, pen and ink, 570 × 760mm, c 1990

J000085]

Ivan Lapper is a brilliant illustrator. If you stand on the same spot that he painted his picture from, it is easy to believe that the scene he shows is directly before you. You are almost a part of it. Each picture is like a snapshot, a moment in time which in a second will turn and change. A Stonehenge chieftain interrogates his surveyor as the huge sarsen stones are moved into position (*see* Fig 5.12); the 'honourable' surrender is accepted at Pendennis Castle by a grim commandant (*see* Fig 5.7); in the medieval kitchen of Kenilworth Castle a cook tastes a dish (Fig 5.6); people throng the marketplace of Roman Letocetum and as you the onlooker, stand there in the middle of the street watching, you believe that the crowd will part, weave around you and pass on by (*see* Fig 5.8).

His pictures are naturalistic. The people behave like you and me. Sometimes they lean out of the picture plane, increasing the feeling of movement, involving the onlooker, drawing them into the action. The illustrations are dramatic and cinematographic and the atmosphere is always optimistic. One remark often made of the artist Alan Sorrell's work was that he made the past look ominous, threatening and bleak. Ivan Lapper is different – mostly the sun shines and the sky is blue. Looked at abstractly the surface of the picture is patterned with small broken shapes and marks, lines and spatters of paint, the paper buzzing with activity, all contributing to the overall impression of urgency and life.

Latterly Ivan moved from London to live in the Isle of Wight. But this was not a retirement, he continues to paint and draw, exhibiting and selling his landscapes and figurative work. He is an Associate of the Royal College of Art and a member of the Royal Society of Marine Artists.

Fig 5.6 Kitchen, Kenilworth Castle, Warwickshire, 1575

A feast is being prepared for the imminent arrival of Queen Elizabeth I. The Elizabethan court resembled a large-scale touring company that annually wound its way through the royal palaces and great houses of England. A train of several hundred wagons set off from house to house transporting all that was needed for the queen and retainers. The queen was entertained at Kenilworth Castle for 19 days in July 1575 at enormous expense. The size of the queen's entourage meant that all the resources her host could command had to be pressed into service. Food was a major form of display and lords ordered their kitchen staff to devise new recipes and wondrous confections to impress their guests.

Gouache, pencil, 730 × 510mm, 1986

[IC053/015]

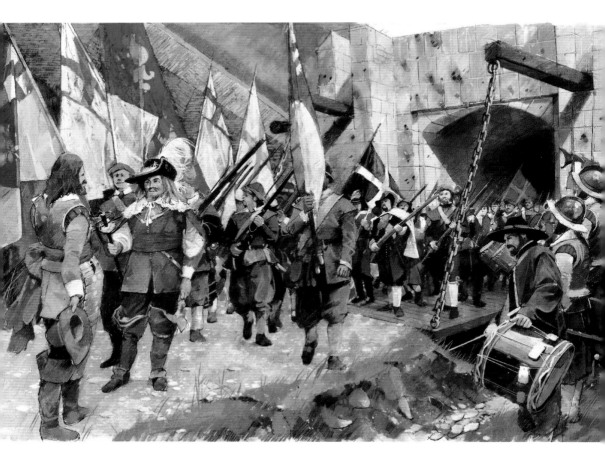

Fig 5.7 Honourable surrender of Royalist troops, Pendennis Castle, Cornwall, 17 August 1646

From 12 March 1646 Pendennis Castle was held under siege by Thomas Fairfax, commander of the Parliamentarian forces. On 17 August an honourable surrender was agreed and the garrison marched out 'with flying Colours, Trumpets sounding, Drums beating, Matches lighted at both Ends, Bullets in their Mouths and every Soldier Twelve charges of Powder ... all their own proper Goods, Bags and Baggage, with a safe Convoy unto Arwinch Downs' (Rushworth Private Passages of State, vol 6, 1645–7: John Rushworth was secretary to Thomas Fairfax 1645–50).

Gouache, pencil, 840 × 560mm, c 1995–2000

[IC077/008]

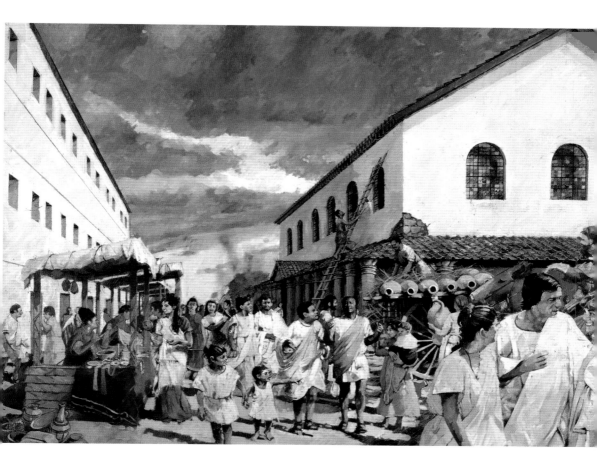

Fig 5.8 Marketplace, Letocetum at Wall, Staffordshire, 2nd century

Ivan's picture of the marketplace in the Roman town of Letocetum shows a flourishing, busy town where local farmers would have brought their produce, imperial administrators could have assessed and gathered taxes and travellers stayed overnight. Letocetum was an industrial centre producing pottery and metalwork to be sold at local markets. The town's position near major crossroads would have contributed to its success as a trading centre for the rural population.

Acrylic, biro, pencil, felt-tipped pen, 510 × 730mm, c 1990–4

[J970017]

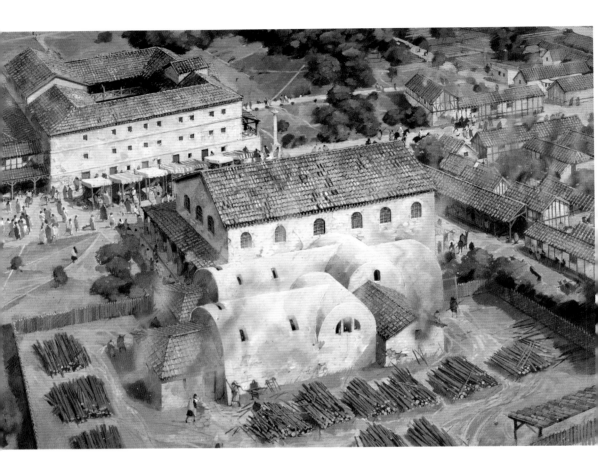

Fig 5.9 Bath complex and lodging house, Letocetum at Wall, Staffordshire, 2nd century

Letocetum was a staging post on Watling Street – the Roman military road to North Wales. Official travellers and postal couriers would change horses there and stay overnight. The settlement started as a fort but the picture shows the most important buildings in the early civilian years of the town – the baths and exercise hall and the guesthouse beyond. The huge piles of logs in the yard by the bathhouse give some idea of the quantities of fuel needed to ensure that hot baths were available on demand. The baths building would have dominated the surroundings, giving off clouds of steam in winter and in summer shimmering with heat.

Gouache, pencil, 730 × 510mm, c 1990–4

[J970060]

Ivan Lapper

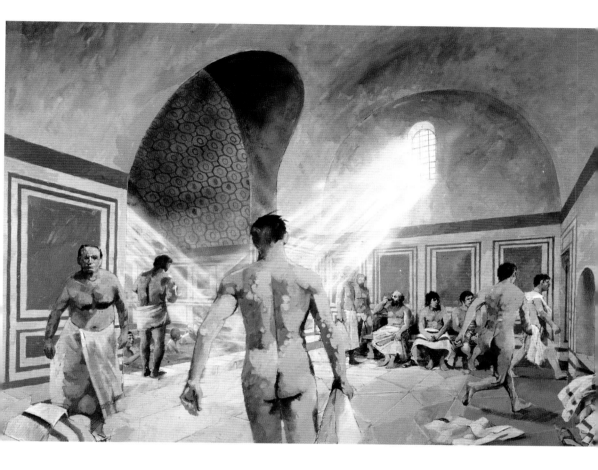

Fig 5.10 Men's changing room and small baths, Letocetum at Wall, Staffordshire, 2nd century

'I live above a public bath. I can hear all sorts of irritating noises. There are groans when the muscle men are exercising with their weights. Some unfit men just have a massage and I hear the slap of hands beating their bodies. Ball players come along and shout out the score in their matches. Drunks have arguments, thieves shout when they are caught. Some men sing in the baths. People dive into the pool with a great splash. There are shouts from those selling drinks and snacks' (Seneca the Younger, Letters 56.1–2, 1st century AD).

Acrylic, pencil, white wash, 730 × 510mm, c 1990–4

[J970064]

91

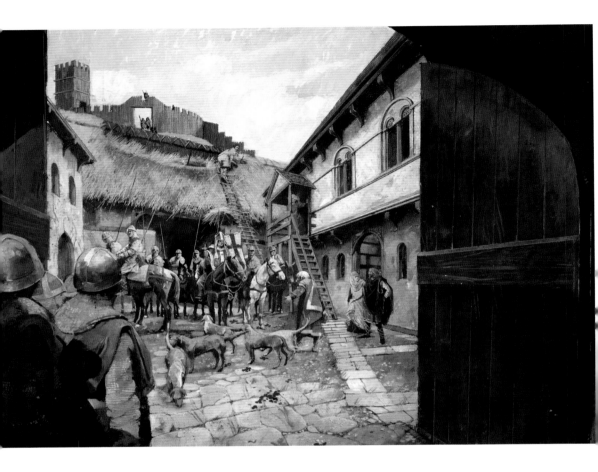

Fig 5.11 View of the courtyard, Totnes Castle, Devon, 1100

Totnes Castle, a motte-and-bailey castle built by the Normans, is situated on a hill overlooking the town of Totnes. Ivan Lapper's picture shows the courtyard, the bailey, crammed with buildings. The lord would have lived in a first-floor chamber and there would have been a chapel. At the back of the picture you can see the motte with a wooden tower surrounded by a timber palisade.

Gouache, 680 × 1000mm, c 1991

[IC101/002]

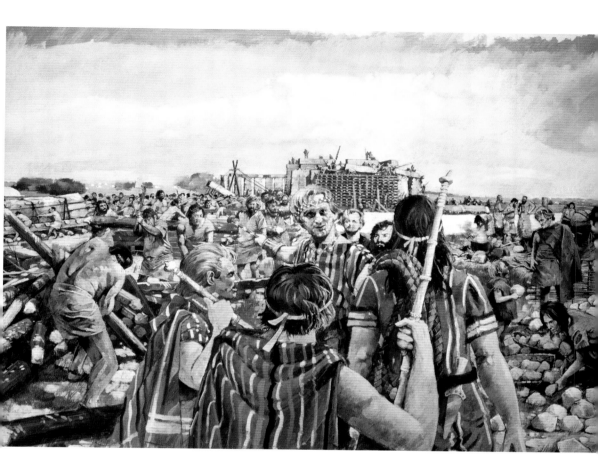

Fig 5.12 Erection of the sarsens, Stonehenge, Wiltshire, c 2300 BC

In the foreground of this reconstruction picture the surveyors receive instructions. In the background a stone is pulled on a sledge over rollers. Other stones are being hauled upright or capped by lintels. Finds from the Bush Barrow, a nearby burial mound, have been used to draw the copper dagger tucked into the man's belt, the zigzag bone mounting on the mace held by the chief figure and the gold ornament on his headband. This was a new sort of picture for English Heritage as previously reconstructions had been architectural, often an aerial view disengaging the viewer from the subject. This picture is not so much about the structure of Stonehenge as about the people who built it. As a viewer you are in the action, you can read expressions, study the dress. This raises all sorts of questions previously avoided such as hierarchy, age, gender, of which we can only guess the answers.

Gouache, pencil, 1120 × 740mm, c 1990

J920370]

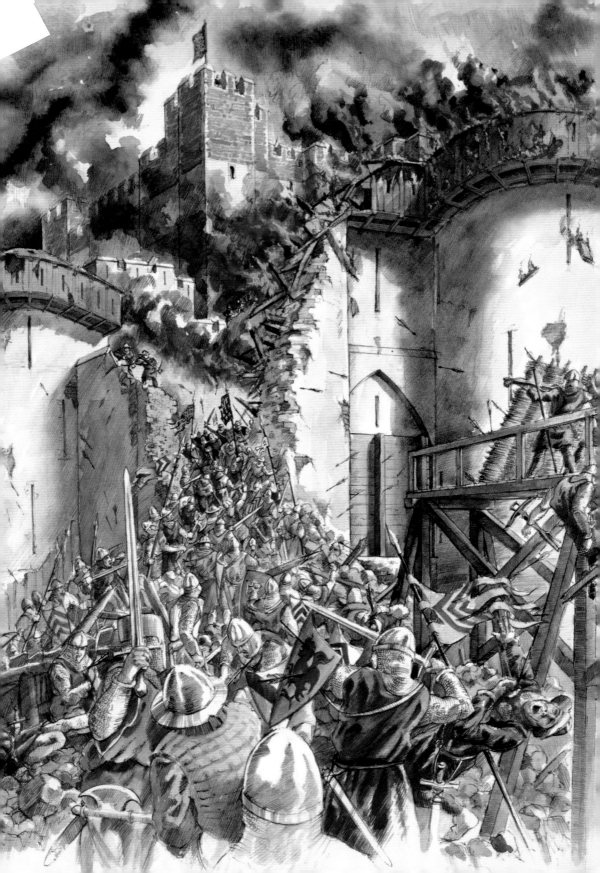

6 | Peter Dunn

Peter is a Midlander from Stoke-on-Trent in Staffordshire. He comes from a family of coal miners, potters and artists. Both his grandfather and great-grandfather were highly skilled artists/designers decorating ceramics in the late 19th and early 20th century, working for Grimshaws, the firm which eventually became Royal Minton. Despite his family connection to the great pottery industry of Stoke, Peter says that there was little interest in art in his family when he was a child but what enthralled him, encouraged by weekly visits to the library with his father, were tales of the Greek heroes, the Trojan Wars, of King Arthur and Camelot. Films such as *Jason and the Argonauts*, *Anthony and Cleopatra* and *Ben Hur* thrilled him and he thinks that memories of these epic films, with their dramatic scenes of crowds and battles, influenced the way that years later he painted his visions of prehistoric gatherings at Stonehenge, Durrington Walls and Bush Barrow, and battles such as the siege of Dover Castle (Figs 6.1 and 6.2) and the Battle of Hastings (Fig 6.3).

At art school at North Staffordshire Polytechnic he studied illustration and intended to make a career drawing covers for science-fiction books. A science-fiction enthusiast, he was influenced imaginatively by the writings of Tolkien, Michael Moorcock and especially Mervin Peake, both by his writing and by his Gothic horror paintings and drawings. After leaving college in 1977 Peter worked as an illustrator/designer in Stoke and in the Yorkshire Dales and as a country park warden in Pembrokeshire. Landscape is important to him and he kept a daily sketchbook recording the countryside he lived and worked in.

He joined English Heritage in 1985 as an archaeological illustrator and was one of a group of nine working on publication illustrations for excavation reports. The work was mostly pen-and-ink drawing of finds and of trench plans and sections. He found it hard to do. Drawing finds with a fine-nibbed dip pen requires a lot of patience and a steady hand. Peter was impatient and his hand shook. The tension he felt as he tried to draw an even pen line gave him an ache in his neck which, he says, has never left him. But although he did not enjoy this accurate, exacting way of drawing, he admits that the time spent producing illustrations of finds, plans and sections and architectural detail was invaluable in creating a background knowledge and understanding for the reconstruction paintings he later produced (Fig 6.4).

Initially the only reconstructions painted in the archaeological drawing office were by the head of the office, Frank Gardiner. The reconstructions used in guidebooks and for site graphics were painted by Terry Ball, who worked in a different department. But attitudes to illustration in archaeology were changing, archaeologists were beginning to realise that a picture could be a powerful force to explain your findings and engage others. Peter was eager to do this sort of illustration and would suggest images to the archaeologists he worked with. He wanted to paint illustrations with atmosphere, landscape, people and action, to bring to life the archaeological sites he had been working on. He wanted to communicate the findings to a wider audience. Sometimes his

Fig 6.1
Siege of Dover Castle, Kent, 1216–17

Peter painted a series of six pictures of the civil war between King John and the barons. This picture shows the partial collapse of the north barbican under the bombardment of Prince Louis of France. The King of France had sent his son and a large force to support the barons against King John. All aspects of siege warfare were employed against Dover Castle, siege engines, mining, even bribery, and all ultimately failed. The French did capture the barbican and undermine the gatehouse but the English defenders rebuilt their barricades and beat the French back.

Watercolour, pencil, gouache, pen and ink, 540 × 710mm, 1995–2006

J020152]

suggestions of images were taken up, and gradually he did more of this type of work and became more confident in his ability to portray the past.

When Stephen Johnston, then Head of Publications at English Heritage, initiated a series of books with the publishers Batsford there was an opportunity for all of the illustrators of the archaeological drawing office to extend their range. Authors were commissioned to write of a particular site or theme or place and the books were aimed at an informed but general readership. There was a small amount of money for illustration or copyright fees and in addition the authors could use the work of the archaeological drawing office illustrators and many did. Peter worked on one of the first books, *Bronze Age Britain* (1993) with the archaeologist Mike Parker-Pearson, then in his first job after university as an Assistant Inspector of Ancient Monuments. This was the start of a long association, over 25 years, working with Mike Parker-Pearson reconstructing some of the best-known sites of prehistory – Durrington Walls, Stonehenge, Woodhenge and Bush Barrow.

Peter does not see himself as simply a conduit for the ideas of others but as a partner in the exposition of a site. Scrutiny of reference material such as maps, site records, artefacts and photographs means that the artist sometimes notices things others have missed. His familiarity with the phase plans of Stonehenge, the constant overlaying of plans of stones and postholes, has led him to new ideas about the first monument. The geometry and astrometry of the site intrigue him and his command of the detail of the many excavations

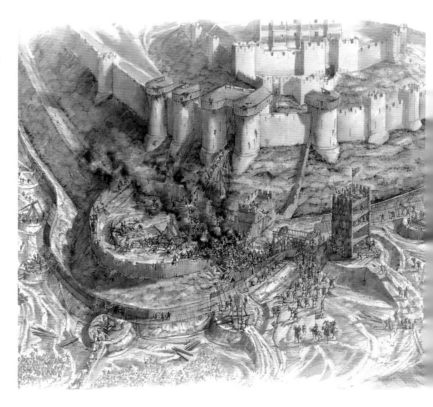

Fig 6.2 Siege of Dover Castle, Kent, 1216–17

This is a scene of the Great Siege in the civil war between King John and the barons and shows the French force that supported the barons assaulting the old north gate of the castle. Prince Louis, son of the King of France, established his main siege camp on the higher ground north of the castle. From here the great stone-throwing engines, seen in the forefront of the picture, bombarded the walls while miners tunnelled underneath the northern barbican. Only when the barbican partly collapsed did the garrison cease their attacks and withdraw behind the north gateway.

Watercolour, pencil, 690 × 530mm, *c* 1995

[IC032/036]

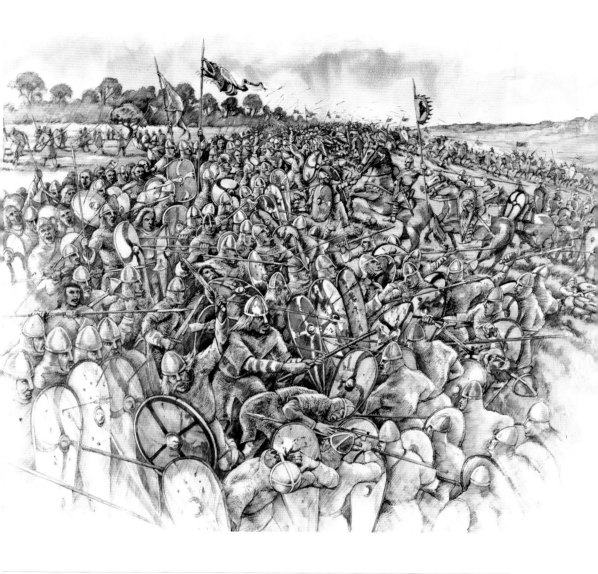

Fig 6.3 Battle of Hastings, Kent, 1066

Peter's picture, which is one of a series, shows the first Norman attack on the English defensive wall of shields. Harold's army formed a dense line anything from three to twelve men deep, stretching about 800yd (732m) along a ridge. The battle began early in the morning when William ordered his archers forward to fire at the line. The archers were followed by his infantry and then the cavalry. The fighting was fierce but the attack failed. The English exploited their defensive position and their axe men and javelin throwers inflicted heavy losses. Most battle scenes show an overview, the grand design; this picture shows the battle from the troops' point of view as a wildly unstable melee. The image is largely frameless and fades at the edges from full colour to monochrome. This emphasises the impression that you are seeing just a section of the battle – an extract of the panorama which extends off picture.

Pencil drawing copied onto art paper, pen and ink, crayon and watercolour, 580 × 740mm, 1990–99

[J000015]

Fig 6.4

Roman Fort of Segedunum, Wallsend, Northumberland, 3rd century

The fort was almost entirely excavated from 1975 to 1984 and no other fort on the wall has such a complete plan. By the 3rd century a standard pattern for Roman forts had developed and Segedunum conforms to this. It held a strategic position on the north bank of the River Tyne at the east end of Hadrian's Wall.

Watercolour, gouache, pen and ink, 560 × 755mm, 1966

[J960244]

and of the surrounding landscape has enabled him to persuade the experts of his ideas (Fig 6.5). Peter lives in the Vale of Pewsey in Wiltshire close to the great prehistoric monuments of Salisbury Plain which he walks with his dogs. His love and knowledge of the countryside show in his reconstruction paintings.

His first reconstructions were painted in watercolour but gradually his technique has changed, his paint becoming more opaque, using gouache and mixed media such as crayon, biro or pencil. He was influenced by the work of his colleague, Terry Ball, admiring his free economical style full of atmosphere and light, and also by Ivan Lapper, the freelance illustrator who worked for many years producing illustrations for guidebooks and site graphics. In his work Peter has tried to combine the lively, atmospheric feeling of Ivan Lapper's pictures with Terry Ball's scholarship and accuracy and his restrained, deceptively simple style of painting. Peter's paintings are direct and assured, full of energy and restlessness. He uses long, sweeping brushstrokes to give movement to his compositions. They are cinematographic and dramatic, the atmosphere he creates more akin to the feeling of foreboding of an Alan Sorrell picture than the sunny aspect of Ivan Lapper's reconstructions.

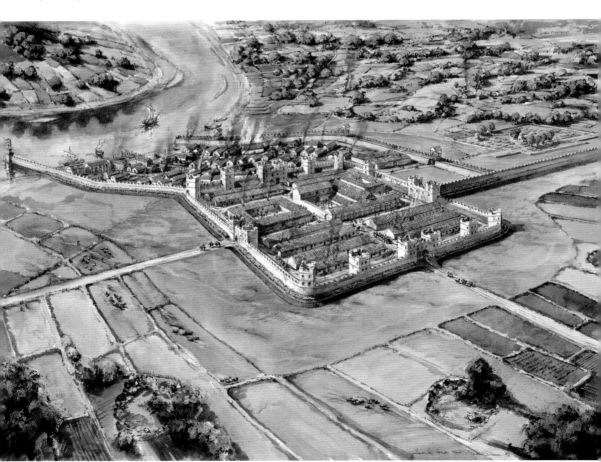

Fig 6.5 Midwinter sunset, Stonehenge, Wiltshire c 2500 BC

Peter shows Stonehenge in its final stage with the site dominated by megaliths – the massive local sarsens and the smaller Welsh bluestones. Peter worked on reconstructions of Stonehenge and its landscape over many years and it was this close study and familiarity with the archaeological records that enabled him to make connections others had not recognised. He realised that the most central circle of stone holes had the same diameter as the circle of bluestones from nearby West Amesbury. Their dimensions fitted the arc of the circle at Stonehenge perfectly. Perhaps, he reasoned, the bluestones from West Amesbury had been removed to Stonehenge and rebuilt in a replica setting. This is what the reconstruction shows, the West Amesbury stones rebuilt, perhaps enclosing the symbolic place where earlier solar and lunar alignments were focused. Painting landscape in snow puts an unfamiliar mask on well-known things. It has made the ridges, banks and ditches clearer and more orderly and focused our attention on the dynamic centre of the composition.

Watercolour, body colour, 1010 × 670mm, 2005

© Peter Dunn]

Fig 6.6
St Cuthbert's
Hermitage, Inner Farne,
Northumberland, AD 686

Peter's reconstruction picture
is based on the writings of the
Venerable Bede. Cuthbert was 40
years old when he was called to
be a hermit fighting the spiritual
forces of evil by a life of solitude.
He built a hermitage, a circular
enclosure of turf and stone with
a hut and oratory but was not
always alone as people came
in little boats to consult him
or ask for healing and at the
landing place a larger house was
built where brethren from the
monastery at Lindisfarne could
stay. He died in the hermitage on
20 March AD 687.

Watercolour on board, body
colour, crayon, pen and ink,
760 × 510mm, 1988

[IC059/003]

Peter's flair for painting landscape singles him out. One of the first archaeological pictures he painted and the one he likes the best was of St Cuthbert's Hermitage on the Inner Farne Island off the Northumberland coast (Fig 6.6). Most reconstructions would start by study of the archaeological evidence but in this case even the location of the Hermitage is uncertain and Peter's picture is based on the writings of the Venerable Bede. Bede, a monk living in 7th–8th-century Northumbria, tells of St Cuthbert's life as a hermit a century before. Gathering material for his picture, Peter journeyed from Lindisfarne to the Inner Farne Islands, his boat surrounded by seals and seabirds. He roamed the island to match Bede's descriptions to the landscape he saw, to piece together the likely places for the scenes Bede told of – the boat landing place, the site of the guesthouse whose thatch was stolen by ravens, Cuthbert's dwelling place and his chapel which, Bede recounts, the angels helped him build. Peter's painting is an aerial view of the island. From overhead the layout of Cuthbert's world is clearly mapped out for the viewer. The rough seas encircling the island show his isolation, the bank and ditch around his house and oratory increase the feeling of solitude. You can see by the tracks in the painting how Cuthbert lived his life, the path that leads to his chapel and the boat landing place, and another to the fields he cultivated with wheat and barley. You feel the airy, happy atmosphere of the picture and you guess it reflects Peter's experience of his time there.

Peter left English Heritage in 2008 to work as a freelance reconstruction artist. Back in 1992 almost the first reconstructions he made were for Mike Parker-Pearson's book *Bronze Age Britain* and this collaboration continues as his most recent work illustrates the results of Mike Parker-Pearson's (now Professor of British Later Prehistory at University College London, Institute of Archaeology) excavations for the Stonehenge Riverside Project.

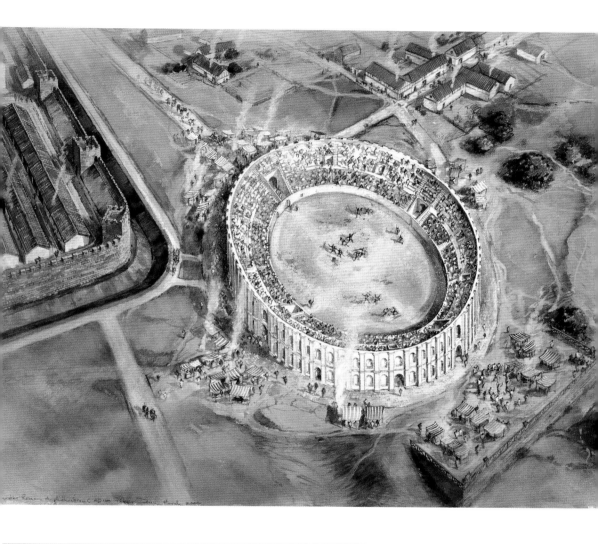

Fig 6.7 Chester Roman Amphitheatre, Cheshire, c AD 190

The amphitheatre dominates the south-east corner of the Roman fortress at Chester – the home base of the 20th legion. Amphitheatres were the grandest and most important type of Roman building and Chester amphitheatre was one of the largest in Britain. It was as much a political statement as a practical building. The most likely thing is that a reconstruction will be wrong, but how wrong? Archaeological reconstructions are constantly revised as new evidence is found or ideas change. Peter's picture was painted before the excavations of 2000 to 2006 and the results from these excavations have contributed to a new digital drawing, every element of which the archaeologists believe can be justified (see Fig 6.8). There were two successive amphitheatres on the site, an early wooden structure and a second larger version which both pictures illustrate. The digital drawing shows a plainer structure, half the height, with fewer pilasters and lacking the blind arcading of Peter's version. In his painting Peter supposed little stalls selling snack food. Evidence for stalls selling beef ribs and chicken was in fact found on the excavation but relating to the first amphitheatre, so was not included in the digital drawing, although you would have expected them to exist.

Watercolour, pen and ink, 540 × 750mm, 2004

J040018]

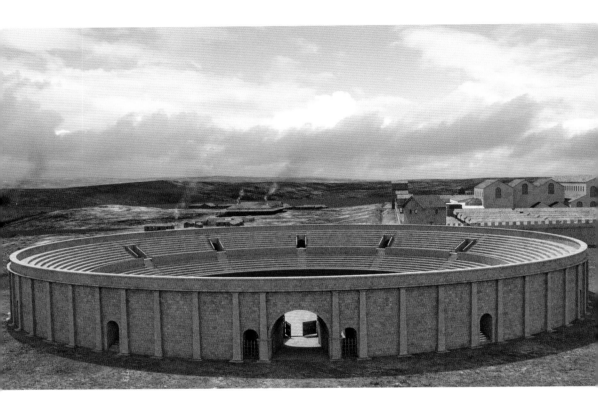

Fig 6.8 Chester Roman Amphitheatre from the east, Cheshire, early 3rd century

Julian Baum's drawing of the amphitheatre is based on evidence from the excavations of 2000 to 2006. Archaeological reconstructions are continually revised and you can see how it differs from Peter Dunn's picture based on earlier excavations and other amphitheatres (*see* Fig 6.7).

Digital drawing, 172 × 96.8mm, 2017

Fig 6.9 Old Sarum, Wiltshire, AD 200

Old Sarum was originally an Iron Age hill fort on the ridge which separates the Rivers Avon and Bourne. It is defined by an outer rampart. In Roman times the hill fort was occupied continuously from the conquest in AD 43 to the early 4th century. It has been suggested that there could have been a fort inside the earthworks in early Roman times and as the locality became settled, the fort not being required, the site was used for a temple. Three Roman roads, from Winchester, London and Cirencester, converge outside the east gate of the hill fort and beyond the ramparts are two Romano-British settlements. One settlement close to the east entrance of the hill fort was established as early as the 1st century, expanding and flourishing during the 4th century. The second settlement was a substantial roadside development extending from the hill fort to the crossing of the River Avon.

Watercolour, pencil, pen and ink, 580 × 510mm, 2003

[030094]

Fig 6.10 View of the nave, Rievaulx Abbey, Yorkshire, 13th century.

Rievaulx was founded in 1132, the first Cistercian Abbey in the north of England. Most of the surviving buildings date from the time of the third abbot St Aelred (1147–67) when the community grew to 140 choir monks and perhaps 500 lay brothers and servants: 'So that on feast days you might see the church crowded with brethren like bees in a hive' (Daniel, W 1994 *The Life of Aelred of Rievaulx*. Cistercian Publications, 119). The original model for the church was the functional austerity of Clairvaux in France, the monastery from which Rievaulx was founded, but in the early 13th century the community rebuilt and enlarged the eastern parts in an Early English Gothic style of architecture. Peter shows the new nave with its three-tiered walls comprising the ground-floor arcades of pointed arches, surmounted by a twin-arched triforium and topped with a clerestory. The floor was paved with yellow and green glazed geometric patterned tiling. This new church was one of the most elaborate to be built in England by the Cistercians, very different from the austerity of the earlier church.

Watercolour, body colour, pencil, pen and ink, 575 × 665mm, 1994

[IC086/015]

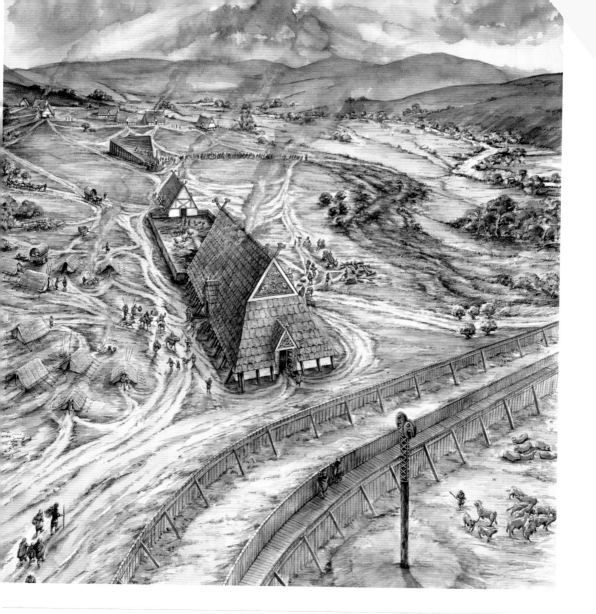

Fig 6.11 Yeavering, Northumberland, AD 627

Yeavering lies in a remote and dramatic site, on a broad and fertile valley floor hemmed in by hills, and is believed to be Ad Gefrin, the Anglian royal settlement where in AD 627, according to the *Anglo-Saxon Chronicle*, the Christian gospel was first preached to King Edwin of Northumbria by Paulinus, a priest from the Roman mission at Canterbury. The site was revealed by air photographs taken in 1949 and excavated in the 1950s and early 1960s by Brian Hope-Taylor. Excavation discovered successive timber halls of a distinctive scale and pattern. One building was the largest of this period excavated in Britain and Hope-Taylor interpreted it as a royal feasting hall. Peter's reconstruction shows the site as it may have looked in AD 627 during a visit by King Edwin. Yeavering has one structure without parallel in archaeology – a tiered staging perhaps in imitation of a segment of a Roman amphitheatre. Maybe this was the place where King Edwin greeted his people, perhaps the place where Paulinus, the Christian priest, first preached and then led his converts to the River Glen for baptism by total immersion – this is what Peter shows in the background of his picture.

Watercolour, pen and ink, 560 × 750mm, 1992

[910320]

Durrington south timber circle

Peter Dunn

Durrington Walls is a massive henge 100m from the River Avon on Salisbury Plain less than 2 miles from Stonehenge; the postholes of two timber circles were discovered there in 1966/67. Woodhenge, another timber circle, lies 200m to the south of Durrington's south timber circle and was discovered in the 1920s.

The 1993 reconstruction of the south timber circle (*see* p 109) which at the time was dated to 2000 BC, was for the Grimes Graves guidebook. Having produced reconstructions showing aspects of the Neolithic flint mine, I suggested a reconstruction to show that flint and stone tools had not only been used for all aspects of everyday life but in the construction of very large structures such as Durrington's south timber circle. I had already explored ideas and done research for a reconstruction of this site.

In 1992 I produced an illustration for Mike Parker-Pearson's *Bronze Age Britain* showing four ways of interpreting the postholes of phase 2 of the south timber circle. It had six concentric circles of oak posts of varying sizes – some very large. A roofed building was the usual interpretation at this time; however, one of the drawings was to show the posts as freestanding with lintels. Mike had given me a reference illustration showing a possible route through the concentric circles and a note of the suggested interpretations: No 5 was lintels and underneath it said Stonehenge. The choice was between reconstructing the postholes as a functional roofed building or reconstructing them as a wooden structure which echoed Stonehenge and was a symbolic construction used for open-air rituals. While producing the drawings I became convinced by the freestanding version – if Stonehenge had no roof why would its equivalent in

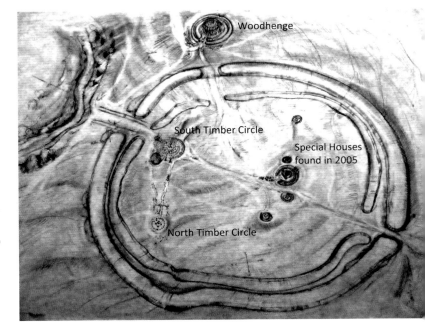

Pencil rough showing the bank and ditch of Durrington Walls henge in Wiltshire, the position of the north and south timber circles, the special houses and the site of Woodhenge.
[© Peter Dunn]

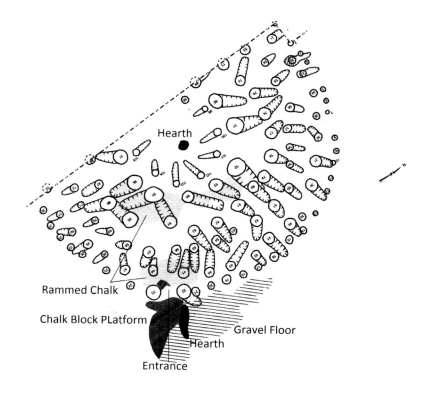

Excavation plan showing the six concentric circles of postholes, the supposed entrance and other features. [Parker-Pearson, M *et al* (2008) 'The Stonehenge Riverside Project: Exploring the Neolithic landscape of Stonehenge'. *Documenta Prehistorica* XXXV, fig 12; drawing Mark Dover]

Hearth

Rammed Chalk

Chalk Block PLatform

Gravel Floor

Hearth

Entrance

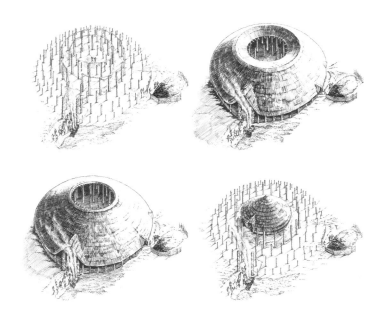

An illustration for *Bronze Age Britain* (1993), showing four different ways of reconstructing the postholes of Phase 2 of the south timber circle at Durrington Walls. [C035/003]

wood need one? The joints used in constructing the lintels at Stonehenge are those used in woodworking, perhaps if they were contemporary structures, which they were thought be, ideas were reflected in structure, purpose and construction techniques.

There was more evidence that a freestanding structure was viable – Maud Cunnington, the excavator of Woodhenge, considered that it was the prototype for Stonehenge; freestanding posts, possibly with lintels. The roofed hypothesis had been proposed for Woodhenge by Cunnington's nephew and much later by Stuart Piggott in 1940, drawing analogy with Brazilian roundhouses and Omaha Native American lodges. True, the excavator of Durrington, Geoff Wainwright, did go with the roofed building theory, but in the Durrington Walls report Chris Musson, investigating the variety of building forms for Woodhenge and Durrington south and north circles, concluded that 'the best hope for an all-embracing explanation may lie in the idea of ritual or symbolic settings of free standing posts' (Wainwright with Longworth 1971).

In the usual calculations for interpreting the depth, height, diameter and function of the posts at Durrington and Woodhenge, the depth of the largest rings of posts appears to be greater than would be necessary for a roofed building, the roof structure adding greater stability to the posts, but their depth is explained if they are interpreted as freestanding with that extra need for stability.

Looking at the plans in the Durrington Walls excavation report the route into the centre became clearer. After entering through the huge entrance posts the route goes between parallel posts, but the direct route into the centre is then blocked by two large posts which direct you to the left in a sunrise direction between two circles of the largest posts. Was this a processional route into the centre (*see* p 107)?

Considering the question of lintels and where they would be if they had been used, I again thought of comparisons with Stonehenge and looked at where they would increase the sense of circularity and height of the structure. The second

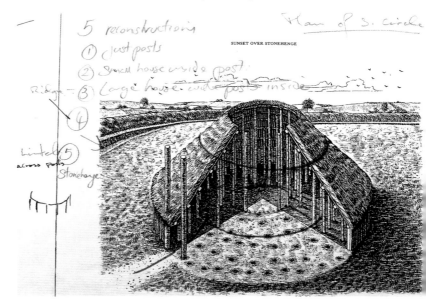

Reference material showing a possible route through the concentric circles.

and third circles from the centre could be linteled as they would be the highest; this also enhanced the idea of this as a processional route. It also seemed appropriate that they could be used to emphasise the height of the entrance and the route into the two tallest circles. All these ideas were discussed with Mike Parker-Pearson and he was happy with the resulting drawing.

All the main ideas were in place for a colour reconstruction. The view needed to change from aerial to eye level as this would emphasise the height of the posts and the idea of the lintels adding to the circularity of the monument and the height of the entrance. The image shows the structure in the last stages of construction, lintels in place, the smallest outer circle being erected and the entrance posts having finishing decoration applied. Offerings are being burnt on the hearth to the right of the chalk-block platform between the entrance posts, and the figure in the foreground leads the viewer into the scene. Grooved Ware pots associated with these timber monuments and found in the postholes at Durrington are being deposited; I thought it appropriate to use the designs from the pottery to suggest that at least some of the timbers might have had

Reconstruction of the south timber circle painted in 1993 for the guidebook for Grimes Graves, Norfolk, to illustrate the sort of monuments that could have been constructed with flint and stone tools. [IC095/022]

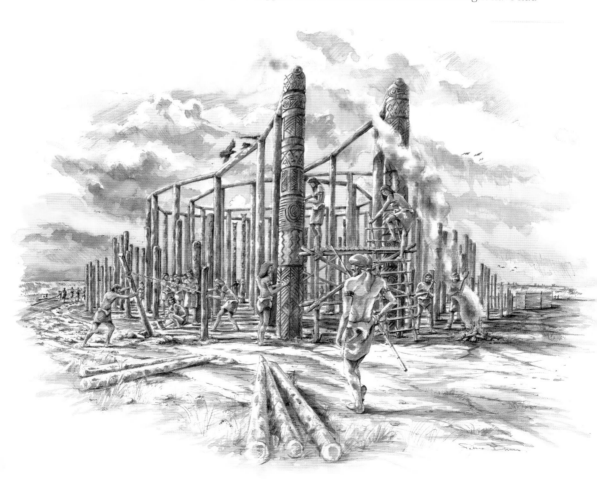

decoration. These geometric patterns, chevrons, zigzag lines, concentric circles and spirals were also known from earlier Neolithic in Britain and Ireland. Figures are applying colour to these carved designs; in the heart of the monument the inner circle suggests something more like totem poles.

A confession – the background in the 1993 reconstruction is wrong. It shows the bank of the henge which was then thought to be contemporary with the timber circles. However, the henge follows the shape of a gently sloping circular dry valley with the timber circle inside the henge's east entrance near the valley bottom close to the River Avon, the land sloping down to the circle on all but the river side (*see* p 106). The line of the henge bank should actually be a lot higher, just below the line of the lintels; though this is an embarrassing mistake no one has ever commented on it, to me at least. With the timber circle being the focus of the image I hope this does not detract too much from the validity of the reconstruction.

This would not be the case now, however. From 2003 Durrington became one area of focus for the Stonehenge Riverside Project led by Mike Parker-Pearson, examining the relationship between Stonehenge and the surrounding monuments and landscape. Results of the project included a new henge and stone circle at West Amesbury and at Stonehenge dating the arrival of the bluestones earlier to 3000 BC and the erection of the Sarsen settings earlier again by 500 years, and an equivalent date for the second phase of Durrington south circle of around 2600 to 2500 BC. But at Durrington it was found that the timber circles had rotted by the time the henge was constructed around them. When they stood they had been at least partly surrounded by a large Neolithic village. An avenue led from the south circle to the river and the timber circles were overlooked by special houses terraced into the hillside; the south timber circle was shown to have a western entrance leading to the largest of these special houses (*see* p 106).

Between 2009 and 2012 I produced a number of reconstructions from the results of the Stonehenge Riverside Project working with Mike Parker-Pearson. One was of the south timber circle again; the ideas in the 1993 reconstruction

Pencil rough of a new picture with new evidence from the Stonehenge Riverside Project excavations.
[© Peter Dunn]

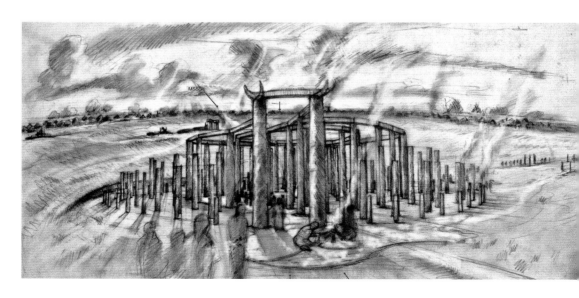

were expanded and reworked with the new information and I managed to get the landscape setting of the circle right this time. This illustrates how information, understanding and therefore interpretation of sites can change dramatically over the years; a reconstruction is only one way of interpreting the known information – it is how a site may have looked and best used to inspire the viewer to ask their own questions.

In 2006 a television programme was made on the project which included a rebuilding of the south timber circle. Strangely this was constructed in a field 50m from my house in North Newton in Wiltshire and I could actually walk through the entrance and be directed on that route through the posts as I had first drawn them in 1992 and 1993.

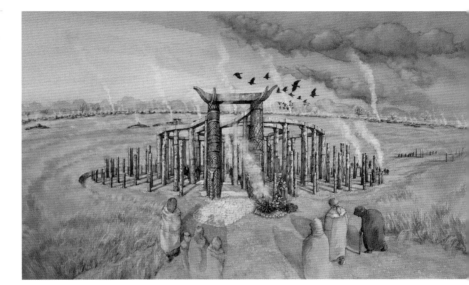

Durrington Walls south timber circle 2600–2500 BC.
[© Peter Dunn]

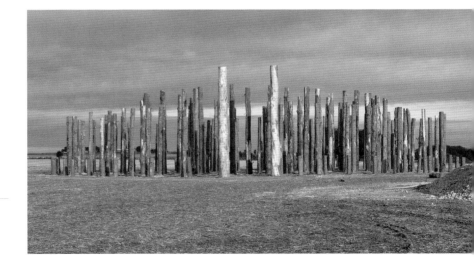

Reconstruction of the post circles for a television programme.
[© Peter Dunn]

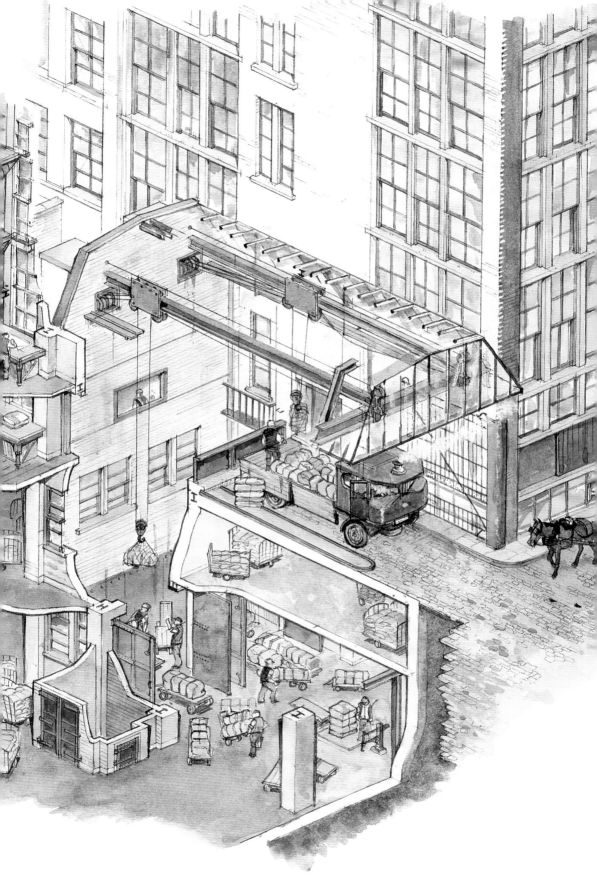

7 | Allan T Adams

At first sight there is not much history to be seen in the former mining village of Armthorpe, near Doncaster, where Allan was born and brought up. The colliery was the main reason for the large village to exist and Allan's father was a miner, as were his grandfather and three uncles, his mother a shop assistant. Many people looked no further for employment but Allan's father was determined that his son's future should be anywhere but in the coal mine. Careers advisers at school generally recommended training for trades in the coal industry but Allan's father was clear; he would 'cut his legs off rather than see him go through the pit gates to earn a living'.

Mining communities had a strong sense of unity, perhaps because the work was hard, dangerous and dirty. Everyone working underground was part of a team and relied on each other to stay safe. They were also aware that this had not changed over centuries despite mechanisation. Recognition of the value of understanding the past has therefore probably always been part of Allan's subconscious, along with the value of teamwork and the recognition that experience is invaluable.

An interest in art, particularly drawing, was kindled early on by Allan's maternal grandfather, Sydney Smith. He had been a miner in the north-eastern coalfield who, like his brothers, had moved to the new Yorkshire coalfield in search of work in the 1920s. Sydney was a man with numerous skills which included making clothes and furniture, and cooking. His talent for drawing and painting was most influential, an example being the painting, in oils on silk, of one of the trades' union parade banners, possibly the one carried by wives and mothers, for one of the mines in the North-East. He also kept a number of sketchbooks for recording everyday scenes and memories.

Some of Allan's fondest memories of visits to his grandparents are of being allowed to look through his grandfather's sketches. He was encouraged to draw himself, at first in the back of one of the sketchbooks. It was during this period that Allan was introduced to history, as well as books, since his grandfather was a great believer in reading.

Any opportunity to use drawing to save writing at school was taken, this approach being encouraged by his teachers at both Shaw Wood Primary School and Armthorpe High School, newly re-established as a comprehensive secondary school (Fig 7.2). The art teachers at this school were more than encouraging – Mr Hawkes, who taught Allan at GCE O-level, and Mr Swift, who passed on his drive and advice for A-level and who regularly had work accepted for the Royal Academy of Art Summer Exhibition. It was at this time that a book was discovered in the local library which explained how to make a living as a commercial artist or illustrator, a better option, it seemed, than trying to get by as a struggling artist.

Like many other students of art Allan learned the real skills needed to succeed after leaving school and starting the four years of formal education leading to a degree. On starting the foundation course at Doncaster College of Art in 1975 when he was 18, all the new students were told that up to then they

Fig 7.1
Asia House, Manchester, 1906–9

The cutaway drawing of the loading bay at Asia House, a packing and shipping warehouse in Manchester, was the first illustration that Allan did in watercolour for English Heritage. While the drawing focuses on the huge hoist in the loading bay, other elements that explain how the building functioned are also shown, helping to put the loading and unloading of goods into their context. It was published in the English Heritage Informed Conservation book *Manchester: The Warehouse Legacy. An Introduction and Guide* (2002).

Watercolour over a copy print of pencil drawing, 420 × 297mm, 2002

IC295/003]

had just been lucky and really they knew nothing about drawing or painting. In one year they were taught the skills that have been essential to sustain a career in illustration. Few of these appear to be taught now. They enabled Allan to secure a place at Gwent College of Higher Education, formerly Newport Art College and now part of the University of South Wales. This offered a degree with an opportunity to specialise in drawing and illustration for two years. At the time Allan, like many fellow students, questioned the relevance of some of the teaching but with hindsight he has realised the value of, for example, the illustration tutor, Tom Hughes, who was a close friend and contemporary of the illustrator Edward Ardizzone. Other tutors, like Charles Gillard and Terry Illott, were practising illustrators and artists at the time. Charles set work which he explained he fully expected students to fail to complete satisfactorily. Terry Illott continued painting after retirement, exhibiting in London and on the internet.

College advice on graduation from Newport was that Allan needed a year or two more to put together a portfolio to succeed as a freelance illustrator and to grow a thicker skin. One suggestion was that he should keep a croft while doing this, to be self-sufficient. Instead he got a job making sausages at Cooplands of Doncaster, a bakery and meat supplier, where he occasionally used his drawing skills in extraordinary ways, for example to paint a picture on a presentation cake. This was an early instance of having to produce drawing work unexpectedly, and under time pressure, with no prior warning.

When a job as a finds and publication illustrator at Winchester City archaeology office was advertised Allan applied because illustration, of any kind, was what he wanted to do. At the time, April 1980, he knew absolutely nothing about archaeological illustration. The interview was conducted by the city archaeologist, Ken Qualmann, and Frank Gardiner from the Department of Ancient Monuments drawing office in London. When offered the job he was told by Frank Gardiner that it was because he could draw and had interpreted

the requirements of the role in an 'impertinent but refreshing way'. The archaeological items in his portfolio were sketches of artefacts in Doncaster Museum, including a sketch section of a Roman burial in a stone coffin. This included some estimated measurements, the result of some limited research into what archaeological illustration entailed, as the coffin was in a glass case – a technique that has been repeated more than once since in the quest for good reference material (Figs 7.3 and 7.4).

Fig 7.3
Roman coffin

[H]e knew absolutely nothing about archaeological illustration'. The Roman coffin Allan sketched at Doncaster Museum in order to put some archaeology into his portfolio before his interview.

Pencil in sketchbook, 148 × 199mm

[© Allan Adams]

Fig 7.4
Pottery drawing at Doncaster Museum

The application form for the job of archaeological illustrator referred to drawing pottery. Another page from the sketchbook used at Doncaster Museum.

Pencil, 120 × 180mm

[© Allan Adams]

Mid 2nd Century Roman Bottle burial Green
Remains from cremation buried in Then - a hole
was deliberately pierced in the side before
burial

Jar for containing cremated human remains
Mouth of jar was covered by an iron shield boss of
Germanic type late 3rd - early 4th century A.D.
Find possibly represents burial of a Germanic mercenary.

Fig 7.5
Excavations at Wickham
Glebe, Hampshire,
medieval period

Allan's first reconstruction
drawings were for the interim
report on the excavations at
Wickham Glebe. The drawings
of the manor house complex
at various dates were mostly
isometric projection drawings
but one or two were perspectives
from ground level. This pen-and-
ink drawing of the manor house
seen from the moat was used for
the cover of the report.

Pen and ink reproduced in
brown/sepia ink, 177 × 200mm,
1980

[© Winchester City Council/
Hampshire Cultural Trust]

One week of training in archaeological finds illustration was provided
at the Ancient Monuments drawing office. Many of the tips and skills have
been immensely useful throughout Allan's career. For example, using compasses
to empirically work out the diameter of pottery can also be used to work out
the geometry of arches in buildings, while cutting erasers into small pieces
allows detailed work to be modified without damaging too much of the drawing.
Winchester archaeology office provided a good introduction to the rigours of
the profession. Whether the work was to draw representative forms of Roman
nails for cataloguing or to complete plans and sections for publication, including
a small number for Martin and Birthe Biddle, the attention to detail was
always present.

It was at Winchester that Allan was first asked to undertake reconstruction
work. This included some small Roman funerary structures from north of the
city but, more important for his future career, the medieval manor house site at
Wickham (Fig 7.5). The reconstruction drawings for this required new, technical
drawing skills to be learned. It also proved invaluable experience in terms of
finding and using reference material. Up to now Allan had drawn buildings to
build up his portfolio, usually opting to portray what gave a building or street
a particular character. For the Wickham reconstructions he was heavily reliant
on the material supplied by the authors (Fig 7.6).

Fig 7.6
**Excavations at Wickham
Glebe, Hampshire**

The report illustrations
also included a number of
reconstructed pottery groups,
drawn mostly from the
archaeological illustrations
of fragments that had been
excavated.

Pen and ink, 140 × 112mm,
1980

© Winchester City Council/
Hampshire Cultural Trust]

Allan's stay in Winchester was relatively short. In October 1981 he took up a post in the Royal Commission on the Historical Monuments of England (RCHME). Initially this meant more training in the use of dip pens to produce drawings of landscape archaeology. Hachured plans have been used from the late 17th century to show landscape features, the hachures, or lines thickened at one end, being a form of shading developed by engravers. To begin with, opportunities for reconstruction drawings were relatively limited and usually given to more experienced illustrators. This steadily changed as illustrators were increasingly given responsibility for a particular project and experience was built up. Among new challenges was illustrating very subtle earthwork remains, including a trial pencil reconstruction. Few of these have been published because different priorities emerged but they helped to change the way academics viewed illustration, paving the way for new forms to evolve.

Initially the work undertaken consisted of a mixture of earthworks illustration and completing illustrations of buildings drafted by colleagues. In 1985 Allan was assigned as illustrator in the team studying medieval houses in Kent (Fig 7.7). Now part of the recording team, he made field sketches and measured the buildings, and did not simply make illustrations from other people's field notes as he had earlier. He developed a special interest

Fig 7.7
Medieval house types in Kent

Medieval house types in Kent, from *The House Within: Interpreting Medieval Houses in Kent* (1994). Because the details of windows in these houses could not be absolutely confirmed they were completely left out of the drawing.

Pen and ink, Rotring pen on drafting film, 95 × 170mm, 1993

[RCH01/048/02/006]

in the way the timber frames of the buildings were constructed, becoming the acknowledged expert in the team. The complexities of construction were found to be more easily understood through illustration. Five-hundred-year-old houses, adapted over several centuries, were good subjects for reconstruction drawings (Fig 7.8).

At this time the audience for the type of work being undertaken on historic buildings was growing, with a greater number of the general public wanting to know more about the past. Academics studying the past were now more prepared to take their studies further and allow suggestions about how buildings might have looked and functioned, based on detailed analysis, to be put forward. RCHME reconstructions were taken only as far as the evidence allowed. A window, for example, could only be drawn if there was clear evidence it was once there. Drawings at this time were mostly in pen and ink as this was the most economical way of reproducing them and very similar to the manner in which permanent record drawings were made. Pencil drawing, usually photographed for use in books, was also sometimes used, allowing more scope for including features which were a little more tentative.

Important influences on Allan's work at this time were colleagues in the other offices doing similar projects, particularly George Wilson, Nigel Fradgley and Tony Berry. George and Nigel had pioneered reconstruction drawings and field survey by illustrators, the survey work having been done in the past by investigators, for the Hertfordshire Houses project, which Allan had also worked on. Tony was doing similar work on textile mills and had produced cutaway drawings for the book on Roman pottery kilns. Of equal importance

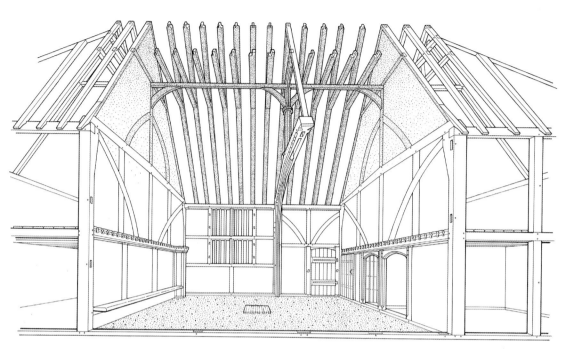

Fig 7.8

Medieval yeoman's open hall

The main features of a medieval yeoman's open hall house are shown in this reconstruction. It is difficult to explain to people that the main part of the house was built without an upper floor or chimney. Many of the features shown were measured in a single house but some are based on evidence in other, similar, houses and excavations.

Pen and ink, Rotring pen on drafting film, 120 × 190mm, 1993

RCH01/048/02/006]

was the work being done in Wales by the Welsh Royal Commission. Their book *Houses of the Welsh Countryside* (1975) had a major impact on the way historic buildings were illustrated. It includes many reconstruction and cutaway drawings, often produced by the book's author, Peter Smith, who had trained as an architect.

Allan makes no distinction in his illustration whether it is for a record or for a publication; all his work aims to enhance understanding the form and evolution of the building being illustrated. When working in the field he produces sketches and visual notes either for recording measurements for metrically accurate plans and sections or to help to tease out details of construction and form. These sketches and measured drawings become the raw materials for reconstruction drawings or cutaways, the latter being a useful means of showing parts of both interior and exterior in a single view. Sketching is also used to resolve problems during the making of an illustration, for example in the case of the reconstruction of Theobalds, a stately home and royal palace of the 16th and 17th centuries in Hertfordshire, when several possible interpretations of the 17th-century written description were necessary to work out the possible form of some of the building. Many of the buildings Allan has illustrated are still standing, the reconstruction element of his work often being to reinstate demolished or altered parts. Whether the building survives or has been demolished, it is important that it is brought back to life. This can be done by repopulating a building with people and/or machinery but it can also be done by using lively, hand-drawn line work and thoughtfully applied colour.

Increasing public interest in the past has led to a need to make illustrations more appealing and the information conveyed more immediately accessible. Technical advances have meant colour can now be employed more widely, its use no longer restricted to high-print-run publications like guidebooks. Pencil drawings can also be more readily reproduced. This has enabled different techniques, in which colour is added to copied pencil or ink base drawing – an economical way to work. At first there was some reluctance on the part of academics to use what they saw as a 'popular' form of illustration. It is now more widely accepted as a result of the continued strict adherence to what the evidence can support.

Illustration is generally part of a collaborative effort. Over the years Allan has worked with a wide variety of historians, building recorders and archaeologists. Many of them are acknowledged experts in their field. He has also worked with less experienced team members, passing on some of his skills in the process. Reconstruction drawings are often asked for at the end of a project but it has sometimes become necessary to change the interpretation because a reconstruction drawing shows that the evidence does not support it. Years of experience has meant many experts are prepared to change their story when a reconstruction makes their version untenable. Reconstruction drawings are therefore considered a valuable research tool, not merely a summing-up of the story. By far the best way to produce a good reconstruction drawing is to research around the subject and collect reference material from as many sources as practicable. As part of his approach to the work Allan reads extensively about the subject and seldom relies solely on the reference material supplied by his fellow team members. He also thinks it worthwhile to question the evidence supplied to ensure that no other interpretation would be more appropriate.

Looking at the work of other artists and illustrators has influenced Allan's work. Artists he has studied include the 19th-century topographical work of Turner, Cotman and Girtin. William Henry Pyne's studies of people at work have been influential, as have the pen-and-ink drawings of Frederick L Griggs. Drawing is a skill which needs constant practice so Allan keeps a small sketchbook handy when travelling to record what he sees. Undertaking similar projects to his daily work in his own time has widened his study horizons, enabling him to work on different historical periods and on subject matter that interests him. When sketching for pleasure or helping out former colleagues and friends he is able to experiment with new techniques and media, gaining a good deal of satisfaction.

Fig 7.9
Barn, Orpenham,
Kintbury, Berkshire

Three drawings illustrate
changes in use of the same barn
over time. The drawings were
used in *English Farmsteads
1750–1914* (1997). Hand
threshing in the barn was
replaced initially by horse-
powered threshing and then by
steam threshing, though the barn
continued to be used for storage
at the heart of the farmstead.

Pen and ink, Rotring pen on
drafting film. Drawn as three
separate illustrations each
on a sheet of A3 film.
The largest 297 × 420mm.
Printed separately reduced to
50 per cent for publication,
c 1996

[RCH01/013/02]

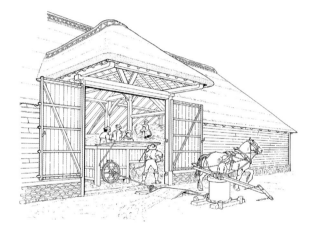

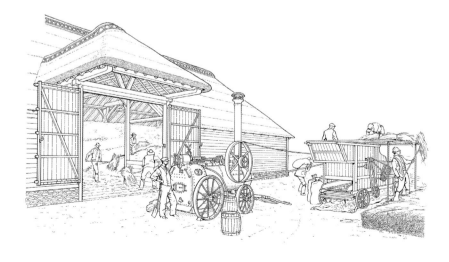

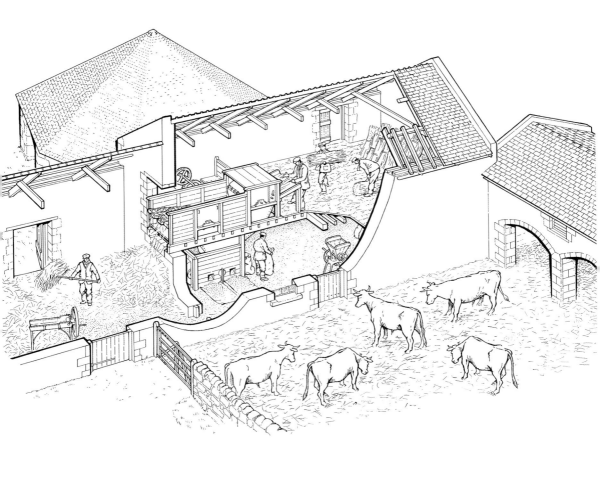

Fig 7.10 Threshing barn, Lanton, Northumberland, c 1850

Northumberland brought back to life by reconstructing the threshing machine and populating the buildings and yard.
A cutaway view allows both interior and exterior of buildings to be seen in the same view.

Pen and ink, Rotring pen on drafting film, 297 × 420mm, c 1996

[RCH01/013/02/324]

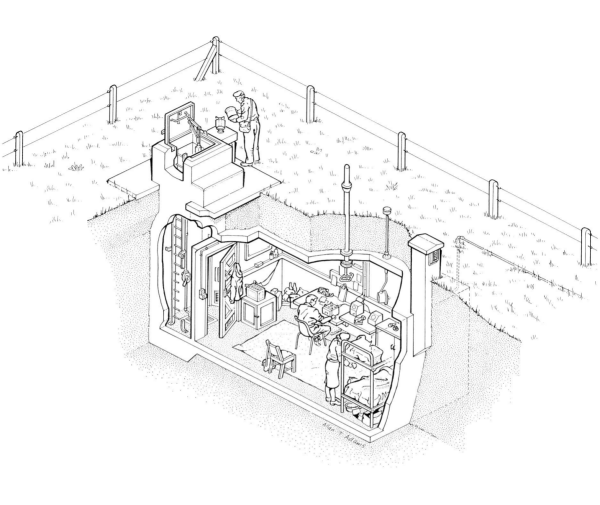

Fig 7.11 Nuclear attack monitoring post, 1957–65

A nuclear attack monitoring post, drawn for the English Heritage book *Cold War: Building for Nuclear Confrontation 1946–1989* (2003). Only the entry hatch and ventilation shaft of these buildings can usually be seen above ground. The drawing also brings it back to life, showing the cramped conditions inside.

Pen and ink, Rotring pen on drafting film, 297 × 420mm, *c* 2002

[IC302/001]

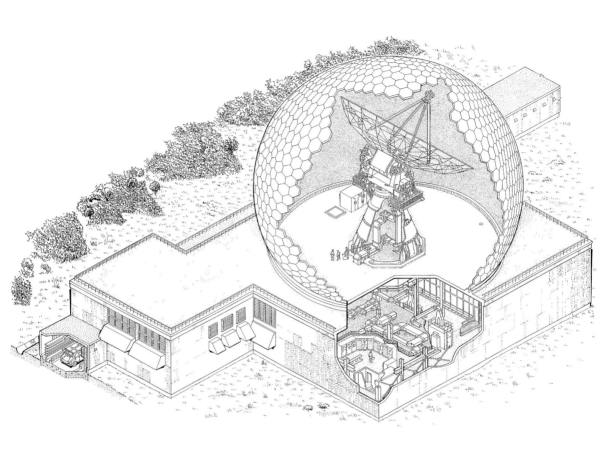

Fig 7.12 RAF Fylingdales, Yorkshire, 1963

RAF Fylingdales' three giant golf balls were a dramatic landmark on the North York Moors. The cutaway drawing was based on information from diverse sources, ranging from old technical manuals, copies of original plans, photographs taken just before demolition and 19th-century illustrations which helped to suggest vegetation, for example the gorse bushes.

Pen and ink, Rotring pen on drafting film, 420 × 594mm reduced to 33 per cent for publication, *c* 2002

[RCH01/056/01]

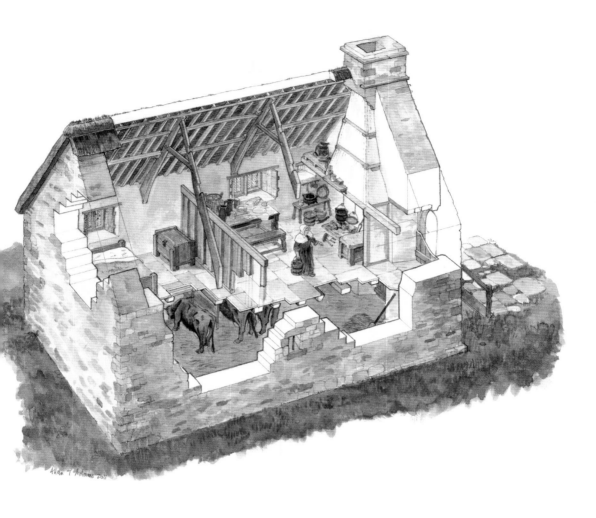

Fig 7.13 Low Park, Alston Moor, Cumbria, mid-17th century

A reconstructed, perspective cutaway drawing of a form of bastle house. Bastle houses are a type of fortified or defensible farmhouse peculiar to the border country between England and Scotland and were homes and refuges for freeholders, lairds and heads of border clans. More prominent landowners lived in pele towers, similar but taller.

Allan's illustration shows how the building was used with the byre for cows on the ground floor and living accommodation above. It is based on detail field survey and additional research by the illustrator.

Pencil, watercolour, 200 × 240mm

[IC288/001]

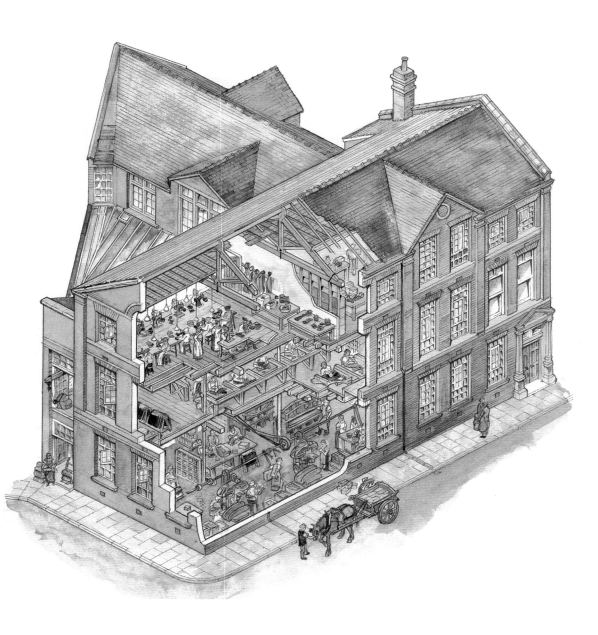

Fig 7.14 G T Hawkins's boot and shoe factory, Northampton

The cutaway drawing is based on original architect's plans with some detail from field survey. The factory housed different departments on each floor, with heavy machinery on the ground floor and various other processes, leading to completed boots and shoes, on the top level.

Pencil and watercolour, approx original size 280 × 280mm

[IC291/011]

Dukes Terrace, a row of 18 back-to-back houses in Liverpool

Allan Adams

Many architectural reconstruction drawings incorporate at least some elements of standing buildings. Illustrators are therefore often asked to either draw the missing parts or to bring the building back to life in another way. This reconstruction drawing highlights a number of these approaches. While most reconstruction drawings are commissioned to fulfil a specific need and are used, unaltered, to serve other purposes, this drawing evolved as the purpose for which it was originally drawn was only the first of a number of different uses for which a reconstruction drawing would be needed.

Back-to-back houses were once common in most industrial cities. Built in densely packed court developments they became a symbol of the worst type of cheap housing for low-paid working people, where living conditions were often very bad. Liverpool was no exception, with large numbers being built in the late 18th and early 19th centuries when the city's population grew rapidly. Dukes Terrace of back-to-back houses originally consisted of 18 individual houses, accommodating at least that number of families but perhaps more. Each house had a basement and three rooms above but it was common to rent out a single room for an entire family. By the 1990s only one block of these houses survived, the rest having been replaced by better housing. Dukes Terrace was therefore an important reminder of these once numerous buildings, but they were in a very poor condition. English Heritage was therefore called, as the terrace was going to be either radically altered or possibly even demolished to make way for new houses.

Reconstruction drawings were needed initially to illustrate a report on the building which would strengthen the case for its retention. Preliminary research aimed to discover if there were any views of the building before the roof and upper storey of brickwork had been removed, as they were unsafe. This uncovered a very useful elevation drawing of the end of the terrace but otherwise only a very poor-quality photograph of the building in a semi-derelict state. Fieldwork was undertaken to ascertain if the basement was integral to the rest of the buildings as a number of these houses were known to have had separate dwellings in the basement, especially in Manchester, though possibly less often in Liverpool. This work was made easier as all the floors had been removed, though this made the structure unsafe. A colleague carried out some of this work from an aerial work platform, while the detailed measured survey was confined to a part of the site designated as safer than the rest by the builders working there.

The first drawings prepared were a record of the building as it stood, with floor plans and a cross section. These were followed by a reconstructed plan of the first building phase and a cross section and a plan of the building after the back-to-back houses had been modernised, creating a passage from the front dwellings through to the back ones which resulted in there being only nine houses instead of the original 18. The research had revealed that none of the houses ever had a bathroom installed, although a single toilet was added in each, which was apparent from the evidence of a small window being added to each house and the marks left by the removal of timber partitions.

The first stage of reconstructing the back-to-back houses at Dukes Terrace was to draw plans and cross sections of the building as it was surveyed. This enabled reconstruction plans and sections to be drawn, as the block had had the walls of the topmost storey of the building, the roof, and all the timber floors and stairs removed. Shown here are the cross section surveyed in 2002 and a reconstruction of the same view as it would have looked when new in 1843.

The project was intended to help preserve the building by showing its local significance, as the area was about to be redeveloped. A bird's-eye view with some external walls cut away to reveal the interior was requested as the plans and sections did not readily convey how the building, in its original form, worked. This drawing allowed other information to be brought into the reconstruction, adding emphasis to the constricted nature of the site and paucity of sanitary provision as only six to eight privies were originally provided. This might have been possible by using photographs, but these would not have been specific to the site. At the time the record drawings were made the building stood alone in a large open space and few historic photographs of it had been found.

My starting point for the reconstruction drawing was a very rough pencil sketch. A second sketch helped to clarify parts of the building which were omitted or missed from the first sketch. These were sent to the report author for approval. After this a pencil draft was prepared. For most architectural reconstruction drawings carefully set-up perspective projections are used, for example by Terry Ball. I sometimes use this technique, aided by a pre-prepared grid, but more often I use an isometric projection which allows measurements to be used directly for length, breadth and height. This can produce some distortion but the carefully selected angle has been found to be similar to the angles typically used for perspective bird's-eye views. The advantage is that the draft drawing can be produced fairly quickly, and additional features easily kept to scale.

During the drafting stage of producing the illustration particular attention is given to the way components of the building are joined together. This type of detail is often lost in quickly prepared computer-generated drawings, especially in work generated from digital scanning.

Once the draft was complete it was shown to the commissioning author and any amendments that were necessary were carried out. The Dukes Terrace drawing was initially finished in pen and ink, for inclusion in a detailed report alongside the record drawings.

The starting point for any cutaway or reconstruction drawing is the preliminary sketch. This is the means to establish the viewpoint of the drawing and have this agreed with the commissioning author. A number of sketches may be necessary to get this stage settled.

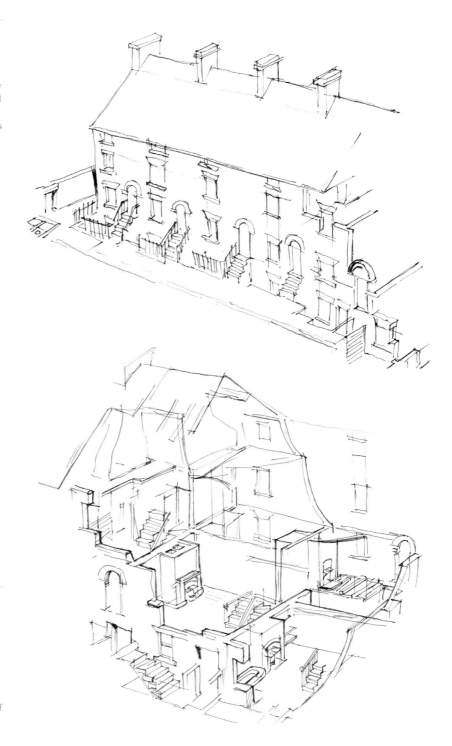

Sometimes further sketches are needed to resolve particular problems which come to light during the drawing up. This sketch explores more carefully where to place cut lines in order to better show the back-to-back arrangement of the houses.

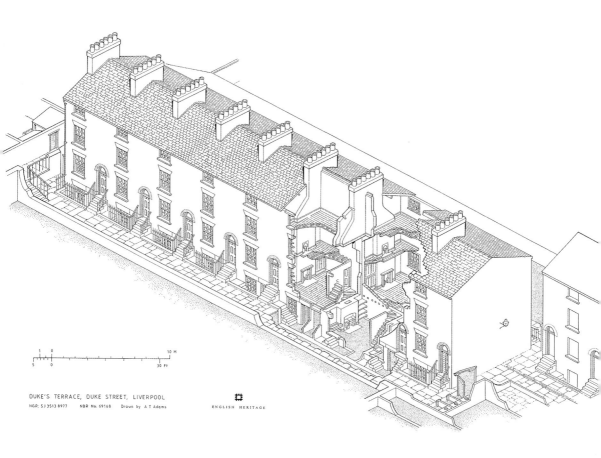

DUKE'S TERRACE, DUKE STREET, LIVERPOOL
NGR: SJ 3513 8977 NBR No: 69168 Drawn by A T Adams

ENGLISH HERITAGE

The finished pen-and-ink version of the cutaway drawing was originally intended to illustrate a report on the building to assist planners who wanted to prevent the building being demolished.
[IC281/002]

A number of years later the drawing was revised. A publication about one of Liverpool's suburbs, aimed at a wider audience than the original report, was being written. One of the project managers felt the back-to-backs drawing would be useful to show what people were moving to the suburbs to escape.

To make the drawing more effective I suggested adding more information about the adjoining properties, since these were shown clearly on historic maps. Further research was needed to enable the timber yard and police garage to be drawn as the houses were surrounded by industrial sites. Some rough sketches were done, from references as diverse as the internet and publications about furniture making, which included trade cards illustrated with drawings of timber storage. The amendments were drawn on a tracing paper overlay. When complete the original drawing and amendments were traced to create the new base drawing which was then copied. Colour was added to a copy print of the drawing to make it more suitable for the intended wider audience, adding considerably to the atmosphere of the location to create a better sense of place.

Pencil sketches from internet references of timber yards, used to work out an approach for adding background detail to the cutaway drawing to create a new illustration.

(below) Dukes Terrace, Liverpool. The drawing was reworked when it was used to illustrate the type of conditions that people wanted to leave when Liverpool began to develop its suburbs, in the English Heritage Informed Conservation book *Ordinary Landscapes, Special Places: Anfield, Breckfield and the Growth of Liverpool's Suburbs* (2008). [IC281/001]

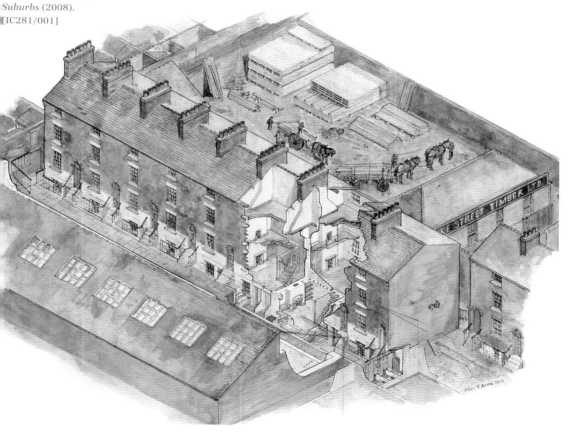

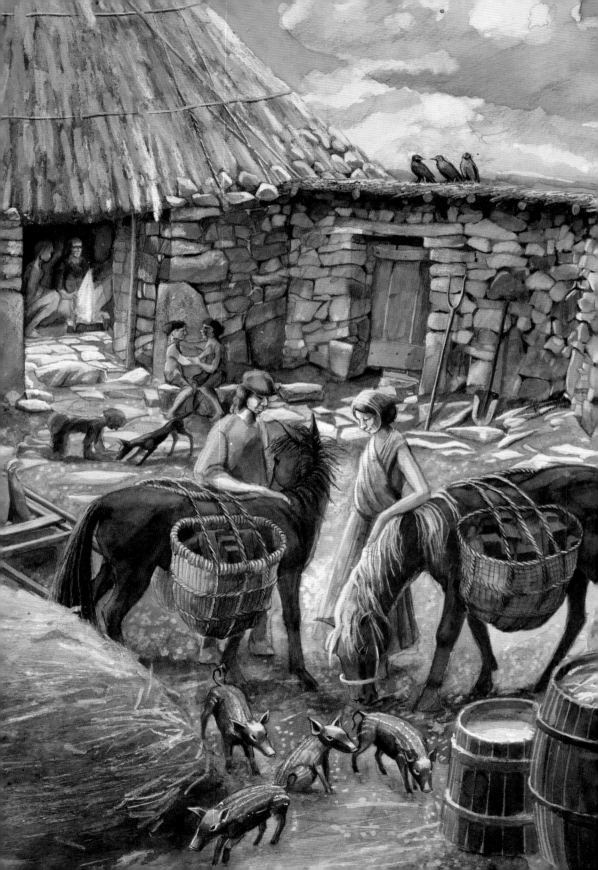

8 | Judith Dobie

Judith comes from the town of Dumfries in south-west Scotland. It is an ancient town, a royal burgh since 1186, and the land around is rich with ancient sites dating back into prehistory. A border town, always vulnerable to attack, fought over by Picts and Scots and Celts and Romans and English, its place names tell how it was surrounded by the Vikings. People even now are partisan – taking their history personally. A memory as a child was of a school visit to the basement of Mr Lennox's grocery shop where among the shop stores was a plaque that marked the spot where formerly stood the high altar of Greyfriars church where Robert the Bruce stabbed the Red Comyn. The Bruce then bolted from the monastic church where the Comyn had sought sanctuary, shouting to his henchman Roger de Kirkpatrick that he thought he had killed the Comyn. 'You doubt, I'll mak siccar.' Kirkpatrick went in and finished him off. 'The Scottish wars of independence started here', said Mr Lennox. The group of schoolgirls glowed with local pride. In the same way the Romans were not just people in a textbook. Hadrian's Wall was only 30 miles away. The children at Judith's school took sides and saw themselves as Celts, members of the Selgovae tribe, living in Valentia – the Romans their foe.

It was the same at secondary school in St Andrews, history was alive; Judith was surrounded by ancient buildings. The school library was a tall, thin medieval house and in it was a room where Mary, Queen of Scots, had slept. Scraps of her sewing were framed and hung on the walls. The schoolgirls used to creep into the panelled closet with the narrow bed and lie on it and close the door and imagine Queen Mary, over six feet tall, cramped and folded in the little space.

Judith's mother's family were artistic. Her great grandmother Maria Pieroni was half Italian; Maria's father came from Lucca in Tuscany and was a figure modeller living in London in an enclave of Italian craftsmen in Marylebone. His brother Stephano was more prosperous, had a studio in Bath, and was a sculptor and an importer of wines from his vineyards in Lucca. A photograph of him in an artist's smock, chisel in his hand, working on a sculpture was in the family photo album.

Judith went to the Glasgow School of Art from 1966 to 1970. In her third and fourth years her tutor was the calligrapher George Thompson. For her final year thesis he encouraged her to study the letter forms of the gang graffiti that mapped the boundaries of city territories. Gang graffiti led to medieval graffiti and her thesis caught the eye of the Professor of Archaeology at Glasgow University who offered her a job drawing finds in his department, but she was interested in a different style of illustration. She admired the work of Brian Wildsmith, Charles Keeping and Maurice Sendack, children's book illustrators. The accuracy and control, the discipline of observation required to draw finds seemed beyond her, but an idea had been planted and after, by chance, working on the excavations of the Old Minster at Winchester and becoming enthused by archaeology she wrote around and went to Durham to the university archaeological department. Here she drew finds from Rosemary Cramp's

Fig 8.1
Interior of house 6,
Chysauster, Cornwall,
Romano-British
1st century AD

You can see the main living room of the family with a stone-built hearth at the back of the picture. The other rooms, constructed in the thickness of the walls, would have housed animals and stores. The stone slabs in the courtyard covered drains to keep the yard dry. Although the site seems remote, we know by the finds from excavation, such as pieces of Roman amphora and blue glass beads, that they were on trading routes and had connections with a wider world.

Watercolour, gouache, wax crayon, 370 × 340mm, 1993

IC025/001]

excavations of the Anglo-Saxon monasteries of Monkwearmouth and Jarrow. From Durham she went to work in the archaeological drawing office of the Department of Ancient Monuments.

Those involved in art often make good archaeological diggers and Judith had a keen eye for the subtle changes of colour and texture of soil and took pleasure in the aesthetics of digging – the clarifying, organising and labelling. Though able to dig well she did not interpret what she excavated. To her it was an abstract exercise of pattern, colour and tone and it was only when she began to draw reconstructions that she saw things differently.

After working at Winchester, Judith excavated each summer with the archaeologists Martin and Birthe Biddle at Repton in Derbyshire, drawing the excavation site plans. At Winchester a style of planning had developed based on a wire metric grid and open area excavation. This is commonplace now but at that time most excavations were dug using Mortimer Wheeler's method of a set of square trenches with permanent sections between. An open area excavation is easier to understand visually than one with permanent sections which interrupt the view, and use of a grid to draw through makes detail easier to record. The archaeology at Repton around the Anglo-Saxon church was complicated, the surface cut and cut again by graves and buildings leaving peaks of layered soil. After each phase of excavation the area was scraped hard to leave the soil colour clear and bright; the layers were then drawn and coloured on site as they were observed. The differences in tone, colour or texture denoting the different layers could be tiny. When reviewing the plan with Birthe if a layer was agreed between them the shape was drawn in ink, but if she and Judith disagreed on what they saw it stayed in pencil. Sometimes, after further excavation, a pencil line could be replaced by pen to Judith's satisfaction. This method revealed features and structures that can be easily missed. The site plans, a patchwork of colour and detail, were a work of art in themselves.

When Judith joined the Department of Ancient Monuments drawing office in 1972, David Neal was in charge. An archaeologist as well as artist and Roman mosaic expert, he built a team of mainly art school graduates, most of whom continued to make prints, life draw, make pottery and paint in their spare time. Judith did not think of archaeological illustration as different from drawing generally. Although there was a house style of illustration using pen and ink and line or stipple, as she saw it a finds drawing can still be expressive, you are searching for form in the same way that you would when drawing anything set before you. Every person's style of drawing in the group was distinctive.

There are different ways of looking at the skills of archaeological illustration It can be seen simply as a technical exercise but David Neal's intent had been to build an artistic drawing office and finds were drawn in more than just a basic way. There was, for example, a movement among finds experts for leather objects – shoes particularly – to be drawn as pattern pieces, but in the drawing office this idea was ignored; there was no thought of changing the office style which was to show the shoe with all the bumps and wear that reflected the shape of the foot and the life of the person who once wore it. At a time when to take a cool, detached, analytical view was prevalent in archaeology, the group naturally, unconsciously, took a different line.

In this way some of the illustrators developed empathy with the people of the past whose possessions they drew. Judith felt this about the early Saxon inhabitants of Mucking, a site on the Thames estuary where the acid soil had

destroyed nearly everything organic yet still you could create a picture of some of the individuals (Figs 8.2 and 8.3). The little girl buried in an outsized Kentish-style kaftan – a stitch preserved on the back of her brooch showed how a tuck had been made in the material at the neck – and a woman buried with a piece of an already ancient sword and a fragment of a great square-headed brooch in a drawstring bag at her waist. Judith wondered if these objects might represent her parents, her pedigree. And then similarly there was the Viking soldier from

Fig 8.2
Cemetery II, grave
936, Mucking, Essex,
mid-6th century

Little is known about how Anglo-Saxon people dressed. Evidence from excavations at Mucking – a site on the north shore of the Thames estuary – enabled this reconstruction. Mucking was inhabited in Saxon times from the first half of the 5th century to the early 8th century. The soil is acidic so hardly anything organic survives; even so, by plotting the positions of the brooches and pins that held their clothes and by scientific examination of the scraps of textile mineralised by contact with the iron pins, it was possible to reconstruct some of their costume (see Fig 8.3). The dress the little girl from grave 936 wears is reconstructed as a kaftan-type tunic. This is based on the position of the two brooches, one below another, and the remains of two braid edgings joined by a stich. It suggests that some children were wearing a simple tunic-style garment rather than being dressed as miniature adults.

Pen and ink and graphite, 1000 × 1300mm, 2007

[C220/001]

Fig 8.3
Grave plan and grave goods from grave 936

The grave plan shows the position of the two small square-headed brooches on the child's body and the string of beads she held in her hand. The pen-and-ink drawing of the back of brooch 1 shows the tablet braids which edge the neck of her dress.

Pen and ink, grave goods drawn 2:1 to be printed at actual size, 2006

Fig 8.4
Grinding corn, Carn Euny, Cornwall, Iron Age

The illustration was drawn for the guidebook to the Iron Age and Romano-British village of Carn Euny. It shows the bottom half of a rotary quern found in excavation and then shows how it was used to grind corn. Quern stones of various types were found in all phases of the settlement, which lies within an extensive field system of great antiquity with origins in the Bronze Age or earlier. Cereals were grown – wheat, oats, barley and rye, and cattle and sheep were raised.

Pen and ink, 320 × 300mm, 1987

[IC022/002]

Repton in Derbyshire with a Thor's hammer amulet around his neck, killed by a blow from an axe. An older man, she imagined a grizzled sergeant-major type, survivor of many skirmishes and battles, dying in the winter of AD 872–3 when the Viking army was in Repton. Judith wanted to mark these people, tell others about them – to tell their story.

She first had an opportunity of site reconstruction when the archaeologist Paddy Christie was asked to write the guidebook for the Cornish sites of Carn Euny and Chysauster (Fig 8.4). She had worked with Paddy on her excavation report of Carn Euny preparing the plans of the Romano-British village for publication. Although many of the houses at Chysauster had stone walls existing as high as the lintel, Paddy was nervous of reconstructing the roofs. Judith worked with Bill Startin, a prehistorian and Inspector of Ancient Monuments who excavated in Cornwall. He was also worried about reactions to the reconstruction and filed away their working drawings and ideas, 'so that if we are challenged, we'll have our defence ready' (Startin, pers comm).

The courtyard houses – particular to this area of the Penwith peninsula – are built of dry stone, double walls infilled with rab, a sort of decayed clay, in some places thick enough to contain a room (Fig 8.5). The picture roughs may have satisfied both Paddy Christie and Bill Startin but by then Frank Gardiner was head of the drawing office and Frank required total accuracy. Judith's drawing of the walls was too generalised for him. 'Think,' he said to her, 'how satisfying it would be for the visitor to the site standing before the house to look at it and then at your picture and see each stone depicted just as it was built.' Judith, though sceptical, changed her illustration. But years later Frank was proved right when Judith's mother in south-west Scotland, at the hairdressers, was asked if she was related to the Judith Dobie whose painting the hairdresser had seen when she was on holiday in Cornwall. 'Every stone was drawn,' she said approvingly. Frank's rigorous attitude and emphasis on explaining visually how things worked was a good corrective to Judith's more relaxed style (Fig 8.6).

Reconstructing a site or a monument excavated and written of some time in the past is a very different process to working with the archaeologists and experts on a current excavation. Judith considers herself fortunate to have worked alongside the various heritage scientists – the archaeobotanists, the animal bones experts, the soil scientists and finds experts – and to be able to visit the site under excavation, to walk the landscape with the field archaeologist and hear their first impressions and first ideas of the interpretation of the site. Working in this way reconstruction is an ongoing process, valuable in that it raises questions, exposes differences of opinion and promotes debate. The process of reconstruction proceeding from a series of evolving roughs circulated to every person of the team becomes as important as the finished illustration in the archaeological report.

To understand the past, to place yourself in a chronology, is important to most people; public enthusiasm for archaeology demonstrates this. Judith is interested visually in figures, their movement and gesture, and in her pictures tries to express the thought that, although thousands of years may separate the people depicted from the present, the quintessence of people remains the same, just the technology around them alters. To connect the present with the past in her pictures is what she aims to do.

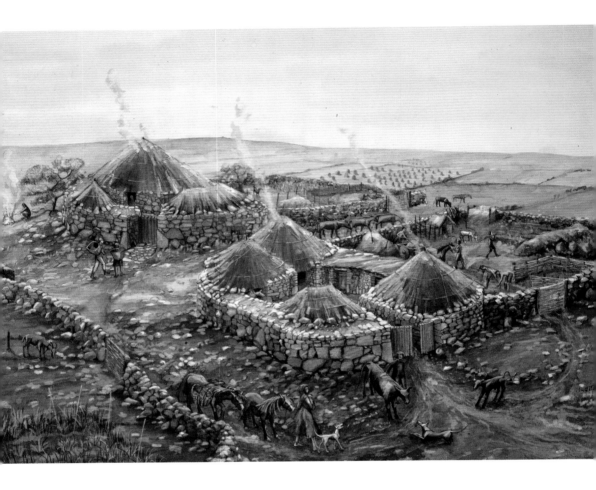

Fig 8.5 Houses 4 and 6, Chysauster Ancient Village, Cornwall, Romano-British 1st century AD

Chysauster is one of a number of ancient stone-walled villages probably dating from the Roman period that are found in the West Penwith area of Cornwall. These compartmentalised houses are known as courtyard houses and it is likely that there were once many more on the hillside and those that survive are just a remnant of the settlement. When Judith first drew the Chysauster houses, where the stone walls survive almost to lintel height, she drew in an impressionistic way. This did not please the drawing office manager Frank Gardiner who obsessed over the accuracy of his own reconstructions and wanted each stone recorded as it was. At the time Judith thought this unnecessary but now she is more sympathetic to his point of view, feeling that drystone walling is a skilled craft and that to express this accurately enhances the appreciation of the talents of the Chysauster people.

Watercolour with body colour, 330 × 460mm, 1993

[J890148]

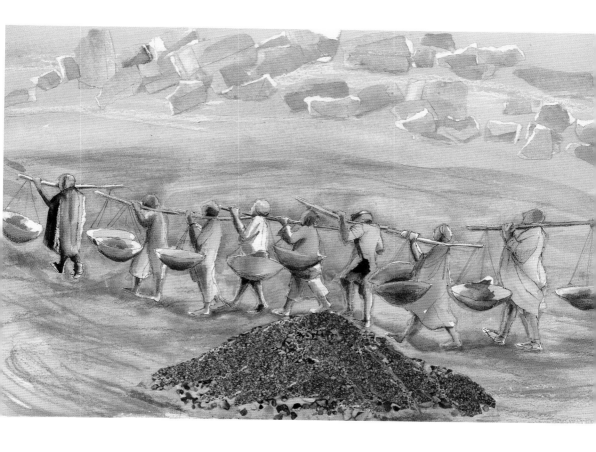

Fig 8.6 The gravel mound, Silbury Hill, Wiltshire, Neolithic period

Silbury Hill is the largest artificial mound in Europe and dates from the Neolithic/Bronze Age period. In 2000 a large hole appeared in the top of the hill, the opening up of an excavation shaft of 1776. Because of concern about the stability of the hill a decision was made to backfill the many voids that were remains of old openings and trenches. However, before that happened there was a re-excavation of a tunnel dug in the 1960s to re-examine the archaeology. The illustrations are based on the results. The gravel mound is the earliest mound on the site of Silbury Hill. In the side of the 1960s tunnel it showed as a heap of dull, sticky golden gravel resting on the stripped Neolithic ground surface. It was a little less than 1m high and nearly 10m in diameter. The gravel had been specially selected and must have had a special significance for the people who collected it. The ground surface had been scraped of turf and top soil to an orange/grey soil. Sarsen stones would have littered the ground and they are shown pulled to the edge of the prepared surface where they help to define the area.

Watercolour, collage, pen and ink, wax crayon, 470 × 310mm, 2009

[C245/007]

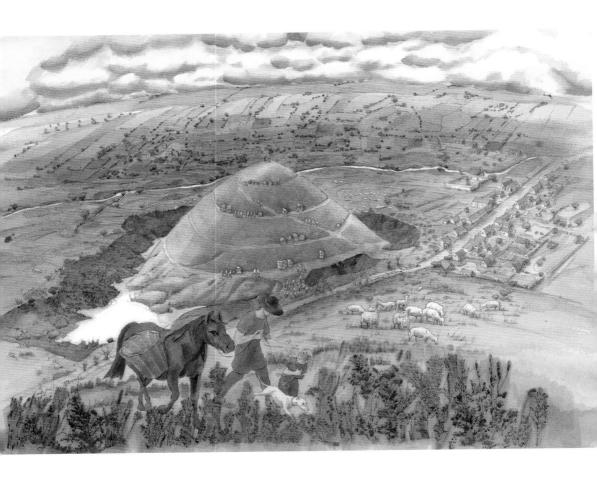

Fig 8.7 Silbury Hill, Wiltshire, Roman period

The picture shows Silbury Hill terraced, with a winding path to the top and small shrines and mausoleums. The ditch is filled with water from a spring. Shops and houses, part of a Romano-British settlement, line the Roman road with individual plots behind them. To the north of the road a temple stands on the site of an earlier Iron Age temple and on the surrounding hills are small farms and fields. The settlement and temple were revealed by geophysical survey and the farms and fields by aerial survey. This interpretation, understanding Silbury Hill as being embraced by the Romans, recognised as a special place and being incorporated into their religious ideas, was not accepted by all of the experts involved in the archaeology of Silbury Hill. However, the picture raised debate and directed people's thinking about the site and that process in itself is valuable.

Watercolour, pen and brown ink, 540 × 390mm, 2012

[IC005/028]

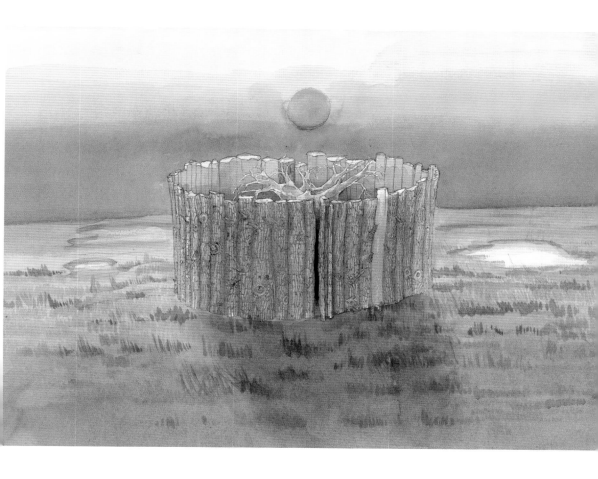

Fig 8.8 Timber circle at midsummer sunset, Holme next the Sea, Norfolk, c 2049 BC

The circle was made of 55 split timbers and study of the wood remains which survived 39in (990mm) deep in the mud can tell a lot. They were cut from 15 to 20 oak trees which were felled all at the same time in the spring or early summer of 2049 BC. They were cut from knotted, gnarled wood and dragged into position with ropes made of old man's beard (wild clematis). All the timbers but one were positioned with the bark facing outwards and there was a 7.9in (200mm) gap masked by another timber, which would have allowed a person to slip into the centre. The central tree, also an oak, is buried upside down with its roots in the air.

Watercolour, pen and brown ink, 340 × 520mm, 2004

[IC222/002]

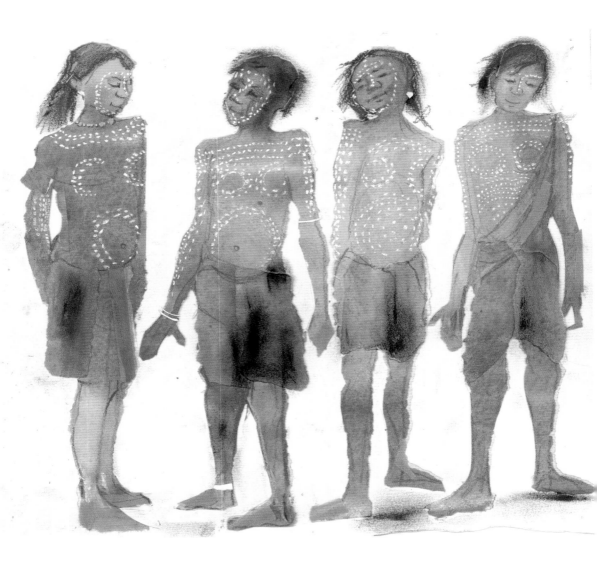

Fig 8.9 Neolithic/Bronze Age children, Silbury Hill, Wiltshire

This illustration was for *The Story of Silbury Hill* (2010), a book aimed at a general readership with more relaxed illustrations than those for a specialist academic audience. We do not know if prehistoric people painted, tattooed and decorated themselves but they probably did. We guess that they would have cared about their appearance as we do today.

Collage, chalk and white paint, 300 × 270mm, 2010

[IC245/001]

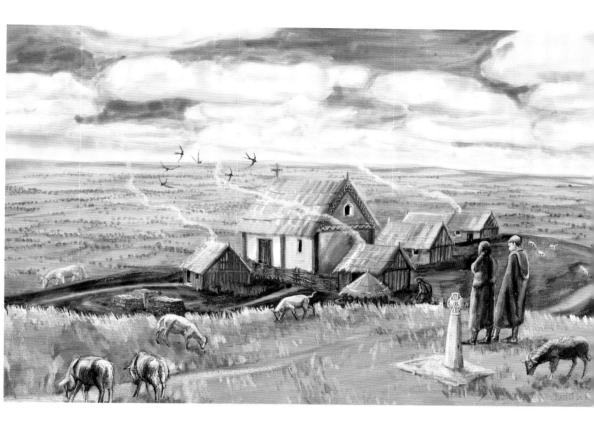

Fig 8.10 Monastic settlement, Glastonbury Tor, Somerset, Anglo-Saxon period

The remains of an Anglo-Saxon monastic settlement, probably a daughter settlement or hermitage to Glastonbury Abbey, were discovered by excavation from 1964 to 1966. On the summit, in the foreground, is a wheel-headed cross which dates from the 10th or 11th century. Below, on the shoulder of the summit and cut into the slope, are the monastic buildings. The largest is the church or communal building with several small cells and other structures.

Watercolour with body colour, wax crayon, 320 × 210mm, 1993

[J920411]

Reconstruction of the abandonment ceremony in Greenwell's Pit, Grimes Graves, Norfolk

Judith Dobie

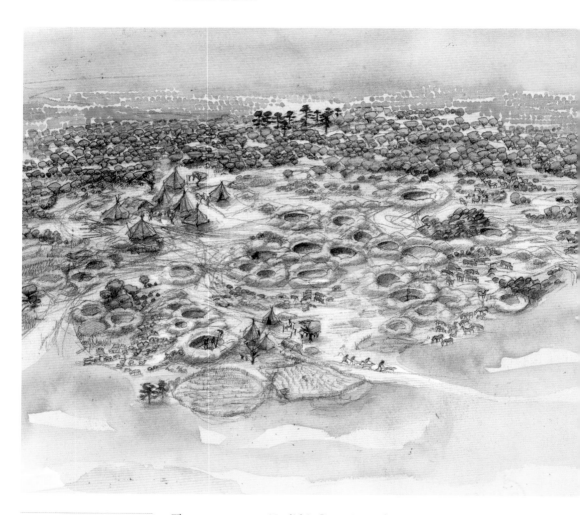

Grimes Graves, Norfolk.
A miners' temporary camp
in the late Neolithic period.
Pencil, watercolour, pen and
brown ink, 2010
[IC046/014]

There was more to Neolithic flint mining than a search for the best material to make tools. Flint to make axes and other implements could have been collected from the surface, as it commonly was in the preceding Mesolithic period. At Grimes Graves some of the mine shafts are 13m deep. Why go to this effort? We know that flint mining was highly ritualised – there are shrines or deposits of objects in many of the shafts and galleries at Grimes Graves. We also know that some flint axes, mined and made so laboriously, were never used but were buried in hoards, suggesting a ceremonial rather than functional purpose. Maybe the act of mining, the effort and collaboration required, contributed to the value of the flint obtained.

A reconstruction of Neolithic flint miners at work extracting flint from galleries at the base of the mine shaft using picks made from red deer antlers.
[IC046/020]

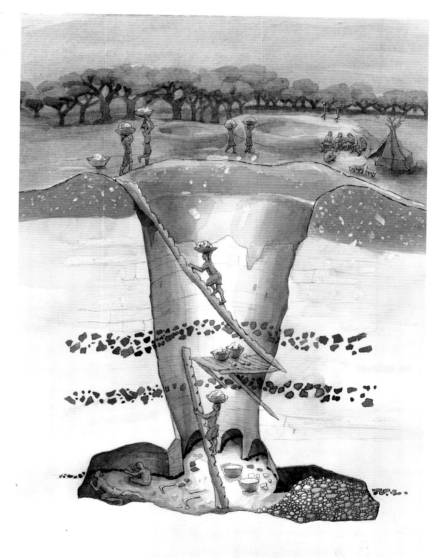

One significant deposit was discovered in Greenwell's Pit at Grimes Graves. A Greenstone axe, mined in Cornwall and dating the pit to Neolithic times, lay on a gallery floor positioned beside two antler picks lying parallel to each other with their tines facing inwards. Between them lay the skull of a rare wading bird – the phalarope. When I was asked to paint a picture for the site guidebook to show a ritualistic event I chose to show a scene of the placing of this deposit.
I imagined the making of the 'shrine' would be the final event in the closing of the gallery, the flint exhausted. I pictured a shaman placing the bird's skull in position as the last act.

The author of the guidebook, the archaeologist Peter Topping, stressed that the miners should be depicted as collaborative, organised, carefully coiffured and decorated – the opposite of the wild men they are sometimes shown as.

Picturing the scene, I thought of the huddle sportsmen sometimes make when planning a move or celebrating a success, a coming-together for the effort required in the next episode of play. As hearths are found in many of the pit shafts that were not used for cooking or heating but possibly

A reconstruction of the careful arrangement of antler picks, greenstone axe and phalarope skull found in a gallery of Greenwell's Pit. These objects must have been deliberately placed like this when the gallery was abandoned. Watercolour, pen and ink [IC046/011]

One of a series of quick pencil ideas for the abandonment ceremony.

for ritual purification, I saw the huddle backlit by such a fire, casting black shadows and silhouetting the figures.

As to the appearance of the people, there is an early Bronze Age grave of a girl from Egtved in Denmark who was buried dressed in a costume of cropped top and little skirt made of lengths of rope – like fabric. There are sculptures too, dating from this period, of women similarly dressed. This is different from other burials from the site where the women wear long skirts and shawls and it is sometimes suggested that the girl's costume might be the dress of a shaman. This is the model that I used for the central figure in my picture. It makes the woman look contemporary but for a period when few items of dress survive it is based on some evidence.

I drew a series of quick initial ideas in pencil and then developed the one that seemed to work best visually. I made a coloured rough with collage and crayon and paint and sent this with the drawing to the author for comments. As I had not appreciated how far along the gallery the shrine was positioned and therefore how low the roof was, I had to change the posture of my figures from standing to crouching. Peter also wanted me to add to the picture some of the objects found in the mines – animal remains and mysterious chalk cups. These changes made and approved by the author, the new rough was the basis for the finished picture.

I think that the illustration works quite well to convey atmosphere and suggest what people might have been like but I prefer my roughs, which are more dynamic. It is often the case that first quick ideas have an immediacy and directness that is hard to retain when the picture is revised. To combine both content and abstract qualities is difficult. The reconstructions that achieve this are the most memorable and successful.

gtved Girl's Costume.
ie girl aged 16–18 was
iried on a summer's day
1370 BC. Egtved is in
enmark but from analysis
the enamel of her teeth
id the fibres of wool of her
othes it's now known that
ie most likely came from
iuth Germany.
he National Museum
Denmark
tps://samlinger.
atmus.dk/DO/asset/4368
C-BY-SA 4.0)]

The drawing developed in
collage, crayon and paint.

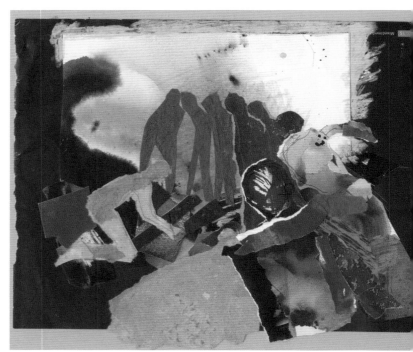

A further development
in collage.

Final rough with crouched figures, collage and crayon.

The finished picture below shows the shaman placing the phalarope skull between the antler picks. The Cornish greenstone axe lies between their handles. In the forefront are the chalk cups and slain deer.
[IC046/027]

Alan Sorrell

9 | Summary: Interpreting the past

It was said to me when I was writing this book and speaking to people who had been involved in commissioning reconstruction work, 'Doing something from the artists' side is of course all well and good, but these drawings are nothing without content and for my money that comes from the "commissioning historian". Surely that is what is special about them. They are not pieces of art to be admired in their own right but highly technical drawings meant to be viewed in a particular place or in a particular way.'

My colleague saw the work of the artist as a tool to explain the historians' view of the structures or sites but that is not the way I see it. I see archaeology as collaboration between many disciplines, a group activity. The range of techniques used, each with its own practitioners, is formidable – for example, aerial photography, land survey, geophysics, excavation, sieving, flotation, soil micromorphology. Then there are the archaeological science techniques such as dating and analysis of artefacts, food remains and other environmental evidence and there are the specialist archaeological illustrators – an art in itself that can illuminate the methods of manufacture and the style of the original object or structure – and then reconstruction art. Thinking how a site might be reconstructed should affect how it is excavated and what questions are asked of the site, and it should generate new questions when the original ones are not answered. The end product of all this activity, the archaeological report, remains a scientific publication but it will be the richer for all the personal experiences that have gone into its completion.

To draw is to see. The practice of drawing is almost identical to taking something apart with the eye connected to the hand. Observation of differences in colour, texture and tone, the recognition and interpretation of patterns, the play of light and shade on the contours of the land – these are the foundations of archaeology. It is no chance that some of the best field archaeologists have been involved in the visual arts. Mortimer Wheeler, who gave Alan Sorrell some of his first commissions, had had thoughts of a career as an artist and while studying at University College took drawing classes at the Slade School of Art. His distinctive style of section drawing was widely imitated and still influences archaeological illustration today. Brian Hope-Taylor was an illustrator before becoming an archaeologist; his brilliant excavation of Yeavering in Northumberland unpicked a sequence of Anglo-Saxon halls. Philip Barker, art teacher and artist whose acute excavations at Wroxeter, minutely recorded, revealed the wooden buildings others had missed and changed ideas of how to record a site. These archaeologists developed new ways of seeing, enabling others to look in the same way by anticipating what they might expect to see. Archaeology is an art as well as a science; imaginative ideas run through the whole process, for excavation is never totally objective, all interpretation is a subjective opinion.

Record survey is accurate, the accuracy can be proved, but some records give a fuller picture and this is because of the artistic input. For instance, planning graves is not difficult – most people can plot a skeleton but some

Fig 9.1
Miner extracting flint (detail), Grimes Graves, Norfolk, Neolithic period

When Alan Sorrell drew this picture in the 1960s he showed the Neolithic miner as a wild, naked man but ideas of the prehistoric have changed and most recent illustrations of Grimes Graves show the miners carefully and neatly clothed with elaborate hairstyles.

Charcoal, 1960s

[?/Y03058/003]

planners can step back from the detailed measuring and record a fuller picture of how the body lay – the tilt of the head, the angle of the shoulders and pelvis. When reconstructing coffins and bodies from the Anglo-Saxon site at Mucking, although no bone survived and all that was recorded of the body was a shadow in the soil, still some plans were subtle enough to recreate with confidence a three-dimensional figure. By using differences of tone the artist/planner had picked up hints of how the body lay. Similarly, the landscape surveyor; many people can make the measurements and draw the topography but to capture the whole, to record the subtlety of the shapes and feel of the undulations and express them in the pattern of the hachures – that is something special.

In practice the creation of a reconstruction is rarely just the visualisation of one expert's ideas. It is much more likely to be a dialogue, a process of negotiation between the artist and specialists, and the artist often contributes to the picture's academic content. You can think of Terry Ball, head of the architectural drawing office at English Heritage, drawing plans, sections and elevations and then constructing models from his records, testing the feasibility of his reconstructions and in this way raising and solving problems before he painted his exquisite watercolours. The Inspector of Ancient Monuments, Glyn Coppack, remembers Terry returning again and again to debate with him the different questions his architectural reconstructions had raised. And Ivan Lapper, the freelance artist, also reveals how the models he constructed as a basis for his paintings sometimes pointed out the incongruities and impossibilities of the experts' ideas. Alan Sorrell's method of work demonstrates his intellectual input into the reconstruction. His first rough sketches were overlaid with tracing paper on which he asked questions or made comments prompting the archaeologist for information. He would develop his drawing in this way with the sketch going between artist and expert, each making comments and Sorrell alterations or additions, the picture gradually growing – the product of cross-disciplinary collaboration. Sorrell's illustration of the Mesolithic site of Star Carr in North Yorkshire is one such case (Fig 9.2). His first drawing, showing the hunter/gatherer camp discovered by excavation, included a tent-like structure which he had thought the evidence justified. This was overruled and the published version of 1952 shows no such structure. But further excavation in 2010 discovered firm evidence of a post-built building and in a turnaround the report of the excavation in the media was illustrated by Sorrell's first discarded version.

In the same way Peter Dunn tells of how the scrutiny of reference material – maps, plans, sections, artefacts and photographs can mean that the artist notices something no one else has seen or connected before (*see* Fig 6.5). He had this experience when working on illustrations of Stonehenge for the Stonehenge Riverside Project; studying new phase plans, he realised that the timber corridor setting from the earliest stages of Stonehenge was cut through by a lunar alignment, providing further evidence that perhaps the initial design of the monument was based on a lunar and solar cosmological theme. Carrying this idea through to the next phase of Stonehenge, he made the connection that an early setting of stone holes believed to have held bluestones made an arc of the same diameter and spacing as the bluestone circle at nearby West Amesbury. It had already been suggested that the West Amesbury stones when removed had been dragged to Stonehenge; he thought that this was evidence that they had been reset in the same arrangement inside the newly erected

trilithons. Both of these new ideas were accepted as evidence for the increasingly complex nature of the development of Stonehenge.

I have described in the introductory chapter how reconstruction paintings can be categorised, some technical and some more narrative, but they are all primarily illustrations, not fine art meant to be hung on a wall but intended in the most part to be reproduced in books to accompany text. Not secondary to the text but integral to it, a collaboration. The best illustrators will bring more than a visual translation of the academic's ideas, for whatever the strength and interest of the evidence, the picture will only be effective and memorable through the personality and skill of the artist. The compositional unity of a painting

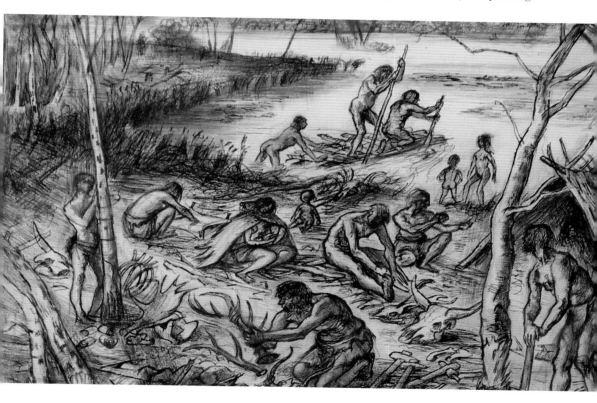

Fig 9.2 Star Carr, Scarborough, Yorkshire, Mesolithic period

Star Carr is the site of a Mesolithic hunting camp in the Vale of Pickering near Scarborough in North Yorkshire. It was first excavated from 1949 to 1951 by Grahame Clark, and Alan Sorrell's picture is based on his findings. The occupation area measured only 201 × 220yd (184 × 201m) and was situated by a shallow lake on a gravel promontory extended to make a rough platform by laying down birch brushwood weighed with stones and lumps of clay. The site was probably only occupied during the winter and early spring months and might have supported three or four families. Bones of slaughtered animals and hunting tools of flint and antler were scattered over the whole area. This is Sorrell's first version which included a tent-like structure vetoed by the archaeologist.

Charcoal, pencil, size unknown, c 1950s

[Alan Sorrell]

contributes fundamentally to the strength of its image and has power to carry imagination beyond the limits of the text. That is why Amédée Forestier's picture of 1911 illustrating the Glastonbury lake villages (see Fig 1.9) or Alan Sorrell's pictures of Hadrian's Wall from the 1950s are still often reproduced. Besides, the picture is not always just about structures and architecture, it can be much more, especially when describing the prehistoric period before the written word; it is about the experience of the site, the weather, landscape, sense of mystery or solitude, the play of light and dark – we are searching for new ideas and avenues into a different world. Colin Renfrew writes in his book *Figuring it Out*, published in 2003, of the experience of excavating the Cairn of Guerness on Orkney, one of the earliest completely preserved built spaces in the world. He describes working in the cool, dark interior of the sharply cut and closely constructed sandstone structure; of reaching up to touch the still completely corbelled ceiling – the first person to do so for thousands of years. And then the contrast when he emerged into the bright, clear, Orcadian light and brilliant landscape. He writes of the reality of being there, in that particular place, and of feeling the effects of wind and rain and light. The past reality was made up of complex experiences and feelings such as these, experienced by human beings similar in some ways to ourselves. Renfrew writes 'you don't find much about these moments in the printed excavation report but they are an integral part of the reality' (Renfrew 2006, 40). These impressions are elusive, difficult to capture, but pictures such as Ivan Lapper's view of 5th-century Wroxeter in the snow after the Romans had left describes a hard life for the inhabitants, the insecurity and the melancholy of decaying buildings (Fig 9.3). Contrast this with his view of the exercise hall in the 3rd century where he creates a huge, magnificent space full of light that tells you more of the Romans than just how they constructed their buildings (Fig 9.4). Allan Adams's reconstructions also focus on providing a sense of place. For him, actually standing in a particular space, getting the feel of it and imagining how it might have been used makes this easier. His picture of the back-to-back houses at Dukes Place, Liverpool is an example of this. The small rooms are left empty to emphasise their compact nature in contrast to the expansive area of the timber yard filled with activity and bustle hemming in the houses (see p 129 [Fig CS7.6]).

I began this book with a quote from Mark Edmond's book *Ancestral Geographies of the Neolithic: Landscapes, Monuments and Memory*, 'The past is dead and we cannot reconstruct it as it was' (Edmonds 1999, x). He was writing of his frustration at the gap between the hard evidence of survey and excavation and the abstract discussion of what we cannot know such as the relationship between material tradition and social life, the importance of ritual, how the monuments of the Neolithic, the circles and henges and long barrows and causeway enclosure camps, might have been used and be sustained. The study of the past, he came to realise, must be an act of imagination, bound by convention and by evidence but ultimately creative. In his book he bridged the gap with stories of Neolithic life. Reconstruction art does the same thing by pulling together all the knowledge and evidence gleaned from the archaeology, all the different processes, the scant traces surviving from far-off times, and combining them with imagination until gradually a picture emerges, a visual statement, a synopsis to illuminate the past.

Fig 9.3 Wroxeter Roman City, Shrewsbury, Shropshire, 5th century

Ivan Lapper's picture shows Wroxeter in the 5th century when the Roman administration had withdrawn from England and the city of Viroconium was in decline. The baths had gone out of use and a large timber-framed winged building had been constructed along the north wall of the redundant exercise hall. This late development seems to have been a private rather than public enterprise and could have been the vision of a great local leader reviving the city as the capital of the region. Most of Ivan's pictures are upbeat but this is a muted picture maybe reflecting dislocation and hardship.

Acrylic, pencil, brown crayon, 510 × 730mm. 1990

J900036]

Fig 9.4 Exercise hall, Wroxeter Roman City, Shrewsbury, Shropshire, 2nd century

All that remains of the exercise hall are its foundations and part of a side wall, but this reconstruction by Ivan Lapper gives a good impression of its grandeur. The plan comes from excavation. To give an idea, the building is equal in size to the nave of larger English cathedrals of the Middle Ages and is described as perhaps looking something like an Italian basilican church with classical columns topped with Corinthian capitals. Ivan Lapper has shown plastered walls painted in formal panels and a coffered ceiling, but it could have been simpler with colonnades carrying an open timber roof. The floors of the aisles were covered in mosaics and probably originally the nave was too. Before going into the bath itself bathers socialised, did exercises and games to work up perspiration. From the exercise hall the bather went on to the undressing room and then to the bath. The picture is interesting visually because of the play of light in the basilica, which helps to create a feeling of the proportions and magnificence of the room.

Gouache, pencil, 730 × 480mm, 1990

[IC118/011]

Bibliography

Ambrus, V 1975 *Horses in Battle*. Oxford: Oxford University Press

Ambrus, V and Aston, M 2009 *Recreating the Past*. Stroud: History Press

Ball, T 1989 'Castles on Paper' in *Fortress* **2**, 2–15

Barringer, T, Rosenfeld, J and Smith, A 2012 *Pre-Raphaelites: Victorian Avant-Garde*. London: Tate Publishing

Berger, J 2008 *Ways of Seeing*. London: BBC and Penguin Books

Blake, Q (ed) 2003 *Magic Pencil. Children's Book Illustration Today*. London: The British Council/ British Library

Bradley, R 1997 '"To See is to have Seen". Craft Traditions in British Field Archaeology' *in* Molyneaux, B (ed) *The Cultural Life of Images: Visual Representation in Archaeology*. London: Routledge

Brindle, S and Kerr, B 1997 *Windsor Revealed: New Light on the History of the Castle*. London: English Heritage

Brown, N 2000 *Splendid and Permanent Pageants: Archaeological and Historical Reconstruction Pictures of Essex*. Chelmsford: Essex County Council

Bruce-Mitford, R and Taylor, R 1997 *Mawgan Porth, A Settlement of the Late Saxon Period on the North Cornish Coast, Excavations 1949–52, 1954 and 1974*. London: English Heritage

Catling, C 2013 'Alan Sorrell "An artist, and not an archaeologist"'. *Current Archaeology* **285**, 32–9

Cunliffe, B 1985 *Heywood Sumner's Wessex*. Wimborne: Roy Gasson Associates

Davison, B 1996 *Picturing the Past: Through the Eyes of Reconstruction Artists*. London: English Heritage

Drury, P J 1982 *Structural Reconstructions: The Approach to the Interpretation of the Excavated Remains of Buildings*. Oxford: British Archaeological Reports

Dykes, D W 1981 (ed) *Early Wales Re-created*. Cardiff: National Museums and Galleries of Wales

Edmonds, M 1999 *Ancestral Geographies of the Neolithic: Landscapes, Monuments and Memory*. London: Routledge

Gombrich, E H J 1950 *The Story of Art*. London: Phaidon

Grigson, G 1948 'Authentic and False in the New Romanticism'. *Horizon*, **XV11**:99, March 1948, 205

Grinsell, G, Rahtz, P and Warhurst, A 1966 *The Preparation of Archaeological Reports*. London: John Baker

Hamilton, J R C 1968 *Excavations at Clickimin, Shetland*. London: HMSO

Hay, G D and Stell, G P 1986 *Monuments of Industry: An Illustrated Historical Record*. Edinburgh: RCAHMS

Hirst, S and Clark, D 2009 *Excavations at Mucking Vol 3 The Anglo-Saxon Cemeteries*. London: Museum of London

Hodgson, J 2000 'Archaeological reconstruction: illustrating the past', IFA Paper No 5

Hodgson, J 2004 'Archaeological reconstruction illustrations: An analysis of the history, development, motivations and current practice of reconstruction illustration, with recommendations for its future development'. Unpublished PhD thesis, Bournemouth University

Hope-Taylor, B 1977 *Yeavering: An Anglo-British Centre of Early Northumbria*. London: HMSO

'Reconstruction Drawings of Ancient Monuments: A New Project'. *Illustrated London News*, 3 August 1957, 191

'Leicester's Roman Forum To-Day: A City's Unique Heritage', *Illustrated London News*, 13 Feb 1937, 254

'Leicester's Roman Forum 1800 Years Ago: A Restoration', *Illustrated London News*, 13 Feb 1937, 255

Johnston, S 1989 *Hadrian's Wall*. London: Batsford/ English Heritage

Leary, J and Field, D 2010 *The Story of Silbury Hill*. Swindon: English Heritage

Leary, J, Field, D and Campbell, G 2013 *Silbury Hill: The Largest Prehistoric Mound in Europe*. Swindon: English Heritage

Macaulay, D 1975 *City, A Story of Roman Planning and Construction*. London: Collins

Martin, D 1989 *The Telling Line, Essays on Fifteen Contemporary Book Illustrators*. London: Julia MacRae Books

Mellor, D 1987 *A Paradise Lost: The Neo-Romantic Imagination in Britain 1935–55*. London: Lund Humphries

Merriman, N 1990 *Prehistoric London*. London: HMSO

Moser, S 1998 *Ancestral Images: The Iconography of Human Origins*. Ithaca, NY: Cornell University Press

Neal, D S 1974 *The Excavation of the Roman Villa in Gadebridge Park, Hemel Hempstead, 1963–8*. London: Society of Antiquaries

Parker-Pearson, M 1993 *Bronze Age Britain*. London: Batsford/English Heritage

Piggott, S 1965 'Archaeological draughtsmanship: Principles and practice, Part 1: Principles and retrospect'. *Antiquity* **39**:155, 165–76

Pitts, M 2005 'Hysteria, gloom and foreboding'. *British Archaeology* **83**, July/August 2005, 16–19

Rahtz, P 2001 *Living Archaeology*. Stroud: Tempus Publishing

Redknap, M 2002 *Re-Creations: Visualizing Our Past*. Cardiff: National Museum of Wales

Renfrew, C 2003 *Figuring it Out: The Parallel Visions of Artists and Archaeologists*. London: Thames and Hudson

Riley, H 2006 *The Historic Landscape of the Quantock Hills*. Swindon: English Heritage

Smith, P 1975 *Houses of the Welsh Countryside: A Study in Historical Geography*. London: HMSO

Sorrell, A 1973 'The artist and reconstruction'. *Current Archaeology* **41,** 177–81

Sorrell, A and Sorrell, M 1981 *Alan Sorrell: Reconstructing the Past*. London: Batsford

Sorrell, J 2013 'The artist and the wall'. *Current Archaeology* **285**, 40–2

Sutcliffe, R 1957 *The Silver Branch*. Oxford: Oxford University Press

Thurley, S 2013 *The Men from the Ministry: How Britain Saved its Heritage*. London: Yale University Press

Wainwright, G J with Longworth, I H 1971 *Durrington Walls: Excavations 1966–68*. Reports of the research committee of the Society of Antiquaries

Index